MY HEART IS NOT BLIND

MY HEART IS NOT BLIND

On Blindness and Perception MICHAEL NYE

TRINITY UNIVERSITY PRESS San Antonio, Texas

CONTENTS

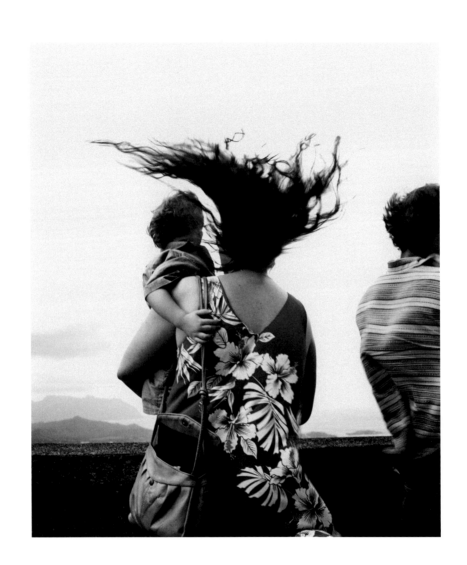

Not all blind people are blind. Not all sighted people can see. Knowing what the world looks like is not a requirement for understanding. For many, "blindness" suggests a lack of awareness. If that is true, then everyone is blind to what they don't know.

I had a photography exhibition in Riyadh, Saudi Arabia, thirty years ago. I was asked to give a gallery talk to a group of international blind students. What I remember visually was their intense gaze and resolute attention. With them, a whisper traveled far. I tried to describe the difference between early light and twilight—that black-and-white photography could represent less than or more than what was experienced in ways that might amplify visual perception. Their questions were straightforward and profound. "Why are you a photographer? What is beautiful that is nonvisual? What is the meaning of these photographs? How can anyone, blind or sighted, understand the world outside themselves?" It was the students who were giving the gallery talk, and I was listening.

I began to think about the deep well of perception and attention. It is attention that strengthens connections of neurons and allows us to remember. It is attention that can lead us out of our private lives into the wider world and lives of others. It is attention that pushes us, protects us, and creates expertise. It is attention that can unearth what is necessary, important, and hidden. What did these students understand about our human experience as a result of their attention and reliance on their other senses, especially relating to touch and sound?

When I returned home I arranged meetings with a group of blind individuals and sighted visual artists (poets, sculptors, photographers, and painters). We had conversations about awareness and perception. We talked about metaphor, articulation of light, echolocation, three-dimensional visualization, the deeper

meaning of voice, touch, and the intuition of space and time. Everyone, blind and sighted, came away excited, carrying new and revised vocabularies.

Over the last seven years I have been listening to men and women who are blind or visually impaired. I spent two to three days with each person. It's been a rare privilege to have these deep and personal conversations. My ears saw much more than my eyes. This project is about blindness and perception, but it is also about human adaptation. It is about a grave misunderstanding of the nature of blindness. It is about what we have in common, and the fragility that is a part of our shared human condition. No one I met wanted to feel or be insignificant. Everyone I met talked about the notion of giving, and a hunger to know and do more.

The first individual I interviewed was Larry Johnson. He is tall, thin, bearing a contagiously deep radio voice. He lost his vision as a baby due to infantile glaucoma. When he speaks, his voice rises with enthusiasm. He spent twenty-two years working as a top DJ in Mexico. Larry is a teacher, a writer of compelling op-ed pieces, and tireless encourager to many. He is fascinated by the powers of observation and the challenges of life's puzzles. I interviewed him in his home. Inside it was extremely dark. I stumbled against walls and furniture. At the same time, Larry was dashing around his house, answering his phone, heating up tacos, making coffee, and helping me plug in my recorder. Who was in a position of advantage?

Jacques Lusseyran (1924–1971) became blind in an accident at the age of seven. He became a leader in the French resistance movement fighting the Nazis in 1942. In his moving memoir, *And There Was Light*, he writes about his adaptation to his changed condition: "People often say that blindness sharpens hearing, but I don't think this is so. My ears were hearing no better, but I was making better use of them. Sight is a miraculous instrument offering us all the riches of physical life. But we get nothing in this world without paying for it, and in return for all the benefits that sight brings we are forced to give up others whose existence we don't even suspect. These were the gifts I received in such abundance."

Blindness is not what the public thinks it is. It is something very different. It doesn't diminish someone's cognitive or emotional abilities. Vision races, whereas touch, sound, taste, and smell are slower, more deliberate. Eyes are greedy. Vision examines surfaces, where sound and touch are more intimate. The public fears blindness in the same way they fear cancer or dementia. For many, darkness and the unknown are deeply frightening. Whenever I hear any sighted person speak of blindness, it is always about inabilities or limitations. The conversations are rarely about competency or newfound perspectives. When something is taken away, often something else takes its place.

Generalizations fall apart along the edges. Stories about blindness are not stories about darkness. Every person's particular vision loss or impairment is acutely unique to their adaptation and life experience. Being born blind is nothing like losing sight in middle or old age. Losing vision slowly due to a genetic eye disease is nothing like losing vision in a moment. The first year of blindness is very different than long-term developed

nonvisual adaptation. Living with shame, without support, is very different than being surrounded by encouragement with the expectations of education and independence.

Visual impairment (having some vision or light sensation) is also inexplicably complex. Terms such as "legally blind," "moderate or severe low vision," and "near blindness" are used to describe degrees of impairment. For many, visual impairment is like living between two unfriendly worlds. Natalie said, "It feels like being inside a slowly constricting narrow tunnel on a foggy day. I might see a fly on the wall across the room and trip over an elephant getting to it."

There are so many ways eyesight can be lost or impaired or damaged. Some of the diseases and causes in this project include retinopathy of prematurity, brain aneurysm, Peter's anomaly, car bomb, detached retinas, scarlet fever, Charles Bonnet syndrome, cone and rod dystrophy, idiopathic intracranial hypertension, septo-optic dysplasia, train accident/collision, Leber's hereditary optic neuropathy, Leber's congenital amaurosis, cancer of the retinas, gunshot, retinitis pigmentosa, diabetic retinopathy, choroideremia, spinal meningitis, hereditary glaucoma, Stevens-Johnson syndrome, narrow- and open-angle glaucoma, cortical blindness, infantile congenital glaucoma, osteoporosis-pseudoglioma syndrome, and macular degeneration.

The diversity of impairment to vision further emphasizes the divergent experiences and nonvisual adaptation. Every story carries a point of view, and the simple awareness of it is enough to make it rare and valuable.

Each person I met has been intensely tested. Most who lost eyesight after having vision went through an initial period of depression and desperation. Language seems so inadequate to describe such early seasons of despair.

> "I was first in denial then fury. I tore apart my mattress and bed frame, and I did this by hand."

> "Losing your sight is like being shot—not in your heart but in your soul. I asked God for mercy. I cried every day."

> "How can I live? How was I going to be the same person I was before?"

Yet many others, including Richard, had very different responses: He was driving home from work and was hit by a train. The glass exploded and took out his eyes. "The way I adjusted to my blindness was that I had a family and two small children who depended on me. My worry was how was I going to support them?" he said. "So I jumped right into mobility training, trying to find out how do things being blind. I started repairing automobiles as a blind man simply because I did that when I was sighted."

I've rarely met a long-term self-pitying blind person. The voices I heard were grounded in humility and surrounded in reflection and humor. Many born blind told me that they never really think of their blindness unless someone brings it up. Many individuals, either born blind or long-term blind, said they would refuse sight if it were offered. Juanito said he would only take sight if it had an on and off button. Some pray to God every

day for their restored sight. Many who have been blind long term said it would be difficult to live again as a sighted person. Ann, who lost her vision gradually, said, "The word 'blindness' doesn't scare me anymore. I used to fear being called blind. But I've crossed over. It's taken so much to adapt to being blind that I would hesitate to go back."

Discrimination and ignorance run deep in the pages of world history. Wars are horrible, but so is every act of human cruelty. Historically, how were the blind treated? Many accounts suggest that the blind were thought to be possessed with some sort of evil or were being punished; some were institutionalized, and their conditions sometimes equated with mental illness or mental retardation. Into adulthood, many were treated as children; others ended as beggars, or were locked away by families or sold into slavery or prostitution. As recently as the twentieth century, some U.S. cities passed ugly ordinances that included the following language: "Any person who is diseased, maimed, mutilated, or in any way deformed so as to be an unsightly or disgusting object . . . shall not . . . expose himself or herself to public view."

Discrimination is itself an affliction. Every person I met, either visually impaired or blind, has a long list of stories of being treated unfairly. How we are seen and treated by others impacts our identities. In John Rawls's seminal treatise on justice, he begins, "Justice is about fairness." Burns Taylor lost his vision at age three when his older brother, age nine, shot him in the face. He has been a university professor and author. He describes his essential questions of existence: "How do you learn to live with something that society makes you feel ashamed of, makes you feel that you are not as capable and not whole? Society's perception is that I'm not equal to them. That's something that I have to live with every day."

Chelsea said: "Almost every day my family told me I was a burden, and would never amount to anything. My mother said her life would be so much more fulfilling without me."

Olivia lost her vision as a baby due to cancer of the retinas. Her mother tells her that when she took Olivia to the grocery store, with both eyes bandaged, friends would say, "Well, if she had cancer, why didn't you just let her die? How is she going to live with blindness?"

Sandhya was born blind in her right eye, with very little vision in her left. In addition, due to a brittle bone condition, she has broken nearly every bone in her body. She became a voracious Braille reader and learner. Graduating from Rice University and then from Stanford Law School, she now works for a U.S. district court focusing on civil rights and habeas corpus cases. When she was fourteen she visited her parents' family in India. "My grandmother said that my blindness was a curse from God," she said. "I was totally devastated. My parents always told me I could accomplish anything. I remember trying to run away from the village. I did not have a cane back then, so that was not wise. I was really, really mad."

Language is stitched into our invisible consciousness. We rarely imagine extended biases. "Blind" means lacking the physical sense of sight. But our dictionary also defines "blind" as an unwillingness to perceive or understand: "blind

loyalty," "blind leading the blind," "turning a blind eye," "blindsided," "flying blind." None of these phrases are compliments, and all point to a person's character flaws. "Blindness" in our lexicon suggests that if we don't physically see something, then we can't know it. Unfortunately, these terms bleed into the public's negative attitudes toward and low expectations of those who are blind or visually impaired.

With the passage of the 1973 Civil Rights Act, Title 5 of the Rehabilitation Act, and the Americans with Disabilities Act, Congress addressed the needs of people with disabilities, prohibiting discrimination in employment and public services. Still today, though, in the twenty-first century, ignorance and discrimination against the blind and visually impaired continue to be red hot.

In response to my question "What does the public not understand about blindness?":

> "Blindness is not a death sentence."

> "Blindness does not mean you can't be a good mother."

> "Blindness does not mean that you cannot make a difference in this world."

> "Blindness does not mean I am clueless, incapable, and incompetent."

> "Many times people talk to me like I'm in the second grade."

> "People tell me if they lost their sight, they would commit suicide."

> "The word 'amazing' has become a thorn in my side. Almost every day I walk down the sidewalk and people stop me and say, 'Oh, you're so amazing.' Really? What am I doing that I'm so amazing? I'm getting out there because I need to go to work or go to the grocery store. The public sees us as helpless."

Michael Hingson was on the seventy-eighth floor of Tower One on 9/11 when the first plane struck. He was working for a Fortune 500 company. Michael was blind and with his guide dog, Roselle. His preparation and understanding of teamwork gave others (sighted individuals, as they climbed down seventy-eight floors to safety) confidence and calm. Michael said, "The biggest problem blind people face is not blindness, but rather what sighted people think about blindness."

When a person loses their sight, let it be understood that he or she loses nothing else. They remain a whole, vibrant individual. They do not lose their intelligence, personality, personal histories, ideas, wisdom, empathy, and all the egalitarian promises of equal rights. Many in this project after losing their sight went to school and obtained undergraduate, master's, doctoral, and law degrees. The majority are employed, take risks, have families, struggle, and flourish like we all do.

Qusay Hussein was living in Mosul, Iraq. He was playing volleyball when a car drove next to him and blew up. "I lost my nose, part of my right face, and both my eyes," he says. "Blindness means you can't see, but absolutely your brain is working 100 percent. I'm blind with my eyes, but I'm not blind with my brain and heart."

The story of our eyesight is the same story as all adaptation. We adapt to our conditions seek-

ing advantage. In time, a crooked road points to order. Scientists suggest that the first eye fossils date to some 540 million years ago. First were eyespots—light-sensitive pigment reaching for light and energy. Vision is a wonder. It is so easy to look out and witness distant landscapes, movement, explosions of colors, detail, and all the complexities of tonal variations at night or daytime. With memory and experience we use our vision as a passport into appearances and surfaces.

Adaptation to blindness also takes time. Acceptance and attitude are the first few steps. Support and encouragement, education, patience, and persistence help. I personally experienced three extraordinarily innovative organizations: the San Antonio Lighthouse for the Blind, the Criss Cole Rehabilitation Center in Austin, and Ho'opono Services for the Blind in Honolulu. These passionate groups change what it means to be blind. Blindness is not a barrier to success.

Katie spoke of her adaptation: "When you lose your vision as an adult, you are a child again relearning. It's like bringing two lines back together again. I was expecting two years for rehabilitation. I remember it took me seven years almost to the day of losing my vision, when I woke up and thought, 'Oh, I'm normal again.' I began the next chapter of feeling integrated in my community and equal to my peers who are sighted. Blindness has given me a different form of stability and an innate strength of endurance in ways I never imagined."

Adaptation is not always a choice. If we accidentally cut our hand, our bodies immediately begin the healing process. Ernest spoke of his adaptation: "When I first lost my sight I was still trying to think like a sighted person. One day I realized that my mind was telling me to listen, feel, and smell. Sounds are incredible now. I can hear every little noise, the person above me in the apartment walking or turning on a faucet. Once I started utilizing my other senses, I realized, 'Oh, wow. Why wasn't I paying attention to this? This is easier than I thought it was going to be.'"

Neuroplasticity is the remarkable story of neural adaptation. "Neuroplasticity" is a term that describes lasting changes to the brain throughout an individual's life as a result of synaptic connections constantly being removed and re-created. Recent studies suggest that new neurons can be born in the hippocampus and in neural stem cells and can participate in circuits that underlie learning. Our brain has the ability to reorganize itself.

The initial vision processing occurs in the visual cortex. Studies suggest that up to 20 percent of our brain is dedicated to "visual-only" functioning. There may be another 25 to 30 percent that participates with vision—vision and touch, vision and motor, vision and navigation, vision and meaning, and more. More areas of the brain are dedicated to vision than all our other senses together. What happens when someone is blind? What happens to these areas committed to vision? Although much is unknown, it is clear from multiple studies that areas of the brain previously used for sight are now being used by our other senses and existing memory in order to compensate for the lost sight. Blindness causes structural brain changes. The brain reorganizes itself to favor nonvisual thinking.

Nonvisual thinking may have similarities to learning a new language. Imagine someone mov-

ing to China to learn to speak Chinese. At some point in time they begin to think and dream in Chinese. The brain shifts in consciousness from one language mode to another. Qusay said, "When you have vision, the ear takes a back seat. But for me right now, the ear takes the front seat, and my eye takes the back seat, yes." Frances said, "It's stepping from one dimension to another." Natalie said, "Blindness is just a different way of existing in the world."

Perception is deeper than we can imagine and more mysterious. Our other senses have their own wisdom separate from sight. Our eyes miss so much. Most believe that hearing has not improved, but what changes is the ability to extract new meaning from familiar sounds. Voices expose sincerity and character, laughter echoes and swirls, and barking dogs become markers for street signs and addresses. Sounds are not just sounds but have origins and destinations. The fragrances of peppermint, pine needles, and pencil shavings float and fly, leaving impressions like fingerprints. Without the assistance of vision, a kiss, a touch on the back of an arm, the first soft breeze in the morning occur in a different time zone. Memory awakens and tilts. What becomes more sensitive is awareness from a cultivation of attention. I heard many examples of heightened perspectives and amplified abilities as a result of nonvisual adaptation:

> "If I had the choice to restore my vision, I wouldn't take the chance of gaining physical sight but losing the perceptions and the abilities I have. I've learned to perceive things in a way that other people don't.

I like what Sherlock Holmes once said to Watson: 'You see but you do not observe.' Vision is limited."

> "I don't care so much what people look like. I hear their voices, their manner, their energy, their sense of compassion, and how they reach for my hand. A handshake will tell you how that person might be feeling."

> "I can hear the echo bounce back. The closer you get to an object, the shorter the bounce is going to be. I can locate the distance between myself and a wall, mailbox, or car. It's almost like not seeing a shadow but hearing a shadow."

> "I am a firm believer that everything has energy whether it's a dead tree, a pole, iron, or a person. Every object out there gives out something. I could walk by people and not even physically touch them, and I can feel their energy coming off of them."

> "A few years ago, I took a trip to the Grand Canyon. Standing at the rim, I could feel the vastness, the enormity of the canyon. Something came over me. I felt a chill. I was even shaky, but not scared. It struck me as a spiritual feeling. I don't know if it's the same feeling that someone who sees it feels, but that's what I felt. I felt small."

In addition to heightened perceptual abilities, many individuals who lost their vision later in life remain visual in their orientation. Blindness does not erase one's past visual memories. "Everything I hear, smell, touch, and feel turns into a vision

in my mind's eye," Katie said. "I don't try to make the mental images. It just happens. When I meet someone there's a vision in my mind's eye of how they look. It's not in the finite detail. It's more an essence."

John McPhee, who writes about deep time, suggests that the best way to describe complexity may be through metaphor or analogy. Dean Georgiev from Mililani, Hawaii, describes his experience of losing and finding:

> Many sighted people think blindness means the world is over. *No,* it's not over! You haven't lived with it. You haven't discovered it. . . . When I got to the point where I lost my remaining usable vision, . . . I let go and it was freeing. I felt so unburdened, because now I could focus on nonvisual learning. And what happened is that the world opened up.

> So think of this analogy—that the sun represents vision and then all of a sudden it's gone. Well, what is there? There's not nothing. There's a whole universe of stars that reveal themselves to you. If the sun was out all the time, you would never know the stars existed, at least not visually. That's what people don't know about blindness, that when you take away the vision, you're not taking away everything. No, you're not!

You're basically uncovering and allowing other things to be revealed to you.

The sighted community is blind to blindness. They think only of loss. They fail to appreciate all that has been found. Most sighted persons are vision-centric. It's extremely difficult or rare for a sighted person to imagine another person thinking, perceiving, remembering, and experiencing life with a developed nonvisual orientation. And that is the origin of discrimination.

No one welcomes blindness, but each person I met recognized how their changed condition has expanded their sense of compassion and magnified their awareness and abilities in ways they never thought possible. Marti Hathorn spoke emphatically about being fully present in her life.

> I wouldn't describe seeing as being a better sense than any of the others. People ignore their other senses. So much is missed, and it prevents someone from going deeper. How would I answer someone who says, "Why travel if you can't see"? My response to them would be, "Why do anything?" Experience is not just visual. It's feeling emotion. Tactile. It's smelling. It's listening. There are so many ways to experience moments to their fullest.

MY HEART IS NOT BLIND

DEAN GEORGIEV

My name is Dean. I live in Mililani, Hawaii. It's a good-sized little town in the center of the island of Oahu. I live with my wife and we have two grown children. I work for the Department of Vocational Rehabilitation in the blindness services branch called Ho'opono. In Hawaiian it means "to make things right."

As a child I was night blind, so during the day was when everything happened. I remember light and brightness. I enjoyed the sunshine and the outdoors. I could imagine bright Sunday mornings and going into the woods behind our house to play with friends. My ability to progress with blindness began very young with a curiosity and a rebellious sort of questioning attitude. I'd ask questions like, "Where does this path go?" I would follow it to explore. I didn't know it at the time, but it was part of the way I learned. I always wanted to know why.

I was born with retinitis pigmentosa. The doctors told my parents that I would lose my vision eventually. They couldn't be precise about when that would happen. For the first ten years and most of my teens, I had day vision. I don't think I've ever cried out of sadness as far as being blind. I have maybe cried out of frustration, and a failure at not being able to do something. What I've learned about frustration is that it's just something that you experience on the way to success. That's the way I look at it now. It's the same if you're doing a jigsaw puzzle. Sometimes it doesn't come to you right away. You have to work at it, and then eventually all the pieces fit together.

If someone asked me to describe myself, the last thing I would say is blind. The first things I would say are American and father. Later, another was the identity of teacher. When I'm able to touch people's lives in a positive way and effect change that will help them as blind individuals move forward successfully, that is a great thing. One of the biggest confusing things about identity is the blindness part.

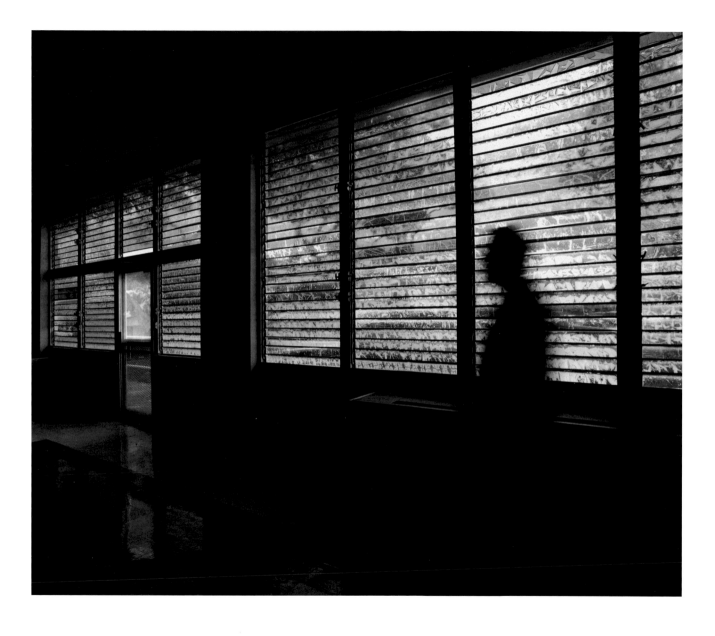

It changes things. Sometimes it makes you seem limited in the eyes of others. It changes people's perception about you. Someone would say, "You're really good at something for a blind person." I believe that it's important to know another person on a one-to-one basis. When they get to know your name, what you're like, what you believe in, what you do, blindness becomes less important to them. They might even come to the point where they say, "Wow, I forget that you're blind." Good that you forget that I'm blind.

As I lost my vision, sound has become primary. I switched over to auditory learning. It wasn't an easy process but I was able to recognize the anatomy of sound. My hearing is normal. It has tested normal and it's still normal. Beyond that, what has really changed is, now, I'm able to distinguish what I hear. I had to make adjustments and notice many things about the sounds I hear. If I tap on something, depending on movement and direction, depending on the air, depending on the acoustics in the room, that same tap is going to sound different. That subtlety of sound is very important. I am confident of my ability to find my way around. I can hear a building beside me when I walk. It's because the sound is flowing around it. I can walk down a street and even catch the sound of a pole that gets between me and the sound on the other side. I can originate sounds by tapping my cane or listen to external sounds.

The whole world is a tapestry. If you were to think of a bunch of colors, that's how different sounds are coming from all the directions. You could have the same exact sound, but because of what it's around or where it's coming from, you'll be able to give it meaning.

Beauty to me is something that you are attracted to, something that you want to give time to savor and experience. Particularly here in Hawaii, the trade winds kiss your skin. The wind leaves you with a sort of a tranquil feeling under a shade tree. You don't have to see what's around you. Baseball is something I love. I love it in its symmetry, in its rules. I love it in its tradition. There are just moments in a baseball game that can be so dramatic. It's a sport that is quiet one moment, kind of a lazy pace to the game, that suddenly erupts in a burst of excitement. You can feel the energy when you hear a crack of a bat or a ball hitting a glove. And then there's the food that you smell. There are people around you who are having conversations, and it's a totally nonvisual experience that is so rich.

Like sound, touch is a very important sensory system. A lot of people think that touch is part of the hand and the fingertips. It's true, but it's a lot more. It's your skin sensing light, or the sun on your face. You're able to feel things thermally. Touch is also a sense of space. What space are you in? You can identify through sounds whether you're in a big auditorium or a small room. But being spatially aware is knowing where you are relative to another person and being able to move through space.

Blind people need to expand their reach. They need to stretch out their arms. The cane is a very important part and extension of the tactile senses. When people started to see me with my cane—that cane belonged to me and I used it proudly. A lot of people want to hide the fact that they're blind. They might use a folding cane and put it away. That is a mistake. Blindness means

you do things differently. But it doesn't mean that because of blindness, you need to be treated differently.

I am the director of the New Visions Program in Honolulu. We change what it means to be blind. Blindness is not a barrier to success. Some people who lose their vision shut themselves down. It's almost self-fulfilling, because they are not doing anything. Some who've been blind all their lives can be socially backward. They haven't been exposed, because they've had parents or teachers who took control of their lives and said, "I need to watch you because I don't want you to get hurt." That person has not been allowed to grow and evolve.

A person coming to our program is not sitting around talking about their problems. What we're saying is, "Yes, we understand. Okay, now let's go to work." We have students stay with us for nine to twelve months and learn to adjust to their blindness and grow in their confidence and skills. Through the Socratic method, we teach critical thinking and problem-solving abilities. Questions are the programming of your mind. If you ask, "Why am I blind?" well, you're not going to get a very good answer. But if you ask, "How can I live a positive, happy life as a blind person?" those answers will be a lot more rewarding. We're passionate. Our whole crew is passionate about our program and about teaching a newfound perspective, confidence, and skills to our students.

Many sighted people think blindness means the world is over. *No*, it's not over! You haven't lived with it. You haven't discovered it. You haven't played with it.

When I got to the point where I lost my remaining usable vision, I just let it go. I couldn't do it anymore. I let go and it was freeing. I felt so unburdened, because now I could focus on my strengths. I could focus on nonvisual learning. And what happened is that the world opened up.

So think of this analogy—that the sun represents vision and then all of a sudden it's gone. Well, what is there? There's not nothing. There's a whole universe of stars that reveal themselves to you. If the sun was out all the time, you would never know the stars existed, at least not visually. That's what people don't know about blindness, that when you take away vision, you're not taking away everything. No, you're not! You're basically uncovering and allowing other things to be revealed to you.

CHELSEA MUÑOZ

I like to learn more about everything. The more I know about life and humanity, the more options I have. I used to enjoy going to the butterfly gardens when I was six years old. My elementary school teacher would take us. They encouraged us to listen to the sounds and talk about how the air felt, and how we felt being around ponds and nature as a whole. I remember that they said the female peacock was really ugly. I questioned it actually. I asked them if they could describe "ugly" more clearly, because I didn't understand what it meant. They couldn't explain what it meant.

I used to be able to see out of both eyes. It was never very reliable. People would hold something blue up to my face and ask, "What color is this?" Deep down I knew that I couldn't tell them accurately. I just guessed. Sometimes I was right, sometimes I was wrong. When I was younger I could see the moon. Not wishing my blindness away, it would be really cool to see the moon again, or the sun. I was able to thoroughly see the shapes of things. I could never see somebody's face or any details. I haven't seen birds or any kinds of animals. A couple of years ago I woke up one morning and had nothing but light perception. I could no longer see the outlines of people. I don't see anything right now.

Initially when I lost my sight, I was scared. But very quickly I became relieved, because I didn't have to lie to myself that my vision is going to improve. Being totally blind has made my life much easier in more ways than I can ever express. I don't have any vision to distract me. I'm not straining or trying to focus, and I'm free to use alternative techniques of touch, taste, and smell a lot more. I'm not bound by this notion that if I go blind my life's going to suck—because that's just not true.

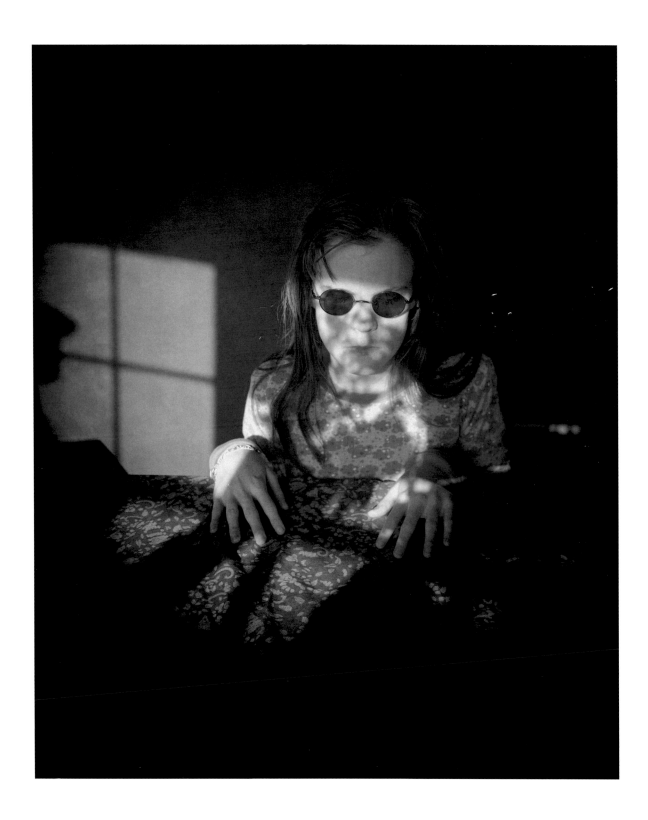

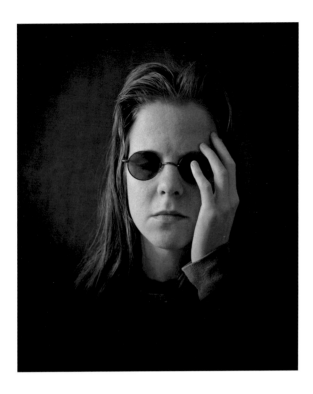

As a young girl, I always knew I was different. Even as a child I kept thinking, "Why does being different have to be a bad thing?" My mother and her relatives would tell me that I was a burden, because I couldn't see. I also have this additional disability, which is mild cerebral palsy. I walk with a limp and use an additional cane for balance. I believe that the only limitations we have are those which we place on ourselves. They told me that those two things combined were the reason I was a burden, and that I would never amount to anything. Just about every day, my mother would say that her life would be so much more fulfilling without me. Her voice sounded controlling or cold. Whenever I heard her voice, it would instill fear.

I haven't always been assertive, but I've been adamant about wanting to make the most of life. I moved out of my mom's house a couple of years ago. Neither of my parents are a part of my life. My father lives in the Virgin Islands and doesn't have phone service. He knows I live on my own, but that's the extent of his knowledge. I'm financially independent, and even if I'm having trouble paying bills, I never ask anybody for help.

My name is Chelsea. I'm twenty-four years old. I was born premature at twenty-six weeks and was only two pounds, three ounces. I have retinopathy of prematurity. I went back and forth between the incubator and the ventilator, and in the late 1980s the technology wasn't as advanced as it is now. Too much oxygen was what made me blind. Today I live in an apartment by myself. I'm enjoying the freedom. I can't even articulate how awesome it is. I also have a part-time job as a transcriptionist, which really helps as well. I've never been happier.

Two years ago I was raped. This experience has made me a lot less naive. I didn't want to be out of the house, and for a while I viewed people differently. I thought maybe somebody else would assault me. I also had bad nightmares. I would wake up very easily, when I heard the slightest sound. I would think that it was my attacker coming to get me. I also had a lot of trust issues.

I've been able to gain perspective through the rape, because I believe wholeheartedly in making my life as meaningful as I desire it to be. I just can't control what other people decide to do. I just trust immensely in myself. So if I'm faced with a similar situation, I will probably handle it with more grace than I did the last time. I will come out stronger, more resilient and more of a fighter.

What do I like about being blind? If you had asked that when I was young, I probably would have said I didn't like anything about it. But the older I get and the more I interact with people, I would say it's an awesome opportunity to offer a different perspective to the world. Perhaps I can encourage people to think a little bit differently—or maybe more openly. I don't wish I had vision. To me, the word "blind" is just a characteristic, like a hair color or somebody's height. I think anything can be a disability. The question is, do you let it? I think that's the real question.

I've been lost lots of times. When I was younger I would panic, because truthfully, I didn't have the skills to get myself out of a situation. I didn't have the confidence or the actual skills to evaluate what I had done wrong. Now that I've attained those skills, I don't think of it as being lost. I like to think of it as being misplaced. If I remain calm it's easier to refocus and get to where I need to be.

I'm constantly imagining things. I imagine the nice cool breeze. Of course, if it's windy I can hear it. If it's sunny, I can feel the sun on my face or the smell of the air. Metaphorically speaking, I would say yes, I see as good as a sighted person. Being blind actually helps me to be less critical and more appreciative of the world around me. Usually I remember people's voices. I think every voice has a unique quality, and I pay attention to inflection. I have intuitions and feelings when I meet a person. It's their voice and the way they treat me and interact with others. Sometimes it is what they do not say. I like when people remember me, so I try to return the favor to the people I have met.

I think prejudice in itself is a disability, because it takes focus away from everything else. I was in a program learning how to become more independent. It was called "Adjustment to Blindness." It was just great to be put in different high-pressure situations to see what I could learn. I was walking around Ruston, Louisiana, learning how to use my cane properly. This lady stopped me. Her introduction was, "Why do they have you out here? You're blind. And you got that other disability. Why are you out here?" I explained to her—very nicely—that I was learning how to get around independently so I could become more confident. She said, "I don't know about all that!" And she walked off—stormed off, actually. When a sighted person thinks of blindness, they react to themselves being blind. It's hard for them to realize the beauty in blindness. I've always said that empathy gets people far, but sympathy gets people nowhere.

I'm not angry that I'm blind. I certainly don't miss anything, because I don't know what I've never had. I don't believe that anger is a healthy emotion. However, there are times that I may experience frustrations. I've always enjoyed life, and no matter the hand I'm dealt, I always embrace every single thing because I know that I can learn more. I really take pride in finding the joys in things and growing instead of letting something break you. I have to be strong of my own accord, and I shouldn't expect anybody else to join me on my journey. So if I can always just live to the best of my ability and remain true to myself—that's my goal.

MARIO AGUIRRE

I work at the Rape Crisis Center. I've been there for twenty years working as a therapist with survivors of sexual trauma. I think listening is a rare quality. Carl Jung believed that listening is such a rare quality that people have to pay for it in therapy. I listen with my whole being, or I might say that I listen with my heart. There is a certain amount of risk involved in listening with your heart. The risk is that what you might hear could change you. Listening in itself can be very healing.

I have been working with survivors of trauma for a long time. I believe that sexual trauma is a deep spiritual wounding. There is a tendency under the stress of trauma to disassociate as a primitive defense mechanism. I've come to the realization that the more I know, the more I don't know. I embrace the Buddhist perspective of not knowing. I once had a client teach me a very important lesson. She said to me, "Listen, Mario. You don't have to try to help me. What you need to do is be there for me. Be present. That's all you have to do." Ultimately, she was right.

My parents are Hispanic. They were always there for me in terms of providing our basic needs. I grew up on the fringe of the barrios. It was a very racist part of West Texas. I always felt like, "God, where did I mess up to have been born in this godforsaken place?" I got the message clearly that we were second-class citizens.

As a child I did not have any visual impairment. I went to a segregated Hispanic elementary school. The students were all brown faces. The teachers and administration were all white. I grew up thinking I was actually a dummy. When I entered first grade I could not speak English—and I was lost. That was a tremendous disadvantage in terms of my self-image as a student.

My second-grade teacher, Mrs. Orange, terrorized me. I sat in the back of the classroom. I didn't know what the hell I was doing. One day she demanded, "You

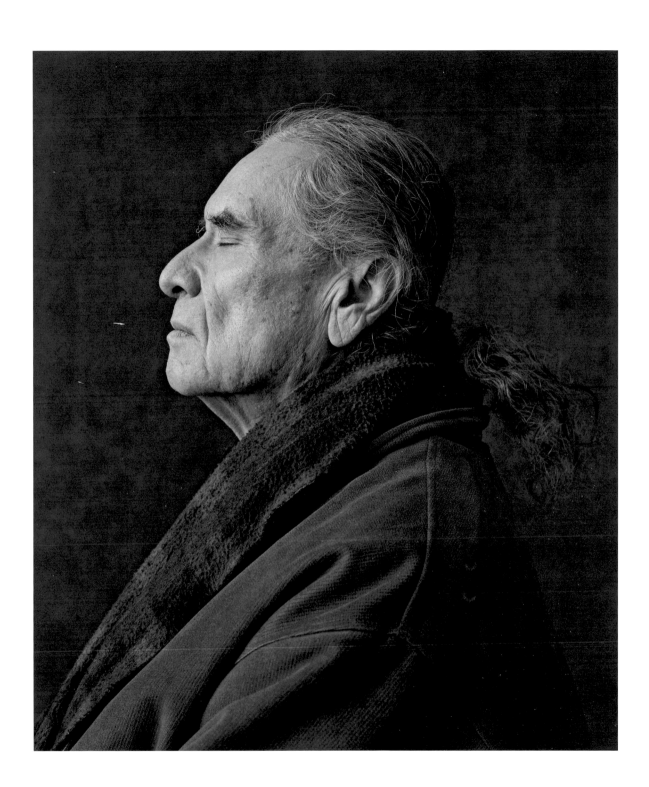

better have this assignment tomorrow morning—or else." She scared me so bad that the following morning I played hooky. I was afraid. One day led to two days of hooky, two days led to a week, and a week led to two months of not going to school anymore. I would hang out in the alley with a little boy, and I would stay with him and his mom. Eventually I was caught and my parents were notified.

If I had been my mom or my dad, I would have tried to find out why my son was not going to school. This was a time of segregation, so we didn't do that. My father took his belt out and knocked the shit out of me. I was begging him to stop. He hurt me so deeply that it ended our relationship. I went through adolescence not speaking to this man. Oh, my God, how could a ten-year-old commit such a travesty?

My parents decided to make a tremendous financial sacrifice. They sent me off to a Catholic boarding school run by nuns, and there I learned to compete academically. Every nine weeks when the report cards came out, they rearranged the desks according to academic rankings. The first nine weeks I was second to last. Eventually I moved up to the first row with the smart ones.

My father is blind due to macular degeneration. His sister was blind. My younger sister is blind. My blindness was a very traumatic experience. Macular degeneration is often referred to as an old man's disease, because it tends to affect people later in life. I had normal vision up until age twelve. When I was in high school I went to an ophthalmologist. After doing all the examinations, the doctor basically said, "You are legally blind, and eventually you will go totally blind."

It felt like a stab to the heart. I remember thinking suicidal thoughts. At eighteen years old, those words were a death sentence.

I struggled and was unable to accept being blind. It's difficult to see oneself as a whole person. I realized that the way I was going to get by was through my intellect. So I pursued higher education. I had this hunger for understanding and a curiosity about life. Eventually I was able to pursue a lifelong interest in Jungian psychology. The Jung Center became part of my community. I had a wonderful, loving analyst named Mary Eileen Dobson. She helped me to finally embrace my blindness, and embrace my existential companion.

Jungian psychoanalysis completely turned my life around and enabled me to find meaning. I had a dream that spoke very clearly which said, "Yes, you are losing your outer vision. But in its place you are gaining a different kind of inner vision." I understand what my unconscious was saying. I have developed an inner vision that enables me to see deeply into a person's energy self. I see it in colors.

I see these colors outside of myself like you would. Open eyes, closed eyes, it doesn't matter. The greens, the blues, the purples, and the reds are energies around me all the time. Blindness has been a tremendous asset in the work I do. I've transformed my suffering, so that I can be with the suffering of others. One of the most prominent colors of energy that I see is the color red. I can see red very easily and especially with survivors of trauma who have been deeply, deeply wounded. Another very prominent color that I can see is green. And green is a color of the heart.

What's really interesting are cell phones. I could be in a conversation and all of a sudden I don't feel the person's presence anymore. I've come to understand that when their attention is focused on their smartphone, their energy becomes unavailable.

Blindness does not make a person less whole. I don't think that blindness has to be a limitation of human potential. Blindness has enabled me to compensate in very powerful ways, by developing other senses of perception besides visual. Most people have an overdeveloped visual sense to the neglect of the rest of their senses. I think in a more enlightened society and perhaps in a more enlightened time, blindness can have a positive side in terms of a deeper understanding. What the public doesn't understand about blindness is how wounding the public's negative or ignorant attitudes can be.

Part of my identity is blindness. Another part of my identity is not. I can see in ways that most people cannot. I'm a Chicano, I am a husband, I'm a therapist, and to some degree I'm a Shaman practitioner, though I wouldn't say that very loudly. I'm a Buddhist, I'm a child of the universe, and I'm an Apache Indian down deep in my heart, Chiricahua to be specific.

A friend of mine bought an old adobe house in a canyon outside of Truth or Consequences, New Mexico. It's in the desert, it's hot, and it's mountainous. There's hardly any water. In this particular canyon there's a spring, and so this canyon has always been alive with old cottonwood trees and people. The Chiricahua Apaches and their spirits are still there. I used to love to listen to the wind blowing through the trees. The wind spoke to me. The wind had this quality of sound and voice. It was incredible. But beyond the wind, there is this sound to the silence in that desert. Oh, my God, that's such an oceanic feeling—that oneness with the desert and the Apache spirits there.

I cried today. Blindness makes me cry all the time, especially when I run into a wall or the edge of a door. I have to be very present in the moment. Otherwise I'm going to get hurt. It's the ultimate spiritual experience to be fully present. If you are climbing a mountain, you must be mindful, because your life depends on it. And it's true with blindness. Do you realize that people spend lots of money to go to meditation or retreats just to learn how to be present? Being blind taught me to be present right away.

A good, crazy buddy of mine always says, "Don't worry about the blind mule, just load up the wagon" [*laughing*]. What he means is, "Let's move on." Zen has had a big impact on my understanding of the limitations of thought. I've learned to embrace pure experience and move on.

In order to understand Jungian psychology, you have to think paradoxically in terms of pairs of opposites. So I think about the interplay of those kinds of opposites: loss and gain, big and small, light and dark. If you lose something, you gain something. If you gain something, you lose something. My heart is my vision. Feeling with my heart, knowing with my heart, and developing heart consciousness, heart energy—that's where my goal is now. I see in the dark. I can tell you a secret, there's light in darkness. Darkness is not the absence of light.

PALOMA RAMBANA

My grandmother makes me feel passionate. I refer to her as Nan, which comes from the word "Nonna" for grandmother in Italian. My mom is from New York, but her ancestors are from Italy. Nan has inspired me to read a lot. I never leave the house without a good book. There's one in my bag right now. Nan has taught me not to be a bystander. She doesn't like when we are on our devices, because she wants us to be present. Her voice is soft and wise. When she's talking, she is talking with intelligence, and uses statistics and logic. She talks in a way that makes me feel safe, calm, and relaxed. She would just tell me, "Don't forget—never give up and never doubt yourself." Being positive is something that she asked me to do. I'm still trying to do that, but it's hard sometimes.

My name is Paloma Rambana. I'm eleven years old, and I have a younger sister. I live in Tallahassee, Florida. My favorite quote is from Kid President (Robby Novak): "Don't be mean, be meaningful."

My visual impairment is called Peter's anomaly. It's cloudiness in the corneas. I was diagnosed when I was born. It's affected me in learning and how to write my letters. It's important that I understand I have it and that I have to make special arrangements with it. It's a condition, not a disease—and it's not contagious. I have two surgically made pupils that take away most of the cloudiness. So I have four pupils because the first two pupils couldn't receive all the light. Being light-sensitive means that I can't be in a room with bright lights, and sunlight hurts my eyes a little bit.

I have had times when I struggled, because I didn't have high self-esteem levels. I had to find things that would make me happy and distract me from feeling low about myself. I have a lot of classmates. I have never really felt like I fit in.

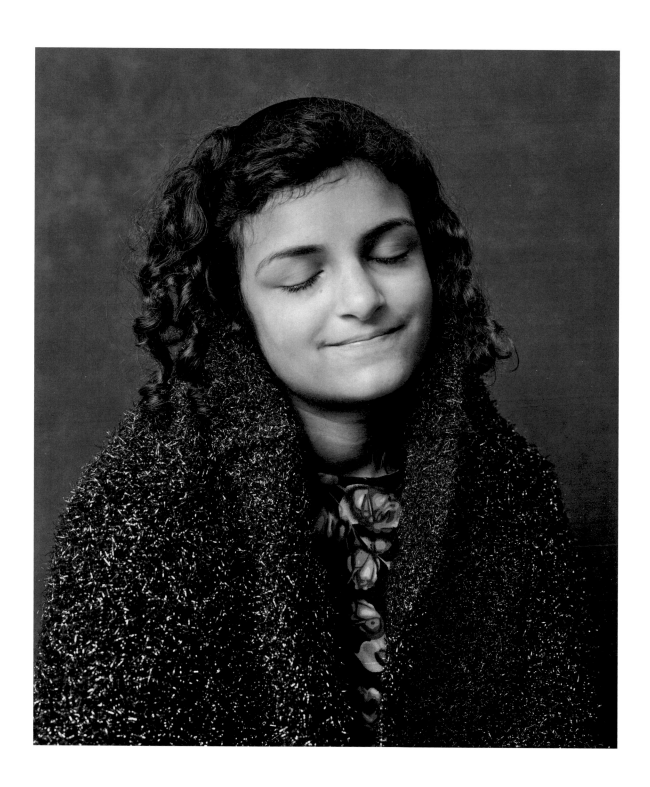

One student said to me, "You suck at sports." And I was like, "What? I'm pretty good at sports. I just couldn't see the volleyball." Another classmate of mine said, "Don't talk to me. You are blind." Just the other day I had taken my glasses off and I walked into the classroom, and one of the students came up to me and said, "How many fingers am I holding up?" And I guessed the right number of fingers and he said, "Oh, so you're not that blind." He was making fun of me—and I was just sitting there like, "What? What is this?"

Accepting that I have a visual impairment wasn't hard. I had to start out researching it, and then understanding how it's going to affect me. I didn't wake up one morning and be like, "Hey, I like myself. I like my eyes." I just had to go through many stages of acceptance. I still have the struggle of trying to understand if everybody accepts me. We all have our quirks, and being disabled shouldn't be something that makes you feel sad. I've had a lot of people say, "It's going to be okay." That's helpful.

When people hear "visual impairment," most of the time they will think of negative things. They'll think that the person is weak. What they don't understand is that we're equal. I don't think that it affects me in negative ways. In my mind, there's no normal. We are the same, but we have different ways of thinking about things.

Seeing is hardly 10 percent of what makes us human. I can feel emotions and I can touch things. Touching is something really important. The doctors said that they didn't think I would be able to read. But I can. I don't know how other people see things. I have a lot of tools that I use. I have a big magnifier on my desk that I use to see papers and tests and quizzes. I don't know if I'll be able to drive someday. I want to drive, and with this new technology we can have self-driving cars. I'm hoping, crossing my fingers, because I want to drive.

I think of *empathy* as a positive word. It is when you think less about yourself and more about others. And you're showing you have passion, and that you care. I think we can learn to be empathetic by using courage to help others. It's not always about what we want but about what others want. And we should respect what others are going through.

When I was nine, I heard there was no funding in the state of Florida for visually impaired or blind students ages six to thirteen years old. That's my group. However, there was funding for kids who are zero to five and fourteen to twenty-two. So the funding gap here in Florida was from ages six- to thirteen-year-old children, who were not receiving vision tools. That's so disappointing, because that's when you're learning major things like beginning math skills. Once I heard about this I told my mom that I wanted to do something. I wanted to help these students, because I wanted them to know they need these tools to be successful.

I thought about it and I was like, "Let's do it." We lobbied at the Florida legislature. I talked to a few senators, a lot of legislators, and then met with the governor. Not all of them, but some really thought this funding gap was unfair and that they needed to do something about it. It was important that they took the time to listen to me. They wanted to listen. The governor of Florida

gave us $1 million for special-education funding and a recurring $500,000 for the children's program (six- to thirteen-year-olds who are blind and visually impaired).

It surprised me that people found out about my story, my dream, and my passion. That is why it's called Paloma's Dream, because it's my dream to help these kids. I was just totally in shock when I found out that I was going to be interviewed by *People* magazine.

Advocacy has given me confidence and made me stand up to the people whom I would normally not stand up to. It has made me see the world with a whole new pair of spectacles, or glasses. It's made me see that there are so many injustices, like animal rights and LGBT rights, that we're not looking at.

I like to read biographies to learn about different people's lives, and how they think of themselves versus how we view them. Alexander Hamilton was one of our founding fathers. I think he's a fun person to read about, because he was an immigrant. It just shows you how our country was made out of a mixed bag of immigrants and all sorts of nationalities.

My family is very supportive, trustworthy, and kind. They are unplugged from negativity. It is not tolerated. We think in a very positive mind-set. I think about how things work. I go more in-depth. When I'm bored I'll look up at the ceiling. If it has tiles, I'll count how many tiles there are. I'll figure out the area and the perimeter of the ceiling. That is just how I think.

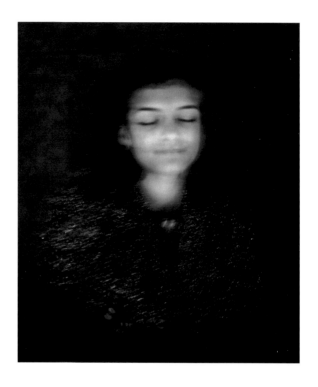

Poetry is beautiful. I really like the poet Langston Hughes. I went to a poetry reading a couple of months ago and read his "dream deferred" poem, called "Harlem." I follow his work at school. We have a class called "The Expressions" where we write about poetry, and that made me more fascinated with it.

Poetry is putting all your passions and everything into one spot. It's going in-depth using adjectives, which is super important. Poetry is literally music to me. I use rhythm and rhyme, take patterns and stitch them into this one big quilt of music. And then I just give the quilt away, and let it be shared with others.

CHAD DUNCAN

My name is Chad Duncan. I'm forty-two years old. I'm a social worker and happily married. I'm the luckiest guy to have the perfect partner in life.

My wife, Jennifer, has been a supporter and a sounding board—for when I'm scared or frustrated or don't understand. I am blessed that she vocalizes anything that is on her mind. If she's frustrated with me, she tells me. If I need encouragement, there's no filter that stops her from saying exactly what she's thinking. Jennifer has to verbally process the environment, which is a benefit to me. I know what is happening as we are driving, which is calming. Instead of slamming on the brakes, she will say, "We have to slow down." So I have that moment to adjust.

As a child I had night blindness. I thought that it was a temporary "child thing." I thought that when I grew up, I would be like adults, because they didn't bump into stuff. I loved Curly from the Three Stooges. Curly would walk full force into a wall and fall down. It was hilarious. That's what I would do at night, so my parents thought I was "doing Curly." When I fell they laughed. Once when I was leaving a night baseball game with my father, I walked full force into a parked car. He said, "It's not funny anymore, Chad." I replied that I wasn't trying to be funny. Then he asked, "You can't see that car?" Surprised, I responded: "You can?"

When I was about nine, I went to one of the experts. I knew there was something rare about what I had when more doctors kept coming into the room. They all said, "Can I look into your eyes?" And then they would whisper, come back, and look again.

In 2005 I woke up and experienced a cloud covering 70 percent of what I could see. It was like an electric fog had descended on my vision. I learned that I had choroideremia. It is an X-linked genetic disorder that passes from mother to son.

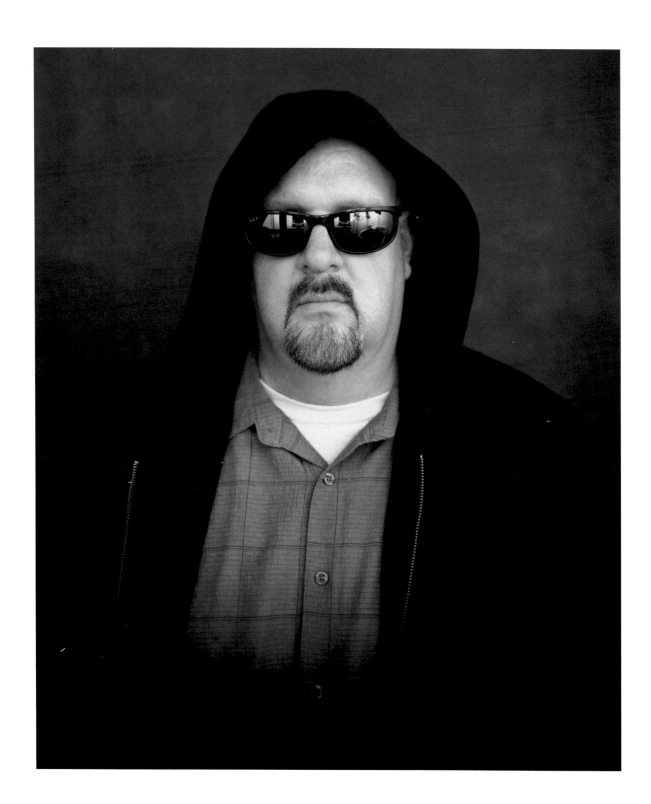

The doctors couldn't tell me how much vision I would lose or what would happen. The local doctor had only seen three cases. Two cases were in medical school twenty-five years earlier. I was number three.

My eyesight took a dramatic turn in February 2011. It happened over a period of three days. I was thirty-eight. Within the first twenty-four hours, everything became blurry. Over the next few days, pulsating flashes and puffs of light of brilliant colors took over everything I saw. The kaleidoscope of colors was not due to anything I saw—it was all happening between my retina and the signals being sent to my brain. I realized that this was going to be a permanent condition when the specialist said, "I'm sorry, I wish there was something I could've done." I knew then that I needed to start accepting what was happening.

For a long time I could not sleep. Imagine trying to go to sleep in the brightest environment possible. It doesn't matter whether my eyes are open or closed, day or night, I see bright pulses, as bright as can be—all the time. Originally I thought the flashes were a curse. But when I was able to reflect, it's actually quite beautiful. People would want to see this, but only for a short period of time, because as the day wears on the flashes are always there.

The colors I'm seeing right now are brilliant whites, electric blues, yellows, and all different shades in between. One day it was an amazing Sunkist orange that was pulsing—I could almost taste it. No one else has been able to describe that this is what blindness is for them. So I'm grateful for my particular experience of blindness.

People will say, "You don't look blind. You don't act blind." My first reaction is—what does a blind person act like? People in this neighborhood thought I was training a guide dog for a blind person. My neighbor said to me, "I thought you were just rude and would not wave back." I've been walking past this lady for a year. I've got the shades, I've got the dog. I think that the public assumes we will be helpless or lost or scared. Many people project what kind of life a blind person can have. That's where the damage is done. A blind person starts wondering, "Can I have a purpose? What can I really do now that I've lost my sight?" The truth is that you don't have to be blind to lose your meaning in life.

I'm disabled by other people's opinions of me. I am not disabled. I have vision. So when people say I'm blind, "Yeah," I'll say, "but I haven't lost my vision. I may not have sight, but I know where I'm going and that's a vision. That's more powerful than sight."

When I dream, I can see people's faces or I can see certain things. But even then I know I'm blind. So I don't imagine a life of seeing again. I can look and see somebody's reaction, but I still have a realization in the next moment that I'm still blind.

When I was given my guide dog, Perry, it was a moment of hope. Something really is lost when you are swinging a cane. The object of swinging a cane back and forth is that you must hit something to know where it is. When you have a guide dog, the object is to not run into anything. So it's a completely different experience.

My relationship with Perry is very deep in the sense that I put so much value in the little things

he does. It's daunting to trust this dog at an intersection. Today I tried to step forward into the intersection because I didn't hear any cars. Perry didn't budge—next thing you know some car goes flying by. He saw it and knew not to go forward. When we're at an intersection, we may stand for minutes until it is safe to cross. That definitely is reflective in his personality. The difference between having a cane and a guide dog is that I have to walk him. We walk four miles a day. I'm very aware that Perry is a dog, but he has so many human qualities, and I can tell that he cares about me.

When I went to Egypt in the summer of 2011, their revolution had just occurred. I had been blind for less than four months. I remember walking through the streets of Egypt, standing at the pyramid, riding camels. The noises were very different. The language is overwhelming. Egyptian men would come over to me, grab my hand, tuck it under their arm, place their other hand over my hand, and guide me. I finally asked my guide, "Why are these men doing this?" My guide said, "In Egypt, our elders tend to lose their sight, and this is how we guide people." What an incredible difference in cultures. I can be walking through Walmart at home and no one even speaks. But in Egypt, these men would walk up, touch my hand, and guide me with a relaxed, calm tone. It's very comforting to have somebody guide me like that.

I went through the grieving process, and I'm definitely at the acceptance stage. I wouldn't change anything about my life, and I'm not just saying that. Blindness has given me the opportunity to slow down and take the time to listen to what someone is saying. To listen to the person's breath, their tone, and their pace. That will give you infinite clues about what is really going on.

I carved out a very humdrum, predictable, safe existence when I was a sighted person. As a blind person you have to fight, you have to be strong and confident. I feel more alive since I lost my eyesight. I don't taste things more intensely than you do. I just appreciate what I taste more than before. Or when I hear the quality of someone's voice or the rustling of leaves. I hear the neighborhood when we're walking, because of the air-conditioner that's always running or the chimes down the street. It creates a visual map that tells me where I am just by the sounds or by the way the wind feels.

People assume that I would ask for my sight to be restored if a miracle was offered. I wouldn't ask for my eyesight back. I would ask for peace in life. I would ask for people to have access to food. I would ask to be an effective person in life and make a difference. Others have much harsher realities to deal with. Giving me my sight back would not mean that I have a purposeful life. Now I realize that blindness is just a nuisance. It's an aggravation. Not a death sentence.

I forget many times that I am blind. It usually takes other people to remind me. I don't even think about it. It's a part of who I am. I do my daily tasks at work. I've accepted that I am blind and can do pretty much everything that a sighted person can do.

As a child I had no visual impairment. We had a tall tree in our backyard. I remember thinking, "What does everything look like from up there?" I started to climb the tree and realized that I could jump onto the roof of our garage. I walked around the roof and looked at my backyard, our house, and the street from that perspective. It was just the greatest thing. I was fascinated by the aerial view perspective.

Today visualizing images in my mind's eye is a big part of how I function being blind. I still like to imagine places from a bird's-eye perspective. I create images in my mind of places I visit. I'm fascinated by new buildings. The minute I walk in a door I start to visualize—based on the information I'm receiving through my other senses. With my cane I receive new information. I'm constantly changing and repairing my mental images. There are times when my mental images are so real that I feel I can almost see.

My name is Marti. I am thirty-eight years old. I am married to a wonderful man, and we have a beautiful two-year-old daughter. I currently work at the San Antonio Lighthouse for the Blind where I'm an assistive technology supervisor.

I do like learning. That makes life interesting. As a child I had a photographic memory. When I was in grade school somebody asked, "Did you study for the test?" And I thought, "Oh, no. I forgot there was a test today." The teacher gave us ten minutes to look over the material. I started on the first page and captured every

page of that chapter in my mind. When she called time, I put the book under my desk. I remember reading the test questions and searching for the answers in the book in my mind and actually seeing the pictures, the colors, the captions, and the subheadings. It was all there. When we got our grades back my friend knew I hadn't studied for the test. She asked, "What grade did you get?" I showed her my grade and her jaw dropped. She couldn't believe it. And I couldn't either.

I also have a fascination with numbers. Not calculating them but remembering them. And for as long as I can remember, anytime somebody said a series of numbers I memorized them. They could've been completely insignificant. My mother worked at a nursing home. She worked with a different person every day. I had memorized all of their phone numbers, zip codes, addresses, and her schedule.

I was diagnosed with cone and rod dystrophy after my first semester of college. It affects the central vision first and then works its way out to the peripheral vision. Basically, your cones and rods are deteriorating. After many tests, I remember walking into the doctor's office for the results. The doctor seemed very cold to me and almost heartless. He told me that I was legally blind and that I would continue to lose sight. He said, "You can go to bed tonight and wake up tomorrow and see nothing."

I went home and had problems sleeping. It was because the doctor's words echoed in my head. "You can wake up totally blind." I was miserable. I wouldn't do anything. It was hard for me to even get out of bed. So I had to rethink everything. Finally I thought, "I can't live like this. I'm not

getting anywhere. I'm actually going backward. I can't live with the fear. It's very lonely, dark, and depressing. I'm going to go to school and have a great career. I'm going to keep moving forward. As the challenges come, I will take them one at a time." Actually, I think being challenged makes me feel human. Makes me feel alive. It reminds me that I have a mind of my own. It was difficult for my friends and family to understand. I had to let them know that everything was going to be fine.

It amazes me how people sometimes view blind persons. People tell me, "If I lost my sight, my life would be over." I respond by saying, "Do you really know that to be true? You'd be surprised at how resiliently your body and mind can adapt to change." I'm guessing the public fears the unknown. I get frustrated when my intellect is questioned. Because I am blind, the sighted think I'm not very smart and they talk down to me. It even happened to me with my college professor, which surprised me.

Anytime I'm out in public, it's no secret that I'm blind. I have a white cane and I wear sunglasses because I'm sensitive to the light. I've had people just straight out ask me, "Oh. Do you know sign language?" And I respond, "No. No, I don't. Do you mean Braille? Braille is tactual. Sign language is visual." Which again—it's all ignorance.

When I found out I was pregnant I was completely elated. It was just a magical moment. I remember thinking, "How amazing it is to have a child. To be a mom." I had a dream that I could see through my round belly. It was like a snow globe. A clear crystal ball. I could see my baby girl in there. She looked like an angel. She had this long flowing

hair and was wearing this beautiful dress. It was almost like she was in clear water. In my dreams I'm not blind. So people I talk to every day are in my dreams and I see them clearly.

When my daughter was born I remember feeling her with my hands. I studied her arms and her fingers, long thin fingers. I would feel her face and her little ears.

As soon as I got home reality set in. I thought, "Oh, no, I have a baby. What am I going to do? I'm blind." I was fearful of the unknown. I started to do research. What do I need to know as a blind parent? I found comfort in talking to moms who were blind. In some cases, they had four or five children who were already grown. I started talking to them, and they made me feel comfortable. As soon as I got to know my daughter and she got to know me, it was very natural. The worry wore off.

My daughter understands that I can't see. So if she says, "Mommy, a mosquito bit me right here," she would put my finger right on it. When she was fourteen months she asked for a cane like her mommy. So we had a cane made in her size. I remember when she saw the cane she was so excited. She immediately put it down on the floor and was using it the way I use my cane. She holds it out in front of her and sweeps left to right as she's walking. When we leave the house and I'm walking out with my cane, my daughter asks, "Where's my cane? I need my cane."

I never realized how intrigued I was by people until I couldn't see their facial expressions. So I had to pay more attention. To the tone of a voice. It's a lot of things. It's their words. I don't judge anyone by what they look like. I wouldn't describe seeing as being a better sense than any of the others. People ignore their other senses. So much is missed, and it prevents someone from going deeper. How would I answer someone who says, "Why travel if you can't see"? My response to them would be, "Why do anything?" Experience is not just visual. It's feeling emotion. Tactile. It's smelling. It's listening. There are so many ways to experience moments to their fullest.

BURNS TAYLOR

My name is Burns Taylor. I'm seventy-four and live with my wife in El Paso, Texas. I'm a former college English instructor and a freelance writer. I just published a book this year called *Hands Like Eyes*.

When I was three years old in 1944, my mother had left us at home while she went to the store. There were four or five cousins, my brother, and me. I don't know how to interpret my brother's feelings, but at some point he picked up a rifle and pointed the gun at me. I think it was partly for show. The gun was loaded with .22 birdshot. At the time, my brother was a little past eleven. I remember my brother asking if I wanted to play cowboys and I said no. That was just before the gun went off. According to the doctors, the gunshot severed my optic nerves. They removed both eyes, and I now have two prostheses, artificial eyes.

My brother is eight years older than I am. My memories of him were sort of shadowy. He was a very troubled adolescent, and I'm sure it was because of what happened. My mother tried to protect him and hold the family together. Everyone in my family was impacted. My sister got the impression from my father that she should have done something, because she was there. My mother felt guilty, because she wasn't there. My dad had been working the graveyard shift, so he was asleep.

After I was shot I had a recurring dream. I would be in the sky, floating down very slowly, almost like through a Jell-O sky. I'd hear these two old hags cackling away. As I got closer and closer to them, they would shove me back up, and then I'd come floating down again. They'd be cackling and cackling [*makes cackling sounds*]. As I got closer again, their old bony fingers would shove me back up into the sky. I had that dream—maybe a year—just intermittently.

I was very hostile after the shooting. I had a lot of fights. I was destructive. I broke things. I smashed rocks with a hammer. I chopped up clay soldiers all over my mother's hardwood floor. That anger followed me into young adulthood. My brother had a very successful business, but I wasn't doing so well. I was working part-time, trying to go to school, and thinking about how he was tooling around in his Thunderbird while I'm standing in the rain waiting for a bus. That created anger and hostility. To make things worse, my sister had been manager of my mother's estate. She found that my mother had about four thousand bucks in an account. My brother was actually the administrator of the estate. My sister contacted him and said, "Hey, Burns is trying to buy a house in El Paso and is looking for some money for a down payment. I found this money in mother's account. What do you think?" He said, "That's my money." When I heard that, I said, "What do you think a pair of eyes is worth—five thousand bucks, ten thousand?" That really fueled my anger.

One of the essential questions of existence is, "As a person with a disability, how can I live peacefully with something that no one else would ever want to be?" People aren't lining up saying "I want to be blind too." That's the last thing they want. In surveys, blindness used to be number one on everybody's list of what they didn't want to happen to them, next to cancer. How do you learn to live with something that society makes you feel ashamed of, makes you feel that you are not as capable and not whole like everybody else? Society's perception is that I'm not equal to them. That I can't do the jobs they can do. That's something I have to live with every day.

Here's one of the things that used to crack me up. I'd be walking down the street and come to a corner. I knew exactly where I was, and was about to cross the street. Then some guy would come up to me and say, "Okay, let's see here. You're at the corner of Third Street and Vermont. You're facing Vermont." I'm thinking, "Asshole, I know where I am, get out of my face." It's like they thought I had just dropped from outer space [laughing].

Another thing. Strangers on the bus would sit next to me and ask, "Do you mind my asking you a personal question?" Usually I say, "Nah, go ahead." "How did you go blind?" I'd make up different stories to amuse myself. "When I was young my mother one time caught me masturbating. My mother said, 'Son, you know that could make you go blind.' Well, here I am blind as a bat" [laughing]. I mean, who the hell are you—a stranger—to be asking me a question like that? You deserve whatever I tell you if you're that brash and goofy.

When you're blind at an early age you really have no impression of your physical identity. Am I good-looking? Am I ugly? Am I handsome? You don't have that access to your own physicality. There definitely were times during my adolescence when I had a feeling of inferiority. I can remember trying to work myself up to asking a girl for a date and thinking, "Well, why would she want to go somewhere with me? I'm blind." I would tell myself, "Well, okay, make the call anyway." Oh, that was so hard for me, because I had no confidence.

I've had a lot of women ask, "Would you like to touch my face?" and I'd say, "Honey, that's the last thing I'd be interested in touching." The cues that I look for in the opposite sex are the voice and foot-

steps, which tell you something about their size and weight. In most cases a person with a disability is the one who waits to be sought after because of the worry of rejection. If a girl makes a move to introduce herself or sits down next to you—you learn to read those cues. I think it is probably easier for a woman who's blind because that's the way it's supposed to go. The guy is supposed to reach out to the woman, right?

I got a secret. Just follow me around and you'll see what it is—that I am competent and I am equal—and on any given day I'll kick your ass. I'm blind, but it's not a bad thing. I've learned to compensate for most things. I can cook a damn good steak. I've taught college. I've written books. I've done a lot more than many people with all their senses and sight haven't done. I'm doing pretty damn good.

I was interviewed at the University of Texas at El Paso for a teaching position by the dean of arts and sciences. The dean asked, "Well, Mr. Taylor,

how are you going to grade papers?" I said, "Well, I plan to use part of what you pay me as a teacher to pay a reader to read the essays to me." "Ah, okay, well how are you going to put up material on the blackboard for the students to read?" I said, "I plan to bring in a typed page and ask for volunteers to write the information on the board." I said, "Look, Dean, I know you have a whole lot of questions. What I'd like for you to do is just look at my résumé. Contact my former employers, because I have had jobs before. Just talk to them, review my transcripts, and make your decision just like you would with anybody else." The dean hired me. So I did something right.

Blindness is not helplessness. It's not something to be ashamed of. It's not something that makes you less fortunate or less competent than other people. It's not something that should warrant your being separated from other people. It's not confusion or helplessness. A lot of those things are society's perceptions of blind people. Blindness

has made me a pretty good judge of character. I've learned to listen behind the words, trying to connect those words with people's feelings.

My sister was my mentor and teacher. She was a compendium of the good and the bad. She was a devil and an angel. She gave me the poison and the cure at the same time. We got into a lot of trouble together. She was a collection of positives and negatives that was just wonderful. She was always ready for an adventure. She was always ready to help somebody who needed help (and a good drinking buddy, too). She taught me that the world was not going to give me any kind of special treatment. She played jokes on me. She'd hit me and run, and I'd start chasing her. She would slam the door right in front of me: *wham!* She could be diabolical. I remember we would be outside at night and she would take my hand and point it at the sky. She would say, "Look, Burns, there's the evening star. Make a wish." I always say that she gave me the faith to believe in myself. When you're blind it takes courage to get you out the door, but it takes faith to get you across the street.

When I was about eight, I discovered echolocation just by accident. We were parked in a car, and I remember distinctly that I stuck my head out the window and made the sound that you make when you're shaming a kid. *"Click, click, click, click."* And I got back an echo. I thought, "Wait, wow, I hear something over there. What is that?" I could hear a house over there and had a sense of how far away it was. Well, with that sound I could measure distances. I could read textures. I could tell whether it was a fence or a wall that I was passing. You can read the difference between hard or soft surfaces.

In a room you get a three-dimensional view of the size of the room.

When I was nine I wanted a bicycle. The echolocation enabled me to ride the bicycle around my mother's laundry store and detect cars that had pulled in or out. I'd go around the end of the car to avoid a collision. I had my wrecks and I crashed and skinned myself. Did you ever ride a bike when you were a kid and fall and hit that bar on your balls [*laughing*]? I did that more than once, but I wanted to keep riding the bike because I loved it.

To me, sight is the most superficial of the senses because it measures surfaces only. It doesn't touch the inside of anything. In a way it has contributed to a lot of the suffering and cruelty in this world. Sight makes a judgment of a person because of the color of their skin or how they look. It just looks at the surface. Whereas touch, of course, is much more real. With Braille you're feeling the dots. Damn, man, it's a sexy thing almost. You're touching those words. I can read Braille even with my tongue, if need be.

My mother had always referred to the shooting as "your accident." As if I were the author of the shooting. I accepted that explanation until I got to college. I started thinking, "*My* accident, hell, how could that be?" I was three and in my crib. How could that be *my* accident?

I guess the bottom line of this whole story is about forgiveness. I went through years of being resentful, hostile, and angry toward my brother. I didn't really work through that one until a few years ago. My brother has in a way suffered the perils of Cain, and I often think about it in those terms. In the Bible, Cain killed Abel. In our case,

it's like Cain maimed Abel. My brother has suffered the loss of both his sons. When he lost the second son, he telephoned. I didn't know about it. He called and told me what happened. I could tell he was very choked up.

After he told me, he said, "Man, I'm so sorry." And I said, "For what?" He said, "For everything." And I thought, "Okay, okay, I finally got something out of this guy." From that point on, I forgave my brother. He had included me in that everything.

KAREN PETTY

My name is Karen Petty, I'm fifty-five, and I've been married for twelve years. I work at the Department of Veteran Affairs as the director of Visual Impairment Services Outpatient Rehabilitation. We work with veterans who have low vision or are blind.

I am legally blind, and I lost my sight at six. I was given sulfa, an antibiotic, and had a severe allergic reaction known as Stevens-Johnson syndrome. After I took the sulfa, I told my mother that I wasn't feeling well. I can remember looking at the TV, and it looked snowy and blurry. I asked my family to fix the TV, and they said there was nothing wrong with it. I began to get so sick that I only have a few vague memories of being in the hospital. My parents said that it looked like I had actually been in a fire. I no longer have the cells that create tears, and without tears there is extreme damage to the cornea. At six years old, I just accepted my blindness. There wasn't any real fear on my part.

No one ever told me that I was going to be blind. I remember clearly walking down the street, and I passed what I later learned to be two trash cans. I thought maybe they were kids and they weren't talking to me. My mother said later, "No, Karen, they were trash cans," which was probably more devastating to her than to me. I don't remember being upset about it. I just knew I had to acclimate.

My mother died when I was seven. She died in childbirth with my younger brother, Phillip. It was devastating for our family. A birth was to be a happy event, and this turned into a tragedy. It changed the course of our lives. My mother was incredibly loving and supportive. She was all the things one would want in a mother.

As a result of my mother's death during childbirth, Phillip had cerebral palsy. He could never walk, he could never talk, and he was always in a wheelchair. He was

unable to feed himself, so he required full care. He could make his long finger press buttons to make his computer talk. Cognitively he was fine. Phillip went on to graduate from college. He was a prankster and funny. We had special communications using boards and letters. When Phillip was eighteen, as a result of a blood transfusion, he acquired AIDS. He lived with AIDS for a long time. It's a horrible disease, and we lost him. If I could ever say that anybody drew a bad hand in life, it was Phillip. He taught me that being blind is a piece of cake compared to what he had to live with. He taught me how to take time to listen.

I don't remember my mother's voice but do remember how she looked. I remember the looks that she would give me when she was happy or when I was in trouble. My older sister and brother were in school, so my mother and I were together during the day. She cared for elderly people. I often feel that my love for the elderly is a gift she left me. When my mom died I lost a lot of my childhood. I lost the carefree security and innocence. You grow up in a different way. It doesn't matter how much other people love and care for you, they'll never be your mother. On my wedding day, my stepmother said the kindest thing. "Can I be proud of you for your mother?" I thought that was the best gift anyone could have given me on that day.

The School for the Blind gave me a strong foundation in Braille and how to use adaptive technology. At the time it was very forward thinking, and I felt an acceptance as a person. I had a third-grade teacher, Marsha Davis, who was wonderful, kind, and caring. I began to flourish academically and really loved school. I did things there that I

might not have done if I had been mainstreamed in a public school. I was the president of clubs and a cheerleader. I was able to be very athletic.

The beginning of my freshman year, my dad was transferred to St. Louis, Missouri. I had to leave the School for the Blind and integrate into a public school. It was not a pleasant experience. Students would be coming down steps and reach out and wave their hands in front of me to see if I could see. They would try to hide my books. I would hear people talking about me. It was unkind and unpleasant. I had come from a situation where I felt normal and was thrown into a school where these kids made you feel very abnormal. When my dad was transferred to Kansas City, they sent me to another public school with my stepbrothers. It is amazing how life changes when you go to school with your brothers. Students may still be unkind, but there wasn't the level of being targeted. I met some girlfriends who were wonderful. We went to football games, movies, and it was a very positive experience.

I have a beautiful guide dog named Jewel, who has been a great traveling companion and a wonderful, loyal friend. She helps me move faster, to get through crowds with greater ease. Having a relationship with a dog is like having a dance partner. They know your routine and are keen observers of your behavior. It's pretty amazing to think that I trust my safety to a dog. Every time we go to a new environment, she gets me through with ease and confidence. When I had a cane, I could hear parents telling their children, "Watch out for the lady. She's blind." But with a dog it's more about, "Oh, look, that's a working dog." The focus is off me and on my dog. Having a guide dog, I get

questions all the time. My favorite question was from a child. I love to go talk to kids at schools. This boy asked me, "So when you drive does your dog work the gas pedals?" All I could say was, "I hope you're very artistic."

I am flawed like everybody else, but I don't see myself as crippled or as an incomplete human being. What bothers me is when people talk about me like I'm not present. Blindness does not mean limitations. Sometimes when people hear the word "blindness," they think of stagnation. It's not that at all. You just have to learn how to do things differently. It may take you longer, but life is still good. The next time you have the opportunity to meet with somebody who is blind, treat them like a person. Our histories, interests, goals, and dreams are all uniquely ours. Give them the dignity to be a person first.

I miss being able to walk into a room and see who's there. I miss the nonverbal communication. That's probably one of the biggest disadvantages. However, I believe people who depend only on their sight are missing out on another level of depth and understanding by not using their other senses. I tend to listen to bird sounds a lot. I'll pay attention to how birds communicate back and forth. I love the sound of rain on the windows. I can tell whether the rain is hitting concrete or grass or puddles along the side of the street. Rain also has an incredible smell. I listen to people's voices. I can tell if somebody is shy or outgoing. I find handshakes are an incredible way to have contact with people in the same way eye contact is to a sighted person. A handshake will tell you how that person might be feeling.

I've been blind for so long, it's normal to depend on my hearing and my sense of touch. I don't think of them as being a different way of functioning. That's just how I function. If I got my vision back today, I'd probably need to go to rehab to learn how to be a sighted person.

I do think places create moods. A few years ago I was in Oregon and hiking near a waterfall. I could picture it by listening to the sounds. I could almost hear the different water drops hitting the pool below. I could smell the dampness and wet rocks. I could hear the sounds of the wildlife around, and it was incredible. I'm mindful of where I'm standing. Just paying attention allows me to be present and take in all that's going on around me.

ROBERT DITTMAN

If I could have my vision today I would turn it down. I don't need it. I have done more incredible things as a blind person than most sighted people will do in their lifetimes. There is nothing wrong with being blind. I'm not broken. I'm not any less of a person just because I cannot see. I am a third-year law student attending St. Mary's School of Law. I have about a year to go before I graduate.

I became blind as a result of premature birth. I was born at twenty-five weeks. The doctors had to give me oxygen at 100 percent. The eyes can only handle 20 percent, so it caused the retinas to become detached. It's a condition called retinopathy of prematurity. It's the same condition that Stevie Wonder and Ray Charles had. So I'm in good company.

I was able to regain some limited sight in my right eye. I could see colors, but I had no depth perception and could not see faces. I had no peripheral vision, which is a real problem when you have a brother who would try to sneak up on you. I was always running into partially open doors. I lost what limited vision I had as a young adult due to a wrestling accident. From about the age of sixteen, I have been completely blind (and I am now thirty-three).

I'll share with you a once-in-a-lifetime experience that I had regarding my vision. In the fifth grade I was walking to my class and looked up. The contrast between the sun and the overcast sky and the colors were just perfect enough for my limited vision that I saw a bird fly from one tree to another. It never happened again. But that's one of the memories I have of actually using my eyesight the way that people told me to.

Every parent wants the best for their child. My parents took me to school and the principal said, "There's a special school for your son. We can't have him in our school. He's different." You can imagine what it's like for a father to have his son

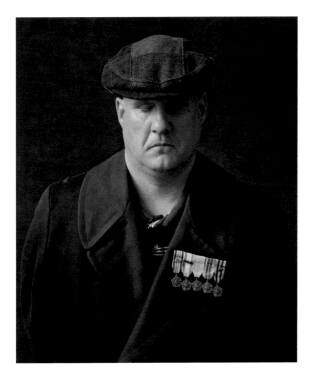

It was actually a relief losing the rest of my eyesight. I'm grateful now that I'm totally blind, because I'm not caught between two worlds. I don't have to struggle to open my eyes and look for something that I physically cannot see. I would have headaches that would last for hours. It is much more of a psychological relief, because I don't have to pretend to be sighted when I'm not.

As a child I would watch TV by sitting about a foot away from it. Cartoons were special because of the bright, vibrant colors and great contrast. So it was mainly cartoons that I could see much better than movies. If I hear the words "pitchfork, dinner plate, lightbulb," I might have cartoon images flash in my mind's eye of each of those things. Why? I don't know. I've never seen a star in the night sky. I only know what I saw on TV. I visualize a black field with pinpricks of light. Whether that looks like real stars I couldn't tell you. So a lot of my images are cartoon images, because I loved cartoons.

Most often it's not the visual reference that's important. It's more the emotions that these words evoke. I don't really care what things look like. That's not important. To a blind person, I wouldn't say, "Oh, it's a black-and-white Jersey cow." That wouldn't mean anything to them. It's not as important as saying, "Hey, do you remember that cow? Man, it stunk and it had all kinds of flies around it. It made that noise, *mooooooooo*." Those are important concepts that a blind person would attach to the reference.

In the beginning I hated the cane—not because of what it could or could not do for me, but because it was a symbol—I had a cane, I was disabled, I was different. But I started using the cane and it

denied the same educational opportunity as anybody else. It's not that a blind child is an idiot or can't learn. It's the school that is unwilling to allow that child to learn. That's frustrating, and it happens to parents all over the place.

My parents were of two minds. My father had no problem supporting me as a blind person. "You can do anything anybody else can do. Let's make that happen." My mother, while supportive, held on to a different view: "Save the eyesight you have now because it's precious. Open your eyes. Use your vision." Physically I could not do it anymore. In her reality, it is not acceptable for a blind person to be blind. There's no way that I was going to admit to her or anybody else that I couldn't see something, because that would be the wrong answer. So I would do things like memorize eye charts.

was okay. Then I decided to get a guide dog, which was like turning in a moped scooter for a Porsche. Snickers was the ultimate manifestation of a partnership. I have my confidence, but it's Snickers that keeps me safe. For example, if I believe a street is safe and I say, "Snickers, forward," and it's not safe, he will get in front of me and not move. They taught him the concept of "intelligent disobedience." Snickers knows I'm blind. He will grab a toy and run in a corner and know I can't find him. He is the most loving, loyal, kind, obedient, faithful dog, and the most brilliant partner that I could ever have.

Sighted and blind people have the ability to be compassionate and loving. They also have the ability to be cruel and heartless. When you get out of bed in the morning, what emotions are you going to use as your compass to interact with others? It is strange the way I have been treated. I remember some phrases such as "Don't let him touch you. You'll go blind." Children can be cruel, and they can be very honest. If the schoolchildren had a particular girl that they didn't like, they would say, "Well, you and the blind guy are going to get married and have freaky little children." When you hear these things as a child, it's devastating. If you internalize it negatively, you'll go mad. If you take it and channel it into something positive, it's almost a hunger, a fever that you must be as good as if not better than the sighted.

Most people see blindness as a limitation. There is a phrase, "A person's perception is their reality." Reading, reflection, dreaming, experiencing, imagining, and feeling provide me with a reality just as real as everyone else's. It just doesn't have the burden of vision attached to it.

I have always known as far back as I can remember that I am a soldier. My father was military, and all my brothers and sister served. I have known that I'm no different, even though I'm blind. When I was aboard ship on the Coast Guard cutter *Dallas*, one thing that we had to do was to crawl on our bellies and exit the ship in total darkness. Most of my fellow sailors couldn't do it. They couldn't figure out where they were. I was the blind person leading them out of the ship. One of the guys said, "If this had been real, you would've saved countless lives."

I'm in law school because of my desire to advocate for others. I've always felt that I've been a leader, and I need to be the one who stands for those who cannot stand for themselves. That's related to my second goal—to become a judge advocate. I believe that the military, through excluding persons with preexisting conditions, are missing out on a wonderful opportunity to take advantage of talent. If we preclude an individual from defending their country in an appropriate capacity, then what exactly are we defending? I intend to change that perception.

The one thing that I really want people to understand is to step outside of your dependence on vision. Go sit in a dark room for an hour and open your ears and listen. Go touch something. But also remember that they're not experiencing true blindness, because they can always psychologically turn on the light. But it's at least a glimpse into our world, and it's not a terrible place. It's not a horrible, miserable world that we exist in. It is a beautiful world, an exciting and adventurous world. It's a vibrant world and just as relevant as the sighted world. It's just different. It's no less.

NADINE SAFFELL

My name is Nadine. I was born with red hair and freckles. I am surprised when I think about being ninety years old. I still feel good and have lots of opportunities to enjoy life in many ways. I was very fortunate to have had a great family growing up, a happy marriage, and children to brighten my days.

I remember that I used to play outside under some big trees, and when I'd come in my mother would say, "Well, go wash your knees." They would call me Rusty Knees because instead of sitting on the ground, I would kneel so I wouldn't get my dress dirty. We didn't wear pants in those days.

I was four years old when I became blind. I had spinal meningitis. In those days, they didn't have any drugs for it. It was an epidemic in 1929. A lot of people had it, and they were left with defects of varying kinds. They kept me alive actually by giving me baking soda and water to keep from dehydrating. I would move all over the bed. I was wretched with a fever of 106 degrees for weeks, which accordingly burned up my optic nerve. I just remember begging mother for a mirror, thinking that that would make everything right. I finally had to accept the fact that I was blind. I had to learn to walk and to feed myself again, because it was a severe paralysis. They really thought I wouldn't live, so I guess I'm lucky.

The thing that I remember seeing as a child was the rain—how it would fall and then spread. I remember the colors in the evening light. That orange-red color was so exciting, and the shadows that came afterward. Unfortunately, I don't remember faces of my family. As a child I asked questions about everything and I wanted to know how to do things. When I lost my sight, I still maintained that questioning attitude.

I know some parents kept their blind children in baby beds because they were afraid to let them experience uninhibited play, but my parents did not do that. I'm

grateful that they had the foresight to allow me to mix with other children, climb trees, and do all kinds of things.

When I was six years old my parents decided that I should go away to a residential school for blind people. This all happened in 1931. They had a full curriculum of academics through the twelfth grade. I cried a lot when I first went there, especially at night. I was very lonely and missed my folks. I had a housemother, Miss Archer, who was just fabulous. She loved each of us and was always very kind but very firm. I remember her voice. She'd say, "Nadine, it's time to be quiet now. It's bedtime and we don't talk in here." Miss Archer understood that it was the first time I had been away from home. They taught Braille, and we even had a science class. My teacher gave me such fantastic insights into experiments. I got into trouble for talking. We wore dresses then, so the teacher switched my legs. I was quiet for a long time after that.

I don't remember that I was angry or felt sorry for myself. I just remember wanting to know how to do things another way. I had chores like my sister did. I washed the dishes and learned where to put the cups and saucers. I learned to add a certain amount of soap to the water. I was blessed with a good memory, and I didn't want to be left out. I had many friends who loved to come over to play. Sometimes they would say, "I'm going be a blind person." We would pretend they were blind. They would put their hands out to reach for things that they couldn't see. They would say, "Well, where is it? I can't find it." Oh, we'd laugh. Yeah, I loved to play.

When I talk about the 1940s and 1950s, it makes me realize that time has passed pretty quickly.

Generations are very different now than when I was a girl. We were expected to stay at home and be quiet. The living arrangements are so different now. It would've been scandalous to live with someone and not be married, or even to be anywhere in the house with a boy other than the living room.

When I was graduating from college they were arranging interviews for jobs. They didn't set up any for me. So I went to the president of the college: "I'm wondering why I have no interviews set up for professional placement?" He said, "Well, I just thought you'd go home with your parents." That was quite a blow, since I had been on the dean's list. I was considered one of the well-dressed people on the campus. I had belonged to the scholarship society, and I was doing everything right. I was fully intent on going out to work and living independently. I knew right away that when so-called educated people had that kind of attitude, then I would have struggles ahead.

During World War II I was an inspector at the defense plant outside of Little Rock. For about two years, I rode to work with Mr. Saffell. His wife was a very delicate person and in ill health. My mother was a nurse and took care of her in the hospital, and she also made home visits. I went with my mom on one of the visits and met James Junior, who was home from the Air Force. Jim never asked me a lot of questions about being blind. I think he understood that it wasn't a problem. When he told his mother that we were considering marriage, I think at first she was a little worried. His dad thought it was a marvelous idea. We were engaged the year before I graduated,

which was 1948, and married the following year. Jim was affectionate but reserved insofar as being demonstrative. I never found him avoiding a situation that might be unpleasant. If you asked him something he was very fair and direct.

I had two sons. Oh, they were a joy of my life. My older son passed away ten years ago. He had respiratory problems and then went into kidney failure. It was a terrible event, and I didn't handle it well. I had some anger and a lot of sadness over a long period of time. You never expect that your child would be taken from you. I still can hear the sound of my son's voice in my dreams. It's really important to be able to recall those kinds of things.

I did meet Helen Keller. She spoke at a meeting, and I was just thrilled with the fact that I could talk with her. Anne Sullivan, her assistant, translated some details. She just seemed to be a very enlightened person who was telling everybody else, "Hey, cheer up. It's not so bad out there." She was blind and deaf. I was encouraged by her attitude and her very cheerful presence.

I don't see anything now, but I do have a sense of light and dark. I can't distinguish whether a light is turned on or off, but I can tell whether the atmosphere of a room is dark or light. The acoustics tell me a lot about where I am. I have awareness about where to go. Sighted people don't need to listen as blind people do. How sound travels tells me more about my surroundings. Vibrations are also a part of my awareness: the way you speak, what tone you use, and how focused you are on the subject matter. It tells me about someone's presence and their sense of purpose. I can tell a lot about someone's intent and sincerity by the elevation or the resonance of their voice.

I don't think about blindness, and it's a rare occasion that I would. I don't get up every morning thinking, "As a blind person, what am I going to do today?"

I like music. I like all kinds of music except some of this new modern stuff. I had always been encouraged to go into the field of music. I sang popular music and opera. I had a high soprano voice, but due to allergies it's kind of lowered. It's a little ragged these days.

[*Singing*] "Getting to know you—getting to know you, getting to know how to love you."

RICHARD CASHAT

My name is Richard. I'm sixty-five years old. I'm married, with five children and nine grandchildren. I work as a machine operator at the Lighthouse for the Blind.

I was raised in a family where everyone pitched in to help. The house we lived in, my dad built it from the ground up. He didn't show a lot of love and never was the type who would hug you. He showed his approval by demonstrating that you were able to accomplish a job. He wanted to make sure that we knew what work was all about. In many situations, my dad was very irritable. He lost all his teeth and wore dentures.

The good times with dad were when he would share his excitement for going floundering. We would wade in the water at night with a lantern, and he wanted to walk all night long trying to gig these flounders. I often thought, "This is kind of miserable." Then I realized through the years how much fun it was to spend time with him. To go home, clean those fish, and cook them different ways were nice memories.

I've had people tell me they'd rather shoot themselves than be blind. Some of the misconceptions I've heard are: "Your wife is gonna have to shave you from now on, and someone is going have to help you get dressed." Well, that's silly. Close your eyes and do those things, and you'll see how silly that is.

I was in Vietnam when a friend gave me the name of a young woman he knew. We wrote for about a year. She eventually became my wife. When I got back to the States, our first date was with her, her mom, and dad. We had never met face-to-face before. I knew somewhat about her personality, inner thoughts, and emotions. What really shook me was her mom. She went to the cafeteria wearing spiky curlers in her hair. She didn't even wrap it up in a scarf to hide it all. I took it all in stride and had a good time.

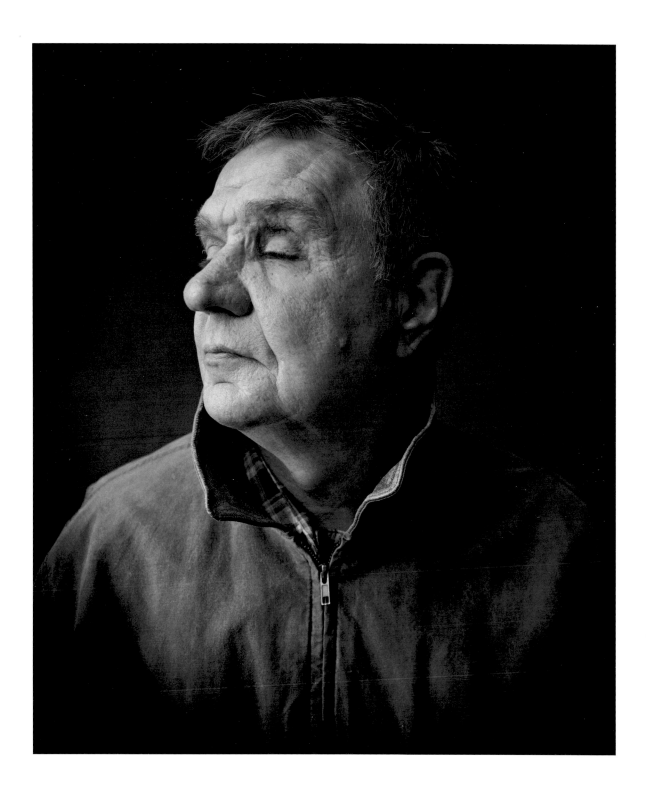

In 1976 on Groundhog Day, I was working at Exxon as an electrician. I got off a little before eight o'clock and it was already dark. I was in my '68 Ford Falcon. The railroad tracks were only guarded by a stop sign. I never saw a light from an engine, never heard a whistle. When I got onto the tracks I saw something out of the corner of my eye. I saw the number 546 on the engine. That was the last thing I ever saw in my life.

The driver's side glass exploded and took my eyes out. I was pushed 236 feet down the track by the engine. It was weeks later when I woke up in the hospital that they informed me exactly what had happened. I went through eighteen hours of surgery. I had major damage to my head. They literally put my face back together with wires. It took a while for my wife to convince me that I wasn't going to see anymore. I think the tears came then.

The way I adjusted to my blindness was that I had a family and two small children who depended on me. I was anxious. My worry was how to support them. It was a very unsettling feeling. So I jumped right into mobilization training, trying to find out how do things being blind.

I realized that no amount of exercise or good eating would correct my blindness. I'd have to live with it. My dreams were kind of eerie and distant feeling. When I first lost my sight, I would get a colorful starburst effect. That diminished after about three years. I am now in total blackness.

I worked on automobiles as a blind man simply because I did that when I was sighted. I enjoyed that tremendously because the work gave me an expression in life. I can still do things and bring some income into our family. I have replaced brakes, overhauled engines, replaced transmis-

sions and axles. I realize that the first thing I take off is the last thing I put back on. I do everything but bodywork or painting. You surely wouldn't want me to do that.

I have had sleep problems. So I would get up at two or three in the morning and go outside to work on cars. Sometimes neighbors would stand around to watch me work in the dark. At night it was cooler during the summer months, and I had no one bothering me. My wife did get up a few times to make sure I was safe. I've caught her bringing me a flashlight. She is someone that I live with every day. I'll never forget that, because at that moment she forgot about my blindness and accepted me.

I don't think I was a very good listener before I went blind. I started to try to focus more on what people were trying to communicate. What frustrates me is what I call "hit-and-run talkers." Someone will walk by and say something. Once I respond, they are already five steps down the road away from me. I find that an embarrassing situation just talking to the air. It happens often.

Using your whole body to live daily life can become very important. When I'm traveling on my own I have to be awake and aware. I'm able to sense a presence of an object while walking. It takes a lot of effort and can be intense.

You can feel shadows, believe it or not. When there is a post in front of me, I'm able to feel the void on each side of the post. Walking down a sidewalk, it's easy to feel parked cars. When I'm looking for a doorway it feels like a dark space because the ambient noise is different. When entering a room, I can physically feel the presence of things around me and know the width of the room when

approaching the other end of the wall. I do admit that I bump into things, which gives sighted people a misunderstanding of what I'm trying to accomplish.

I think sight can make you lazy. The physical eyes miss a lot. They're missing some of the rhythms of life, some of the qualities like quietness and patience. Sight gives us a lot of loudness that blindness hides. I think I have a good grasp on reality, but I find myself hiding from a lot of the pressures of life. I'm not real communicative and sociable because I find all those situations stressful.

My wife is pretty much disabled now, because she's got neuropathic damage in both legs. I do all my own cooking and clean the house and floors. When there's a repair to be done—a door hinge or knobs—I repair all that. I've climbed trees and cut dead limbs off of them. And I've put roofs on homes as a totally blind man. I don't try to paint anymore, that's too disastrous.

Most people don't realize the physical effort and concentration it takes being blind. I've never felt ashamed of being blind. It's not something I did deliberately to myself. I've been embarrassed—not so much for being blind but for the way people act around me. The public treats you like you can't do anything instead of giving you an opportunity. That is most degrading. I don't think most of us are looking for pity. I think we're looking for acceptance. Acceptance is an understanding that we still can produce, we still are functional as human beings. We're not someone that you can just sit in a chair and ignore. I want people to realize that I can contribute. You don't need eyes to be aware.

I was at home raising my children. I did a lot of diaper changing, feeding, bathing, and putting them to bed. I have learned to recognize who they are by the way they breathe and move through a space. One child can come into a room very quietly, and I know someone has entered. The next child can come in real robust and full of energy, and the air around that person seems to explode. I've never seen my kids except our first daughter, who was two years old when I had the accident.

My latest grandchild is only one year old. Because we don't make eye contact, he's a little afraid of me. Someone suggested I give him money, but money means nothing to a one-year-old. So I thought, "Maybe I'll start feeding him a little bit, give him little treats." But I suspect when he starts to know me somewhat, things will get better.

ANN HUMPHRIES

As a girl growing up in the Texas Hill Country, what comes to mind are images of the Frio River—Angora goats, the horses, the saddles, and the skunks we had as pets. Distant views of the fog rising on the river at sunrise. Those images are comforting to me.

The word "blindness" doesn't scare me anymore. It's not dark. I used to fear being called blind. But I've crossed over. It's taken so much time to adapt to being blind that I would hesitate to go back.

When I was in my early thirties, I started noticing a shimmer. It was like floating mercury sparkling in the periphery of my vision. At that time, I was a busy young mother starting my own business. So I thought it was nothing more than a bit of stress. That began a whole process of going through twenty-two doctors over five years to figure out what was wrong. Finally, I went to one of the finest eye institutes in the country, where they had state-of-the-art equipment.

I remember dressing very carefully because I thought, "Oh, they're going to think I'm a southern bumpkin." I wore my nicest clothes and stood to shake hands. The neuro-ophthalmologist examined me. In a very short time, he said, "You have retinitis pigmentosa." I understood that I would have to change my life. I remember the staff telling me, "Don't overthink it. Just go with it. It will be gradual and you can adjust." One of the doctors said that my vision would be gone by age fifty-eight. It turned out that he was almost right, as his prediction was within months.

When I first got my diagnosis, I understood that it was hereditary. I went through the process of worrying that our children might have it. It was a deeply traumatic experience. My father had a master's degree in counseling, and my

58

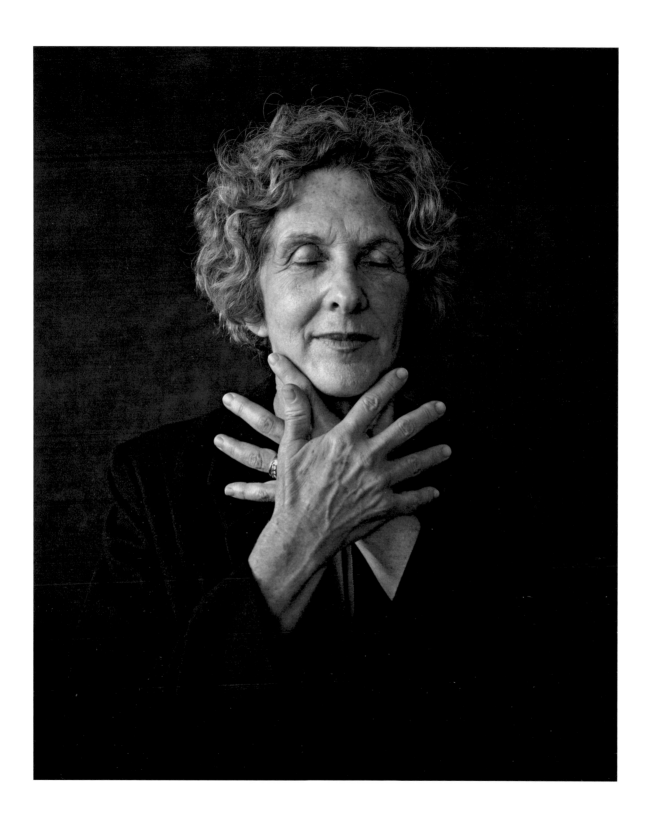

mother was a psychiatric nurse. So discussions were always a part of our family culture. It's not something to be embarrassed about. My husband, Kirk, and I scheduled several individual counseling sessions. That strengthened us. During one of those sessions the grief came to a head. I remember weeping, just shaking my shoulders and weeping. I felt the anger and the sadness. It drained me of the negativity I felt. I had to release my old life in order to embrace my new life. I had to use the energy from this disease to propel me forward—not hold me back.

Over the years, my vision has gradually diminished. I began to see through a Hula-Hoop, then a doughnut hole, and finally down to a straw. I could no longer see colors. Things were either in a fog or completely dark. I can no longer see shapes or buildings. I can no longer see the ocean, a sunset, or a sunrise. I can perceive the moon if someone guides my eyes. I can see a candle. It's more of an aura, like a bright cloud.

I get a sense of people's shapes when I hug them or walk with them. So it's not completely absent. I fill in some of the gaps. I can no longer read. I can remember how I write. I can say that I am blind now. I don't apologize for that. It has been a process to be able to say the word "blind."

I have a seeing-eye dog, a wonderful companion, named Brego. I consider his entry into our family's life as equivalent to our marriage and the birth of our children. It's *that* significant. My guide dog and I are partners. The way we know each other is evident in our routines. He can rely on me to feed him at a regular time. He can rely on me to brush him, to give him free time. He comes to my bedside when I don't feel well. I love how he'll

just stand guard. It's not like he's guarding me against anything—he's keeping me company. We have a mutual respect for guarding each other. I can sense when he's distracted. He is trained to have "intelligent disobedience," and he will stop and block me with his legs, and I'll know to pay attention.

Being blind, my sense of touch is magnified. It has gained different dimensions. I feel the sensitivity of my feet to changes in pavement, roots, bark chips, heights, all the different surfaces in a new way. My sense of feeling has changed as I pass people, parking meters, trash cans, mailboxes, and even empty spaces. I can sense a flowerpot as I go through a street. I can tell where I am in the neighborhood just by a slant in the street, a slight curve, or the center of the road.

When I drop something, I wait and listen. I don't panic. I sweep with my hands and find it. When we visited our son's new house for the first time, I trailed my fingers around every wall so I could feel the windows, the doors, and the textures. I could sense the size of the room. It was so anchoring to know the height of the counter and to feel the surface of the light switches. When I touch things, I can see them. Touch has become alive in my brain.

These days I don't care what people look like. I hear their voices, their manner, and their energy. This is important to me. When I was hugging my family whom I hadn't seen in at least a year, it was the way my father's back felt, his chest, his muscles—my mom's softness, my brother's height. What I sense about people now is more their sense of compassion and how they reach for my hand. The physicality of the image is no longer necessary to be satisfying and fulfilling.

It's almost as if I create a radar that maps out the space around me. Hearing an echo tells me how close something is. Last night, we were driving home from San Marcos through a golf course. The difference in sounds from the busy streets to just sliding through that golf course was so lovely and soft.

I miss the looks people give across a room. I miss moving in a crowd independently, going over to speak to someone. Yet there are trade-offs of equal value. When I hold babies I feel how they sit in my lap in a different way. I smell their hair more. I feel the soft spot, their bones. I just experience people in a slightly different way. You just shift.

Sometimes I will imagine a soothing place. I go back to the springs in the Hill Country when I was young. I remember the land, the breeze, the water, the sky—cedar trees, the smell of the river. I pull in all my other senses to make it richer. I imagine a Hill Country spring. I can still smell it. I remember the sleek feel of the water and the sound of the water flowing. I remember the light, the way the sun feels against my skin, and how it shines on my legs when I'm walking. If in the middle of the night I awaken for some reason, I use those memories to relax and help me return to sleep.

One of the nicest things blindness has given me is the goodness and generosity in people. I had been so frightened to ask for help, yet I found that people are willing. Blindness has helped me to see new dimensions in people.

I find that I enjoy the slowness of some experiences more. Slowing down can enrich and magnify the experience. Blindness has cautioned me not to rush, to get in a hurry. I know how the wind feels on my arms, my shoulders—how it blows my hair. However, there are times when I revert and get frustrated, when I can't go and do what I want to. But again, I've learned not to overreact, to wait and shift gears. It's like you pivot. I pivot and find whole new worlds that are equally satisfying.

MICHAEL HINGSON

I think all of us living in this world have things in common. We're here and we all have a purpose in life. I can look back at my life and see how I got where I am today through the choices that I've made. Life is always about making choices.

My name is Michael Hingson. I was born in Chicago, and we moved to California when I was five. I have a master's degree in physics from the University of California at Irvine. For all intents and purposes, I've been blind my whole life. I became blind because I was born prematurely and given too much oxygen, a condition today known as retinopathy of prematurity. At the time, people didn't know that providing a pure oxygen environment for several days caused the retinas not to grow properly.

My parents were told to put me in a home, because no blind child could ever grow up to be a contributor to society. My mother, with a high school diploma, and my father, with an eighth-grade education, said, "We are going to take our son home, and he will grow up to do whatever he chooses." And that's what they did.

My father was from Oklahoma and was an orphan most of his life. He was self-educated and learned to be an engineer on his own. With my uncle he owned a television repair shop back in the 1940s and '50s. He read books to me. His voice was deeper than mine and spoke with a lot of expression. My father tells a story about chopping wood in winter somewhere in Washington. He cut off his left thumb at the first knuckle. He froze the joint, so it wouldn't bleed. It was a couple of days before he could get to a doctor, who sewed it back on. He was able to keep the thumb but couldn't bend it at the first knuckle anymore.

My parents believed that your word was your bond, and if you made a commitment you always had to keep it. They taught me to be responsible and

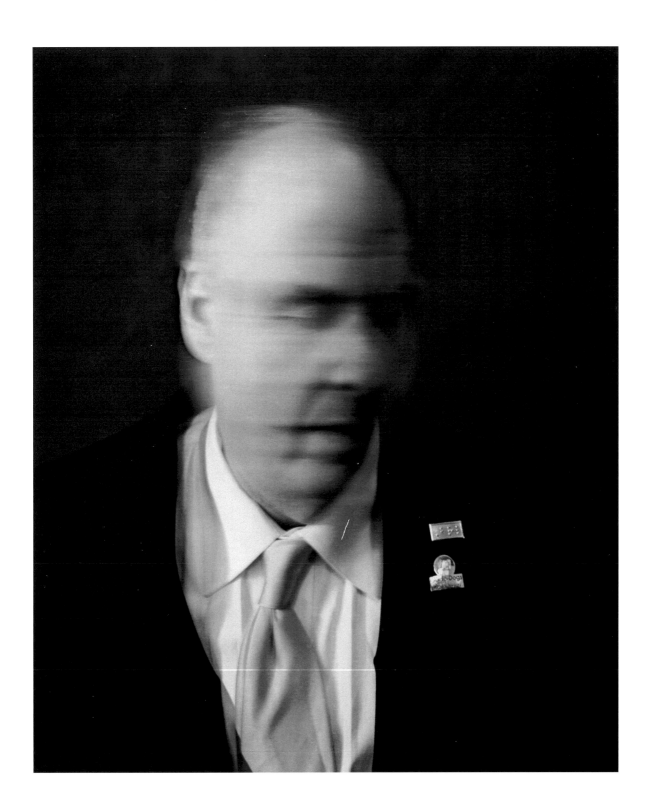

ethical. Their behavior has guided me. For example, when I was a student in high school, I was called in to the principal's office and told that I would no longer be able to ride the school bus. There was a rule that no live animals—including guide dogs—were allowed on school buses.

My father went to the library and studied everything he could find about the law on the subject. The superintendent asked my father to state his position. He said, "It's really simple. There's a state law that says it's a felony to deny a blind person access to any public conveyance or common carrier, if they're using a guide dog. So you're denying my son his legal right to take his guide dog on the school bus." My father wrote the governor. We don't know what happened, except that the superintendent was summoned to Sacramento, and the next week I was back on the bus. My father knew nothing about the law other than what was ethically right. He took on city hall and won. I learned that you can make a difference. I also learned that blind people are going to be treated differently. I'm going to have to expect that and stand up for my rights. It's easier to fight when you are right.

Blindness is not what people think it is. Blindness is not the end of the world. Blindness is not helplessness. Blindness is not something to be feared. The biggest problem blind people face is not blindness, but rather what sighted people think about blindness.

A lot of the blind service organizations are truly part of the problem. They may say, "We're advocating for blind people." But what they're not doing is teaching blind people to do it for themselves and then be partners with blind people. We all live in the same world, and it's important to find common ground to communicate. If you look up the word "see" in the dictionary, one of the major definitions is "to perceive." The problem is that the sighted only think in terms of eyesight. They don't open the world to the possibility of alternatives. How do I get people to understand that we are as capable, as good, and as qualified to be human beings on all levels as everyone else?

I use echolocation like the sighted use light location. It's no different. Do I get all the information they do? No, I don't. But I get information that they never will get, unless they truly learn to use their senses in a different way. Highly skilled members of any military teams learn to use more of their senses than just eyesight. What they know is that one may be able to see 150 degrees with their eyes, but with their ears they can hear 720 degrees.

9/11 ATTACK: WORLD TRADE CENTER

On September 11, 2001, I was working on the seventy-eighth floor of Tower One of the World Trade Center when the first plane struck. To tell my 9/11 story, it's important to understand what the World Trade Center was like. The office lobby was a bustling place, a place of purpose, a place where there was an undertone of excitement because it was part of the world financial capital. If you went out of the lobby of Tower One into the central part of the World Trade Center, you're in a shopping mall where thousands of people come to shop, eat, and do business.

I was working for Quantum Corporation, a Fortune 500 company. Our division manufactured products that were used to back up data and

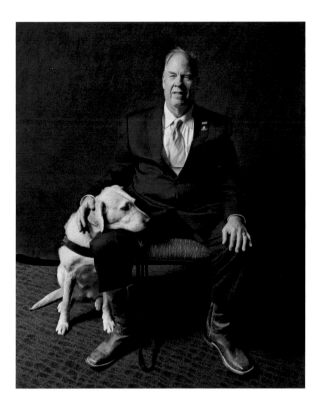

then stored off-site. When I went into the World Trade Center that morning, it was like any other morning. I was with my guide dog, Roselle. There were several banks of elevators. Two banks went to what were called sky lounges, one on the forty-fourth floor and one on the seventy-eighth floor. The elevator I took went straight to seventy-eight. It traveled at twenty-three miles an hour. It took forty-eight seconds to go from floor one to seventy-eight. I timed it. There was always the sound of wind in the background, the wind going up and down the elevator shaft.

I was in the office with David Frank. David and I were in the process of creating a list to send to the Port Authority's security. I was just reaching for stationery—when the world changed. What actually happened was that an aircraft hit our building on the ninety-sixth floor. We heard what was

sort of a muffled explosion and a thud. It wasn't deafeningly loud, because it had hit on the other side of the building, eighteen floors above us. It caused the whole building to shudder, and then it began to tip. We heard the building creaking and groaning as it continued to tip about twenty feet. We didn't know what had happened.

At the time the airplane hit, my guide dog, Roselle, was under my desk asleep. Dogs don't automatically trust people. They're much more open to loving people, but from a trust standpoint that still has to be earned, just like it does between people. What I did on 9/11 was to deliberately praise her, encouraging her and sounding confident as we went down the stairs. "Good girl, Roselle. You're doing a good job. Let's keep going. Forward, down the stairs. Good job!" I was doing a lot of that. It's clearly a synergistic, symbiotic

kind of relationship. So I was helping her help me, which helped her.

While I was walking down the stairs, I had lots of time to think and reflect. I remembered how as I was growing up, my parents always told me, "You can do whatever you want and end up wherever you choose." I remembered when I was in kindergarten, my father challenged me to learn the multiplication tables, which I did. Then he started showing me how to do other math. By the time I was in the first grade, I was doing algebra in my head. It was just a gift I had and still have. I quickly calculated that the stairs were fifty-six inches wide, and it would take a total of 1,473 steps to reach the lobby. I deliberately chose not to worry. I didn't even let my brain go there. I focused on what we needed to do, which was keeping Roselle focused. I didn't ever think about dying.

On the sixty-eighth floor, suddenly someone said, "Burn victims coming through." That happened a couple of times. Two women who were very badly burned, as David described to me, passed us. About the fortieth floor, we met firefighters who wanted to help us. We convinced them that we didn't need any help. Some of them petted Roselle, probably the last time they had any unconditional love from a dog in their lives. There were about fifty firefighters, men and women, who passed us that day but who never came back down again.

When we reached the thirtieth floor it was getting pretty quiet. I started wondering if we were going to lose power or light on the stairs. So I said, "Hey, anybody who can hear me, my name is Mike. I happen to be blind. I've got my guide dog, Roselle, here, and if the power and lights go out

in the building, we're offering a half-price special to get you out, today only." It made people laugh, which was what it was intended to do.

When we got to the first floor, David said, "Mike, the water sprinklers are on. You're going to have to run through a curtain of water to get out of the stairwell." And then he was gone. I heard this torrential downpour. I told Roselle to go forward. I was holding her harness and we ran through this incredible torrent of water falling from the sprinklers. I heard a lot of yelling. It was pretty chaotic. They didn't want people to leave Tower One to go outside. Then somebody from the FBI ushered us outside into sunlight at 9:45 in the morning. I checked my watch.

I tried to call my wife and couldn't get through. Suddenly a police officer yelled, "Get the hell out of here. The building is coming down." We heard this rumble that very quickly became a deafening roar, a combination of a freight train and a waterfall. You could hear glass tinkling and clattering, and metal crashing and falling. Then what I heard was this kind of white noise sound as the building just pancaked down.

Other people were running and screaming. I bodily turned Roselle around and started running. As soon as we started to run, I heard a voice in my head that said, "Don't worry about what you can't control. Focus on running with Roselle, and the rest will take care of itself." It was a voice that was as clear as my voice is now. I immediately had the sense of peace and confidence that if we worked together we'd be okay. And I still take that lesson with me today.

We got to Fulton Street, turned right, and were engulfed in the dust cloud from Tower Two's col-

lapse. With every breath I took, I could feel stuff going into my throat and settling in my lungs. It was that thick. We realized that we were going to suffocate if we didn't get out. I kept telling Roselle, "Go right, right, right." I heard an entrance and Roselle obviously saw it. She turned right, took one step, then stopped. She stopped because we were at the top of a flight of stairs. She did exactly what she was supposed to do. There was a woman at the bottom of the stairs who was crying as I came down. She said, "Help me. I can't see. My eyes are full of dirt. I don't want to fall into the subway." I reached out and took her arm, saying, "Hey, my name is Mike. I'm blind, but I've got my guide dog here. Don't worry about it. You're okay. Roselle will keep us both safe. Why don't you try to clear out your eyes?"

We were standing there when we heard that freight train–waterfall sound again and knew it was Tower One collapsing. David said, "Oh, my God, Mike, there's no World Trade Center anymore. All I see are fingers of flame, fire hundreds of feet tall, and pillars of smoke. The towers are gone." That's what happened to us on 9/11. The rest of the day we worked toward getting up to midtown Manhattan. Then later in the afternoon I took a train back to New Jersey and got home.

After 9/11 the media got my story. I received a phone call from a pastor in New Jersey. He asked me to speak at their ecumenical service for people who lost someone or had some connection to the World Trade Center. It was an outside amphitheater with five thousand people. That was my first public appearance. Now I speak around the country full-time and find it meaningful.

When I'm speaking I'm absolutely selling. It may be selling a better lifestyle. It may be selling the fact that we're all on this world together, a better life philosophy. It's not sales like selling used cars. But when I tell the 9/11 story, what I'm really doing is trying to get people into a mind-set where they recognize, "This could happen to me. And what would I do? Maybe there are lessons about preparedness and understanding that I should learn from this."

What I found is that I am able to draw audiences in with the story of 9/11. I can talk to them about the lessons that we should be learning about teamwork, trust, and leadership. I can talk about inclusion, but I'm still working on a way with a few sentences to create that "Aha" moment about blindness. I want people to recognize that blindness doesn't mean that a human being has less. I think justice means that we treat people fairly. It's important to have consequences when someone is mistreated or wronged. I don't know how to do that yet. I still ponder how to make people better understand.

QUSAY HUSSEIN

I was born in Mosul, in northern Iraq. In the winter it is very cold, and in the summer it is hot. The Tigris River crosses through the city, and there are mountains and a lot of trees. It's very gorgeous. It's a beautiful city.

My dad is the president of our tribe. Every day he has a lot of guests. People come and drink coffee with him. They would burn the wood and make coffee outside at 6 a.m. I sat with them, and they told us stories about how people before were different. If your neighbor doesn't have food, and you make meat and your neighbor smells it, it's a shame on you if you didn't share it with him. This is important for me.

I'm Muslim, but I believe in all the religions. I believe in all the prophets. I don't have any problem with what color someone is. I don't care if my friend is a Christian, Muslim, Buddhist. I care about his heart and whether he is honest with people.

In Mosul I raised pigeons at home when I was young. The pigeons are very smart and friendly birds. I love them a lot. I had a hundred pigeons of different colors: yellow, red, black, and white. The pigeons are actually more like human beings. They love the person who takes care of them. When I return home they fly to my shoulder, to my hand, and to my head. I would always feed them and made sure to lock the door, because the cats would eat the birds. I wanted to make sure the birds were safe. They trusted me.

I lost my vision when I was seventeen years old. Now I'm twenty-six. I was playing in a volleyball match. My three brothers were watching. Then suddenly a car drove fast into the stadium. I was two feet from the car when he stopped. I thought he was coming to watch us play. He was holding a necklace in his hand, and he made a big smile, and I saw his teeth. He pushed his hand on the horn

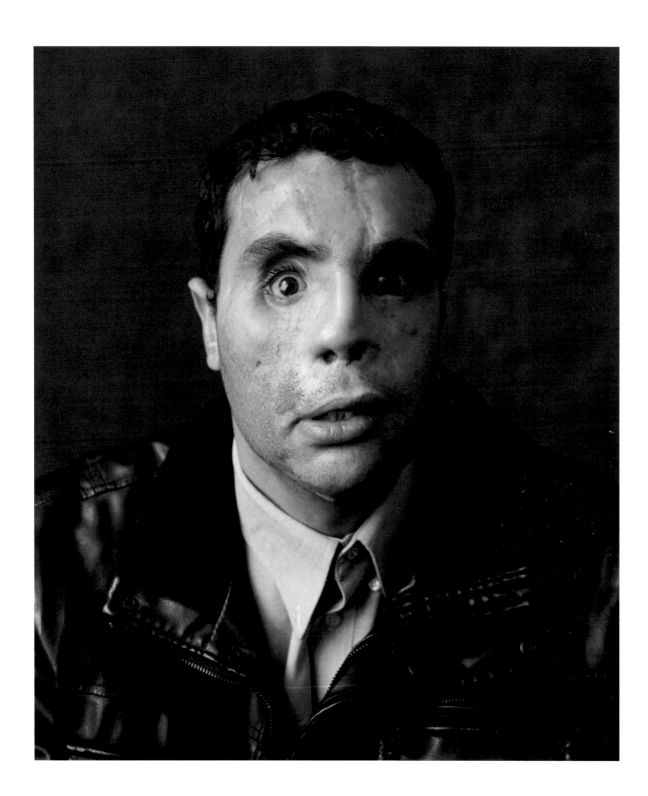

and then the bomb went off. There was a very big explosion and the ground was shaking.

When he blew up the car I flew very high in the sky. When I flew through the air, I looked down and saw all the people on the ground who were watching. When my body came to the ground, my face came before my body. When I stood up, shrapnel came to my head. I lost my nose, part of my right face, my eyes, and then I touched all the bones on my face.

They took me to a small clinic. The doctor told my dad, "After half an hour, your son will die. Go take care of your other sons." They took me to a room where people had died. There were people on top of me and beside me. Six hours later, I heard my dad's voice. Then I yelled, "Dad, don't leave me alone, please. I will die." My dad started shouting, "My son is still alive." He called somebody to help him put me into a car, and an hour away we met American soldiers. They put me in a helicopter and took me to their base. The hospital was like a tent, but it was a beautiful tent.

The bomber killed sixteen people, and fifty-six were injured. My brothers were also injured.

Why did this man kill people, why did he kill children? Why don't we live in peace? Why don't we love each other? Who convinced the bomber that when he died he would go to heaven? Maybe the person who told him was wrong. These are my questions.

I did have depression. I asked God to take me because I didn't want to live. I thought I could not do anything. I had fifty-five surgeries. When you have pain, you can't focus on anything. If you have an infection, you can't turn around to the left or right because it hurts so much. You want to sleep, but the pain won't let you. It's difficult to describe what the pain is like.

In 2006 and 2007 the situation in Iraq was very dangerous. I was just sitting at home, depressed, very tired, and in pain. We heard in the news about Doctors Without Borders. We connected with them and they sent me to Jordan. I stayed there for three years. A lot of people were injured. People had amputated legs and arms. They couldn't walk and they couldn't eat. Thank God, I have my legs and hands. I can eat, I can take a shower, and go to the bathroom.

When I saw this situation it changed me. I started counseling people. The doctors gave me an office for two years. I started teaching people how not to give up. If people had depression, they came to talk to me. The doctors told their patients, "Go talk to Qusay." I told people if they lose something in their body, they don't lose everything. I had to give them hope and enthusiasm. This is what I was doing in Jordan. I helped others.

When I was very young, our family was eating together. My father told everyone, "One day, all of us will depend on Qusay." I was surprised my father said that. After I lost my vision, I asked my father, "Do you still think you will be dependent on me one day?" He said, "Yes, we will." I haven't seen my family in seven years. Every time I call them they are crying. They hope I will be successful. They hope I will not disappoint them, and they are praying for me.

A lot of people don't understand blindness. They treat you differently. Sometimes the public doesn't give you respect. I'm not talking about in America but everywhere. Once I was sitting in a yard and heard a girlfriend and boyfriend say,

"Let's kiss each other, he can't see us." Well, I can't see, but I can hear. This is a simple story but shows how people don't have knowledge about the blind.

Blindness means you can't see, but absolutely your brain is working 100 percent. Not every person that has sight is smart. Some people with sight are also blind. Everyone has different ideas, hopes, energy, background, and faith. I'm blind with my eyes, but I'm not blind with my brain and heart.

When I came to the United States I didn't have any language, family, friends, nobody. Just God. My dad was scared for me, because I am blind. People told me I was crazy for this decision, but I was not scared. Thank God for America, because so many people accepted me. I hope I will give something back to America to benefit people here, because they helped me.

For me right now my ear is like my eye. I depend on everything with my ear. If I need to study, I pay attention to everything my teacher says. When you have vision, the ear takes a back seat. But for me right now the ear takes the front seat, and my eye takes the back seat, yes.

If you ask me if I want my vision back, I would answer, "No. I don't want it." I'm happy with what I have now. I don't want to see anyone killed in front of me or to see blood. I cry a lot when I hear in the news that people are killed in the wars. I don't want anybody to go through my situation.

I accept my blindness, because you can't change it. For example, if you throw a cup of water in the dirt and someone tells you, "Go turn the water back into the cup," you can't do that. You are mandatory to accept it, and you should accept it in a good way and not a bad way. I accept it with faith, with love, with God. If every day, every hour I start shouting, "I hate people around me," it will affect me in a negative way. So I accept my situation. I love it. I live with it every day.

JIMMY PODSIM

As a child I was interested in everything I couldn't do. If I couldn't do it, I wanted to do it. I wanted to be a truck driver. I wanted to be a policeman. I wanted to be a fireman. Just like every little boy.

My name is Jimmy Podsim. I am forty-nine years old. I have a wife and two children. I live on a hilltop, about two miles south of Yorktown, Texas. My family has eight and a half acres. My parents live next door, and my brother Roger, who is also blind, lives next door to them. I had a younger brother who was born with a harelip and cleft palate. He passed away on his twenty-first birthday in a car accident.

I do remember a story of when I was a baby, and just crawling. A friend of ours kept telling my mother that I had eye issues, because I would crawl with my forehead on the floor, trying to find things. I probably knew that I had vision problems, but I didn't have anything to compare it to, so it never was an issue. It was just normal.

I don't remember my parents ever telling me that I couldn't see like other people. I never asked any questions about my eyesight. Basically, we weren't treated like we had a problem. We were expected to do our chores. I had to mop, sweep the floors, wash dishes, feed the chickens and pigs. I got to bottle-feed the baby calves, and that was fun.

I don't remember the exact name of my eye disease, but it's something like Leber's congenital amaurosis. It takes about a page to write it out. So I just decided to accept my condition. There's nothing I can do about it. I don't really see anything clearly. I cannot read. I can't see faces. I can see lights. Depending on the quality of the light, I can see shapes or shadows. Reflections, shapes, and shadows are how I

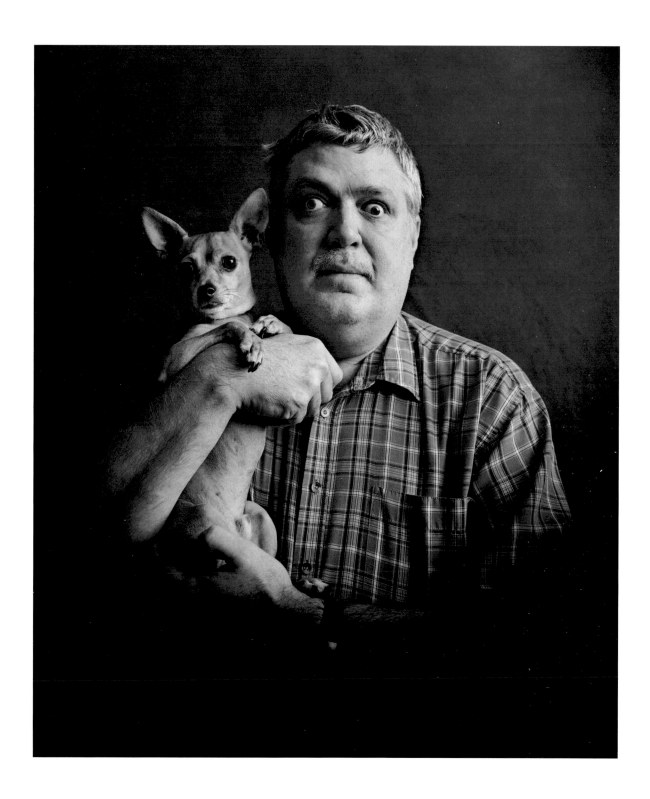

get around the house. For example, the aquarium by that door is a landmark. I can see the light glow from the aquarium, so I know where I am. I use the sound of the refrigerator to find the kitchen. Between the sounds, and light, and shadows, I maneuver in places that are familiar.

Actually I don't use touch very often. I rely more on what I hear. When I use the word "seeing," there is actually no visual context. I am feeling the texture of something, smelling something, or hearing something. Seeing means "feeling" to me.

The only visions I can remember, like faces or places, were in my dreams. I don't even know if they were real. I think I dream like people see. My brain tries to visualize in dreams what I feel with my hands—not so much color but with different shades. I really don't know how to describe my dreams. They just look like a flat moving photograph with sound. If I could see in real life what I can see in my dreams, I could probably drive.

Actually I think my junior high years were the worst time for me. There was a lot of picking and name calling. People were afraid of me. They did not understand that they could not catch blindness. To them it was a disease and it was catchable. They didn't want it. In junior high I had a really phenomenal memory. I would hear something, and it was like a photographic memory. If I heard it I remembered it. If somebody gave me their phone number, I would remember it.

I had major issues with algebra. My teacher wanted me to explain step by step how I answered the problem. I could get the problems right but could not explain how I came up with the answers. I just did it. It's something that happens. It amazed my algebra teacher. He told me, "I just don't understand how you get these answers correct."

My wife says that sighted people are the handicapped, because they rely on their eyes for everything. If they would rely on their other senses more they would educate themselves really fast. Blindness is not as horrible as they think it is. You have sighted people making rules for the National Federation for the Blind, the American Council of the Blind, and the Division for Blind Services. You have sighted people deciding the way blind people are supposed to act. So they're teaching you how to be blind. We already know how to be blind, but we need to know how to fit into the world.

I spend most of my free time either listening or talking on the ham radio. There is a large community out there. I could be talking to somebody across the street or in a different country. It is a comforting thing to do. Shortwave listeners have a lot to listen to, and there's a lot to learn. It's a place where I feel like I belong.

One weekend the club decided to put up a ham radio repeater on a tower. I was determined that I was going to help stack the seventy-foot tower for the club. This friend was adamant that I was not going to climb and stack the seventy-foot tower. The professional climber sent him in the house to get something, and before he got back, they had me harnessed, and we were climbing. He was a little miffed at us. My wife just laid into him. She told him, "Don't ever tell my husband he cannot do anything, because you just made him do it."

If I could have my eyesight back tomorrow would I want it? I don't know, because if I had my eyesight I wouldn't be who I am now. I would not have my children, I would not have my grandchil-

dren. I would have something completely different. I don't know if I would want everything to be different. If I was given my eyesight back, the first thing I would do is look at my wife and kids. I would then get into a car and just drive. I wouldn't care where I went.

When I was in high school, I worked with my father in home construction. For twenty years I worked in a meat-processing plant owned by my family. My brother and I both worked there. We processed hogs and calves for the farmers, and then during deer season we would process deer and elk. I would debone meat, grind meat, and cut meat. Then I'd wrap it and load it into people's cars. I did cut myself quite a few times. I even sliced the side of my finger off on the bacon slicer one day, but everybody who works in meat processing ends up with stitches at one time or another. I have learned that it is not so much the quality of the meat that matters as how somebody prepares and cooks it. The meat has to be stored properly to maintain a good flavor.

A sighted person's definition of visual is what they can see, but to a blind person visual is what you can hear, feel, and smell. Sound can be very visual. I used the sound of my footsteps bouncing off of items like a wooden fence or a barn or water trough. So I can locate items around me.

I pay attention to things around me, but I think it's subconscious because I don't realize that I'm doing it. That's why a lot of people tell me that when I'm walking around with them, they can't tell that I have a vision problem. That's been very important—being able to appear like everyone else—because when you look different, you're treated differently.

When people start making decisions for me, I resent it very much. I'm human just like everybody else. I have my thoughts and ideas of what I want to do. It's upsetting that people assume I don't have the knowledge to find out what I want or can do on my own. Many times people think they should make these decisions for me because I need protection. I don't need to be protected. I need to live like everybody else.

All my life, people have wanted to put me in a corner and say, "You're different." And all my life, I've fought to say, "No, I'm not different. I just do things differently than you do." There's nothing special one way or another. It's just different.

CHRISTINA AND WESTON WRIGHT

I grew up in the panhandle of Florida between Pensacola and Tallahassee. My grandfather owned about 1,500 acres of farmland. There were pine trees, fields of peanuts, and cotton all around our house. I think growing up on a farm helped me learn the simplicity in life, in the way that you become happy with what you have and don't yearn for more.

I was taught to cook, to do laundry, and to help my little sisters get ready for school every morning. I can remember braiding my little sister's hair on the school bus. I knew that I had to step up and help, because my father worked full-time and my mother was going to school. I do believe working hard was instilled in me at a very early age. I know that things don't come easy in life, and you have to work for what you get.

We have two sons. My pregnancy with Weston was my second pregnancy. It was an exciting time of our life. Toward the end of the pregnancy, I had an internal feeling that something just wasn't right. But my mother has always taught me that you never speak of those things. I just told my husband, "I'll be happy when they put him on my chest, and I can see that he's perfect." It was a very quick labor process with no complications. When Weston was born, I distinctly remember putting my makeup on. I wanted to be beautiful and perfect for my son when he saw me for the first time. I remember when they placed him on my chest, he didn't cry out. They told me to keep rubbing his back. When they brought him to us, I remember looking at how perfect he was. He had big beautiful blue eyes. My husband has light blue-green eyes.

For the next two months, I would sit in front of him in the swing. I'd swing and talk to him. He would react to my voice but would never focus on my face. I remember going back to the pediatrician's office and asking the doctor to evaluate

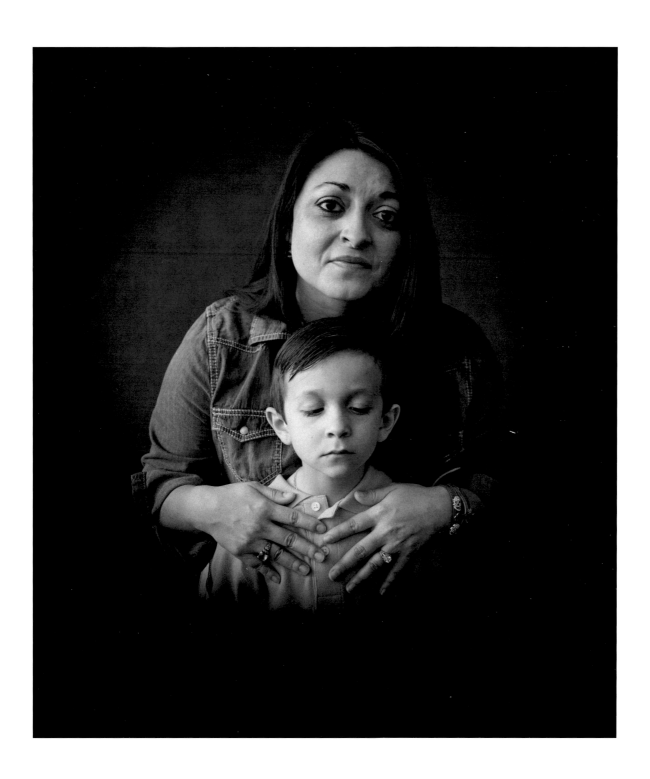

his eyes. They sent us for additional testing. We were called the next day to go to the ophthalmologist's office. The doctor walked in, and there was no introduction. He just sat down and said, "Blind people can still lead normal lives." He began telling me all of the things that Weston probably wouldn't do or couldn't do. This entire time I was in shock. I was not expecting anything about the nature of blindness.

I felt as if someone had punched me in the stomach. I felt a sense of loneliness and desperation. I'd never been around anyone who was blind. The car ride home felt like the longest drive. I remember just sobbing in the back seat. I was crying and my hands were covering my face. When I sat up to take a gasp of air, I looked over and Weston was smiling at me. It was a comforting smile. At that moment I felt something come over me, as if I was a mama lion protecting her cub. I knew that no one would fight as hard or be a louder voice for Weston than myself. I instantly knew I had to do something for him. I had to help him succeed.

Weston was diagnosed with septo-optic dysplasia. His optic nerve did not fully develop, and he also has a diminished pituitary gland that doesn't produce the natural hormones that we produce. This is a very rare diagnosis—one in every 500,000.

I saw on the news that a child, who was completely blind, had been given umbilical cord stem cell injections and regained her sight. So I contacted them and did a lot of research. I found out that this was taking place in China. We raised $40,000 through various fundraisers and used our savings to take Weston to China. Our original ophthalmologist was against the procedure.

So we found another ophthalmologist and went forward. No one could've stopped me at that moment. We traveled to China, and Weston had the procedure. I don't think that we were told the full truth. We were expecting more. I was a bit angry.

If you had asked me if Weston was flawed when he was six months old, I might have said yes. Now, at eight years old, I feel like he's more advanced than I am at thirty-three. He's perfect. I feel like I know Weston from the inside out. He's what completes our family. I can always tell if something's bothering him. Weston takes the weight of the world on his shoulders. When Weston hears something on the news, he worries about things that no child his age should ever worry about. He is very concerned with how our soldiers will get home and what happens to them.

Weston amazes me with his sense of compassion, his sensitivity for the world. When a car goes by he asks, "What is that noise? Why did that car sound different than ours?" If someone mentions there's a rainbow in the sky, he says, "What's a rainbow? What does it look like?" He has a very light touch with the bottom part of his fingertips, just lightly touching things. Smelling things. He can sense when I'm standing nearby, even when I don't think I've made a sound. Weston will know that I'm there, and he always has, even as a baby.

In our household blindness is not a disability. It's an inability that we can overcome. "Can't" is not a word that we use, and I want to raise him with that thought. Weston looks forward to driving one day. I don't tell him that he can't drive. He owns a real dirt bike, a 50cc kick-start crank. We put a walkie-talkie on his helmet and will tell him

from our walkie-talkie which way to turn. We'll tell Weston, "There's a hole up ahead. Please slow down. There's a tree. You're going to go left."

Weston uses echolocation. He told me, "I just know when there's a car there, Mom. I just feel it." He would make clicking noises and the sound bounces off of objects. He uses his cane more than anything.

I think it's very important to expose Weston to as much as possible—whether it be success, failure, happiness, or sadness. I don't want Weston protected in a bubble, even though it's so difficult for me, because I really want to protect him. I have to allow him to be exposed to all those things. It's important for when he grows up.

I get very angry about ignorance and how narrow-minded our society can be. When we're out in crowds, people stop what they're doing to stare. I think what makes me the angriest is when people gawk at Weston. I'm sure it's curiosity on their part because he's blind, but the mother in me feels like they are looking at a freak show. The biggest misunderstanding regarding blindness is that our community wants to combine blindness with mentally challenged. They want to treat him as if he's less intelligent. That is not true at all.

I think Weston struggles right now with his independence at school navigating around the campus. As he has gotten older, he has started to ask me more what it's like to see. It's a very hard question to answer. Just last Sunday, Weston and I were lying in the bed and I noticed his eyes were open really big. I asked him, "Are you seeing something?" And he said, "I see you." So I asked him, "What do I look like?" And he said, "Well, you have makeup on." (I did not have any makeup on. I still had my pajamas on.) And he said, "And you're Mexican" [laughing].

Weston has taught me to see life in a completely different way. He's taught me to see the beauty of nature by the sounds of the birds or the smell of fresh-cut grass. He talks about smelling things. He talks about how he can hear like a hawk—and he does. Weston's taught me to be forgiving. Weston has taught me patience. In my past I've been very busy and on the go. Weston's taught me to stop and take a moment to breathe in all that we've been given.

RICHARD TURNER

I love what I see. I don't see the same way you do, but I'm a very visual person. I still see colors and images in ways that people couldn't even begin to imagine. As I talk with you, I see thousands of beautiful vivid colors, patterns, and images in my subconscious from when I could still see images. It's like looking at one of those old kaleidoscopes—you twist it around, and different colors are moving and undulating. That's how I see things day or night.

I was nine years old when I caught scarlet fever. My throat was full of blisters. I remember feeling miserable and not being able to swallow. My sister Lori also caught scarlet fever, and we were both quarantined. My entire school had to take an antidote to prevent the other students from catching the disease.

When I went back to school I told my teacher, "I can't see what's on the chalkboard. I just can't see it." My mother was heartbroken over it. She really didn't say anything to me. She started crying and just held me when the specialist told her that there was nothing that could be done about it. That was the only time I ever saw her break down and cry. I knew something drastic was going to change my life.

My dad never treated me like I had a problem. He was the kindest, most giving man I've ever known. I never heard him say a bad word about anyone. He would tell me, "Whatever you want to do—you can do it." He was a genius. He could create anything, fix anything, and repair anything. Everything he did was to perfection. Fortunately, I inherited that trait from him.

The doctors called my condition birdshot chorioretinopathy. Birdshot because it looks like someone took a shotgun and shot the retina full of holes with the center blasted out. My condition was degenerative. When I was about twelve I lost

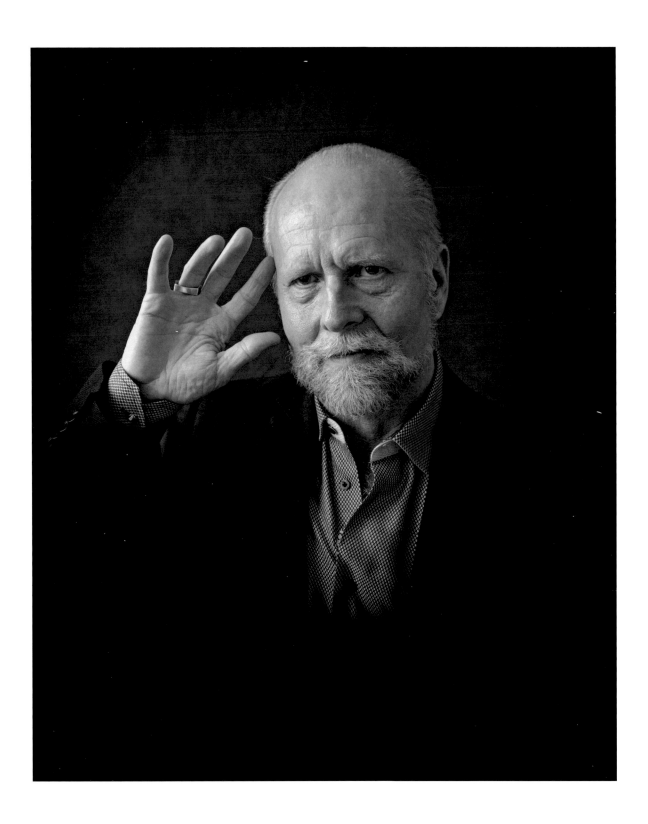

the ability to see detail. I couldn't see straight on, because I had no macula. I did have some peripheral. Today I have light perception only. I cannot see clouds in the sky. I cannot see a face.

The kids made fun of me when I started losing my vision. They would call me "Blindy" or "Mr. Magoo." When I was in sixth or seventh grade, that criticism impacted me in a negative way. It made me feel angry. There was a movie we watched called *Lord of the Flies*. It was about a group of kids stranded on an island who became savages. There was a character called Piggy who was chubby, blind, and asthmatic. Without his spectacles he couldn't see. Those kids ended up killing the kid. I started looking at myself like Piggy. I was skinny, blind, and had asthma.

I did not want to be a weakling. I did not want to be a coward. I would watch Tarzan movies where they would be running across a tree that fell across some deep canyon that was two hundred feet down. Tarzan would always say, "Whatever you do—don't look down." I was always afraid that I would be the coward who would dramatically fall to my death because I couldn't handle the stress. Those movies made me challenge myself. I would walk along the top of fences and chairs. I'd climb up on the roof of the school building on the weekends and walk around the rim. I climbed steep cliffs without equipment. I was more concerned with conquering the fear within me than what I was doing.

When I was young, I fell in love with the TV western character Maverick and the things he could do with playing cards. I became obsessed with playing cards. I would have the imaginary card game set up, and I would stack the deck

in such a way that I would win. And some guy would call me a cheater. I'd roll out of my chair, do a somersault, pull out my gun, and fire my red bullet at him.

When I was nineteen I started getting attention with the things I could do with cards. I had the privilege of working with a man named Dai Vernon. For over half a century, he was considered the best in the world with a deck of cards. For the past thirty-seven years I don't think I've missed a day of practice. The average practice day for the last twenty-two years was fourteen hours a day. People say, "Practice makes perfect." I say, "Perfect practice makes perfect." You could practice the wrong thing wrong and it's going to be perfectly wrong. I would put the card moves into my subconscious. Physical sight is not necessary. I'd break the card moves down piece by piece, and my hands would practice it over and over. I've logged around 134,000 hours of practice. It never bored me for a second.

People that depend on what they see for their input minimize their other senses. If I had the choice of having an operation that would restore my vision, I would not be interested. I wouldn't take the chance of gaining physical sight but losing the perceptions and abilities I have. I've learned to perceive things in a way that other people don't. I like what Sherlock Holmes once said to Watson: "You see but you do not observe." Vision is limited. This may sound peculiar, but to be able to see everything can make us cognitively lazy.

I am a card mechanic. I can control a card game. A card mechanic is a thousand times more difficult to develop than the techniques used to perform card magic. You can shuffle and cut the deck.

You can choose the game you want to play. You can choose the number of players at the table and decide which player you want me to deal the winning hand. You can hand me the deck—and I'll make it happen. I can make anybody win or lose at will. There's one move that I do called the Turner push-off second. Nobody else has been able to do it. As I'm talking to you, that's what I've been sitting here practicing.

I have my whole house set up where I can practice wherever I am. As soon as I get in the car, I pull out my little lap pad and practice. When I got married I had a deck of cards in my pocket and practiced during the ceremony. I practice one-hand shifts or one-handed shuffles in the grocery store. When I'm at church I have a deck of all-white cards I keep in my wife's Bible. I could even sleep with cards and they wouldn't fall out of my hands.

You don't have to physically see to experience beauty. A personality can be beautiful or scratchy or irritating. A voice can be beautiful. I think integrity and loyalty are traits that are beautiful. You can feel happiness. There's definitely a beauty in the way people handle playing cards. My wife has a beautiful disposition. She can walk into a room and the room becomes more beautiful. There's a spirit of peace that comes when she enters a room. It doesn't matter what she's wearing. You can feel joy when somebody has a joyful spirit.

I have a very unusual visual condition, first written about in the 1700s, called Charles Bonnet syndrome. This condition is somebody who has lost their vision but sees colors, patterns, shapes, and images. I don't see these images in the back

of the brain like dreaming. I see them in front of me just as clearly as a sighted person sees whatever is in front of them. I guess you'd have to say they are like hallucinations. It's not a mental illness or mental condition. It's been said that when a person loses one or more of their primary senses that the surviving senses compensate by becoming much sharper. Neural science found this is partly rooted in the phenomenon known as brain plasticity. Neurons regenerate and reorganize themselves around one or more of the remaining senses.

I can write numbers or words in the air with my finger and see them as clearly as you'll see them on a computer screen or chalkboard. That's how I might solve a problem. If I want to remember a phone number or a name, I'll write it down in

the air. Once I've written it, I have to wait until it fades away or I clear my mind.

I see things in what I call two color spectrums: the red spectrum and the blue spectrum. They're present all the time, day or night. I never have any control over what spectrum I wake up in. I'm in the blue spectrum right now. In the blue spectrum everything starts with a deep royal blue, and it goes down to lighter blue to a turquoise, and then to different shades of green to a yellow. The colors are constantly moving. When I'm in the red spectrum the colors are yellows to reds to hot pinks to maroons to royal red. What's interesting about the blue spectrum is everything is in paintbrush swipes and the colors go back and forth. When I'm in the red spectrum everything is in geometric shapes—triangles, rectangles, circles, and circles within rectangles. I can't understand why the blue spectrum is not geometric.

Within all those shapes will be thousands of images—bicycles, stop signs, just oddball things. When I'm out on the street I will see movement of cars going by with a trail of colors. They look like someone made a painting of that item. It doesn't bother me in the slightest because it's beautiful. They're three-dimensional. Some images look closer and some seem farther away.

I have the most wonderful son. I wish I could see what he looks like. His name is Asa Spades Turner. His middle name is Spades. Asa Spades. Ever since he was born, I would lay next to him. We would hold hands, say prayers, and talk about what happened during the day. I could actually feel him growing from one day to the next.

I don't look at myself as having any kind of disability. The public does not believe that a blind person can see. That bothers me. When some people find out I'm blind, they start speaking slower. The public thinks we're stupid. They think you don't have other ways of compensating for the lack of sight. I can discern the attitudes of people by the way they talk. I can tell if they're arrogant or lying. I can feel their thought patterns and form impressions. I don't consider myself blind. I never use the word "blind," because blind implies there's no perception. I like the way I see things. I just don't have sight in the same way you do.

I'm the touch analyst for the U.S. Playing Card Company, the biggest card maker in the world. I can feel things with a deck of cards that nobody else can feel. My fingers are more precise than their measuring tools. I help them make a better deck of cards. I can actually feel the difference of a card that's 10.9 thousandths to one that's 11.1 thousandths of an inch. Touch is very visual for me. As soon as I touch something I instantly perceive the entire object.

I do have challenges. One time I went to do a show. My client said, "Richard, hello." I went up to her and said, "Oh, it's so nice to meet you." When she talked again I realized she's like 6′2″, and I knew that I was talking to the wrong part of her body. It was embarrassing, because women don't like you to stare at their chest while you're talking to them.

I can get disoriented walking to the mailbox. I've gotten lost in my own front yard. My wife is so immune to me running into things. I dashed to answer the phone and ran square into the corner of a wall and split my head wide open. I started gushing blood. I don't know how many scars I have. I blocked with my head, because I have to

protect my hands. It's amazing that I don't look like some old boxer.

I was a person that couldn't sit still. I had a nervous energy. I took that energy and focused on whatever I wanted to create. I had a friend named Steve Terrell. He would say, "Be the best at what you love." I believe that talent trumps wealth. In other words, a billionaire would love to have Tiger Woods come to his house because Tiger's talent trumps that person's wealth.

I once did a run of shows of 2,190 days in a row—that's six years, seven days a week. I've done over 100,000 card shows, demonstrating how many ways you can be cheated at the card table. I had the privilege of performing for people like Brad Pitt, Johnny Carson, Gregory Peck, Muhammad Ali, Secretary of State Colin Powell, and others. After a performance I'm not tired. I'm excited.

People will not know that I have any kind of visual problem nine out of ten times. Some say, "Man, you're doing that almost as if you're blind. It's kind of unique." They're not realizing that they're stating the truth. When they find out after the show, it always makes them even more excited.

When I book myself for a performance, my blindness is never part of the promotional material. If I had a dismembered foot, I wouldn't tell the audience, "Oh, by the way, my right foot is a prosthesis."

The reason I don't tell people I'm blind is because I play the part of a sighted person. I'm a gambler. It's not part of the show so it has no relevance to what's going on. I want the audience to appreciate what they saw on its own level—not because of this but in spite of this.

NATALIE WATKINS, PART I

I love the visual world, and most of my memories are visual in nature. When I was twelve I went to Europe and experienced many countries in just two weeks. In Rome I remember looking at the Sistine Chapel, and I just cried. The bus was about to leave and I knew they were missing me. But I was just completely and totally swept away in the experience of that incredibly beautiful human work.

We lived on the island of Guam for three years from the time I was in the second grade. The island taught me what it felt like to be a minority. I went to an international school. There were students from all over the Samoan Islands, Australia, Korea, and Japan. It was an enriching experience and opened my eyes to different perspectives. I explored the island with my dad in his little jeep. We would go out into the jungle and play in waterfalls. I remember the salty air, white sand beaches, and the varying shades of the blue and green ocean. We had no television, and I became a voracious reader. Before I could read, my mother would read to me tirelessly. I loved detective stories and had fantasies of becoming a detective. Not so much in a police sense, but in terms of finding the truth of an issue. They were some of the happiest years of my life.

My maternal grandmother was blind. She could see shadows but couldn't see faces. She had been married to someone who had been very mean to her for years. I think she felt trapped. She even wrote stories about her youth before she went blind. She could dress herself, take a shower, those types of things. One particular time when I was nine I asked her if I could do her makeup. I started being silly and drew a star on her forehead. I felt really guilty, because she couldn't see what I did. She never complained ever. She had an inner peace that I came to respect as an adult.

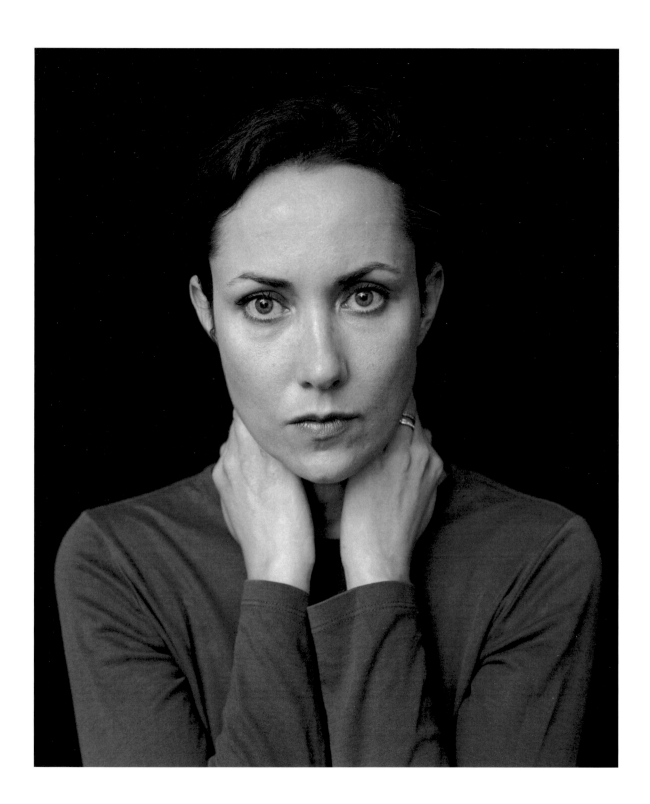

As a child I struggled at nighttime. My friends would run ahead. I remember thinking, "How can they see so well at night?" I was tripping over sprinkler heads and rocks in people's yards. When I was ten I got disoriented in a haunted house and didn't know how to get out. My heart was beating quickly and I started to perspire. I was terrified. I remembered those experiences and felt there was something about me that was different. But I definitely didn't think I was going to go blind.

My parents took me to get my eyes checked. It was no big deal at first. We went to the doctor and they did a test called an electro-retinogram. The doctor was very young. He looked nervous and profoundly sad. He sat down in a small room with my dad and me and delivered the news. I did test positive for retinitis pigmentosa. I cried the entire way home in the back seat. I was devastated, and it felt like my future was bleak.

The first time I heard of retinitis pigmentosa is when I asked mom why my aunts and grandmother couldn't see. I thought it was an almost laughable word. It's so long, Latin, and clunky. Retinitis pigmentosa is a genetic mutation that causes the rods and cones of the retina to commit suicide. It's a term called apoptosis. First, one experiences night blindness, then peripheral vision loss, and finally central vision loss. Not everyone loses all their vision. After the diagnosis, I thought I would kill myself if I went blind. But then I got married and had kids. I have friends and parents who are living. So one has to adapt and cope with daily life.

In my disease process, I've lost most of my peripheral vision, and I'm desperately holding on to my central vision. I love what I can still see. It feels like being inside a slowly constricting narrow tunnel on a foggy day. It's very difficult to explain. I might see a fly on the wall across the room and trip over an elephant getting to it. In the center of my vision, I have between 3 and 6 degrees of sight. A normal field of vision is 110 degrees.

I get a lot of comments about what a great guy my husband is. That's kind of annoying after a while. He is a great guy, but I hear, "He's such an angel" or "He's just like Jesus." That's annoying. So if he is like Jesus, it must mean he is a slacker, since I'm not healed [*laughing*]. In all seriousness, he has been great because I spent so much money and time on ineffective therapies and treatments. We could have used that money to make our family life easier. I tried acupuncture. I tried stem cell implants. I tried microcurrent stimulation. Also, I was hospitalized from all my lack of sleep due to my obsessive search for answers. A researcher at Johns Hopkins University said that he has never met anyone who has tried more treatments for retinal disease than I have. So it would be really easy for my husband to blame me, but he's never done that once.

When I was younger I was a ballet dancer. In college I worked for a modeling agency, traveling to Mexico for photo shoots. I also worked as a makeup artist. That was probably my favorite job because it was so easy to make people feel good. After graduating from college, I taught school for three years. I finally became a financial planning analyst. I knew that my disability was in my future but didn't think it would happen until I was in my fifties. I was very surprised when at twenty-nine, I could not pull up any client data from the new software. I had no choice but to retire.

Then I became a mom. That was far busier than I ever imagined. Now that my children are starting school, I have these little pieces of time being filled with writing and words.

I quit driving at twenty-three because I had so many accidents. I've lost my ability to read standard print. I've lost my ability to walk independently. I've lost the ability to read facial expressions. I absolutely feel like I'm in between two worlds, one blind and the other sighted. I don't really have full membership in either one. I definitely feel like blindness is used by the public as a metaphor for ignorance. Language does shape our reality. So even though it seems harmless it's not, because there are so many people living with vision loss. People are horrified of being blind. I read a study indicating that people are more afraid of being blind than getting cancer or AIDS.

I went to a doctor when I was around twenty and he ran some tests. He said, "You know, if people like you would quit reproducing, this vision disease would go away." I think he believed that some of us were flawed and shouldn't reproduce. There was another doctor I was seeing, and she told me, "I shouldn't say this because of what I do. But if I were in your situation, I think I would jump off a building." I was completely struck silent. Not quite the encouragement I was looking for. I laughed, trying to defuse the situation. I have a very dark sense of humor, and that has helped me cope.

I pay more attention to sounds than I did in the past. I was at a barbecue with some friends and the kids were playing in another room. I heard one of the little boys drop a bat and I said, "Oh, we need to get the bat from your child." No one else had heard the sound. So my senses are different than they were before.

I'm a kinder person because I'm going blind. I've also become a far more spiritual person than I would be otherwise. I don't think I would have that awareness if I were fully sighted.

We all have vulnerabilities and weaknesses. Any of us can be hungry. Any of us can be homeless. Any of us could be a prostitute under the right circumstances. I realize that anything can happen to anyone at any time, and it has made me more compassionate. I don't look at other people as being "less than" because I realize how much that stings.

No matter what joy is in my life there is this constant nefarious monster of blindness lurking in the wings and threatening. It's very frightening and terrifying. There are many people who don't consider their blindness a disability. They have my admiration and respect. But that's not how I feel. I love the vision I have. I love being able to relate to the visual world along with everyone else. No, I don't want to lose my vision. Definitely not. However, if I do lose it I'll find a way to cope, and maybe even find happiness. But I'm not at that point yet.

NATALIE WATKINS, PART II

Six years later

Michael Nye: Natalie, we met six years ago. You were one of the first individuals I interviewed. You were diagnosed with retinitis pigmentosa as a teenager. You said, "It feels like being inside a slowly constricting narrow tunnel on a foggy day. I might see a fly on the wall across the room and trip over an elephant getting to it. I have between 3 and 6 degrees of sight. A normal field of vision is 110 degrees."

 I have not met anyone who fought harder or spent more time and financial resources to reverse your vision loss. You tried acupuncture, microcurrent stimulation, and stem cell implants among other treatments. You told me, "No matter what joy is in my life, there is this constant nefarious monster of blindness lurking in the wings and threatening. It's very frightening and terrifying. I love being able to relate to the visual world along with everyone else. No! I don't want to lose my vision." Now, six years later, you have traveled from visual impairment to total blindness. I would like to ask you some questions about your present perspective and insights on blindness.

Natalie Watkins: The definition of the word "hope" has changed for me. When we met six years ago, my hope was so tied up into maintaining my sight. It was an obsession. I pursued maintaining my sight at the cost of so many other things that were so much more dear. I would spend my time in medical databases instead of playing with my daughter or reading some research article instead of tickling my son. You can't get those moments back. I thought that hope was in maintaining my eyesight, and now I realize hope is in having connections with others. My

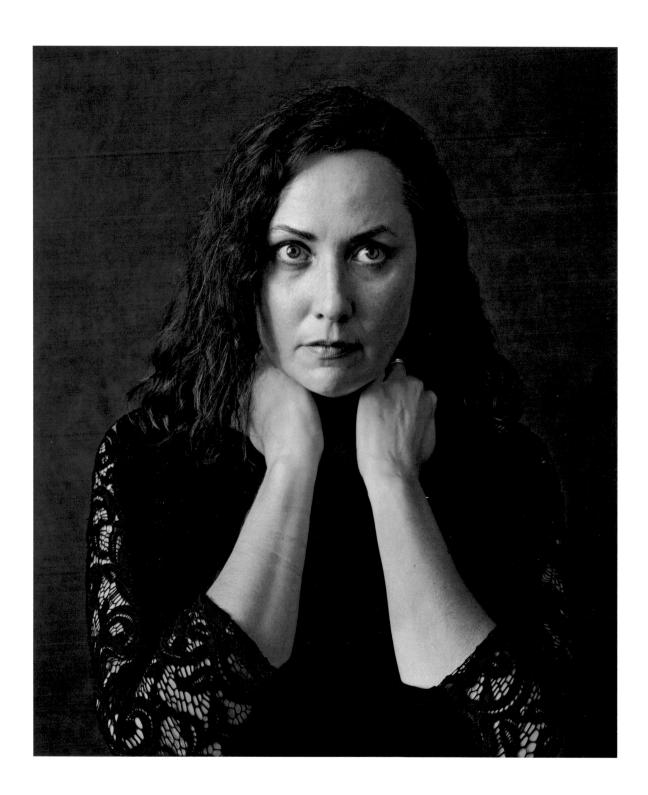

hope was right in front of me, but I just didn't know it at the time.

My total blindness happened rather quickly, which is unusual for my condition. My deterioration was gradual. I noticed I couldn't see my computer anymore, and I would make the font bigger and bigger. It happened within a three-week period. Intellectually, I think it was a blessing because I was holding on to that little scrap of vision so desperately that it was preventing me from embracing how to do things nonvisually. I've had tantrums. I've screamed, yelled, cursed, and cried. But I got over it. I have been on my knees, praying to God for guidance and strength. I've been totally blind now for nine months. Sometimes I get waves of grief that come at unexpected times, but they're not crippling.

The Stoic philosopher Seneca [4 BCE to 65 CE] writes about how our fears of the imagination are so much worse than reality. That has been my experience. I have so much more peace now.

When I was partially sighted, my principal fear of blindness was that I would be a burden and an incompetent mother. I thought I would be a failure as an employee. I was so completely and totally petrified that I would have no quality of life, that it would hit at the core of what it means to be human. I internalized a lot of society's most negative stereotypes toward people with disabilities: that a person's worth is somehow based on what they produce. If you are not producing, you are worth less as a human being. My fear of blindness was its own special kind of torture, and the reality of blindness has not been torturous. It's been a challenge; it's been a massive pain in the ass. Blindness has been an ongoing, never-ending, and relentless lesson in adaptation. But it's not a life of misery, and it doesn't impact my quality of life.

When I was sighted, taking care of daily tasks was easy. Being blind requires so much more cognition and deliberation. I feel like my sighted self was very lazy compared to my blind self. But strangely, I feel less stressed because I'm less rushed. So much of life is not dependent on vision. A hug of a child or rain on your face is not dependent on vision. Walking through wet grass or eating a chocolate bar is not dependent on vision. There are many ways to bring awareness into your life.

Since I have been totally blind, I've definitely noticed that my memory has gotten exponentially better. I think that's because I rely on it so much. I have also noticed that I have become a very adept problem-solver. What I like most about being totally blind is not judging people on superficialities. I don't judge people on how they look. I have no idea of their socioeconomic status. I have no clue as to any of those barriers that separate us from others. By far that is the most freeing thing about being totally blind.

Blindness is definitely not what people think it is. It is the inability to use one of your senses. It's nothing any more significant than that. There are many other ways to compensate. It doesn't break you, and it's not the end of the world. One of the biggest problems that I faced was not the actual physical loss of sight but the public's perceptions. Although well-intentioned, people have said to me, "If I were you, I would jump off a building. If I were you, I would be crying in bed all the time. The fact that you try to make a pot roast is admirable."

But there's nothing admirable about making a pot roast.

I've been totally blind for a short period of time. I have an enormous amount to learn. My hope is that I'll become more mobile, more productive, and more fluid. The challenge is the work, the time, and the energy. Total blindness has enriched the ways I perceive some things, like the songs of birds and many other things that I didn't realize were a part of the world around me. I am hearing differently, and I glean meaning from sounds in ways that I didn't before.

I was passionate about ballet when I was young. I danced every day after school. After my diagnosis of retinitis pigmentosa, it was the one thing in life that I cared about. I would dance so intensely my toenails turned blue. My toes bled. I always put cotton at the end of my pointe shoes. But it was worth it. I wanted nothing more than to be a professional dancer. The joy of dancing was pure absorption. I couldn't be concerned about algebra or having retinitis pigmentosa. I did have moments of what some would call the "flow experience." It is when everything you practiced comes together, and you're just sort of riding the wave. It definitely gave me a love of achieving. At my core, I'm the same person with the same motivations.

I think I'm still extremely driven. It's interesting because the word "driven" means something different to me now. Before, I would have thought about career-focused goals. But now I'm driven to try to be present for my friends. I'm driven to write every day. I'm driven to encourage others in whatever their pursuits may be. I'm driven to be there for other people who are losing their eyesight. I'm driven to be present to my life.

Society tells us that we will be happy—if we are beautiful, wealthy, drive a certain car, have a certain house. It's not until people attain those things and still feel empty that they realize that it doesn't give them any sense of satisfaction. I noticed that I was having fantasies of being someone totally different than who I was. What I was imagining was purposeful and where I was of service to others. I still want to get my book out into the world. I want to start a talk line for people who are losing their eyesight. I want to be that person who's available for them. I don't think service to others is dependent on vision at all. That's something that has definitely come to the forefront of my consciousness since losing my sight.

The public is so mired in their own eyesight that they confuse physical sight or observation with perception. Perception is deeper, more nuanced, and involves all our senses. Blindness is just a different way of existing in the world. If I were going to tell the public any one thing it would be, "Don't be afraid of me, have an open mind, and be prepared to listen." That would go a long way toward better understanding, not only of blindness, but of any human circumstance that differs from our own.

JACK LEVINE

Chaim Levine never went to school one day in his life. There were fewer than two hundred people in his little village in White Russia. It was a life of poverty. They ate out of the ground—beets and potatoes. In 1905 Czar Nicholas II sent out troops of horsemen, called Cossacks, to ravage the villagers. They raped the girls and burned the small wooden buildings. One of the activities of the pogroms was to round up the teenage boys and run them through the woods as human target practice. My father at fourteen, and his friend Benny, packed up their little burlap sacks and left the old country for the new world—a decision made within two days. They never returned.

The most important image I have of my father was astonishment at his life's journey from czarist Russia through immigration to New York and through his business life. He spoke five languages: Yiddish, Russian, Polish, English, and Politics. He knew it was politics that sent those boys running through the woods and vowed to never be a victim ever again. All this happened before his blindness.

In 1943, at the age of fifty-two, my father lost his sight within a twenty-four-hour period. The conjecture was that he suffered an aneurysm. He operated a business for thirty years before blindness happened. I came along nine years after my father's blindness. Some things don't require good vision. I am not blind; however, I grew up as the child of a blind father. I've seen for two people my whole life. I actually think I am double-sighted. It's the opposite of being blind.

We lived in the resort town of Long Beach, New York. The kids in our neighborhood wouldn't come to our house. My father was such an odd person. I think they were afraid of his blindness and of his age. When I was ten, my father was seventy. When my friends' grandfathers came to visit, they were younger than my father. Some of the kids used to run up to him and say, "I'm Jackie, I'm Jackie" to

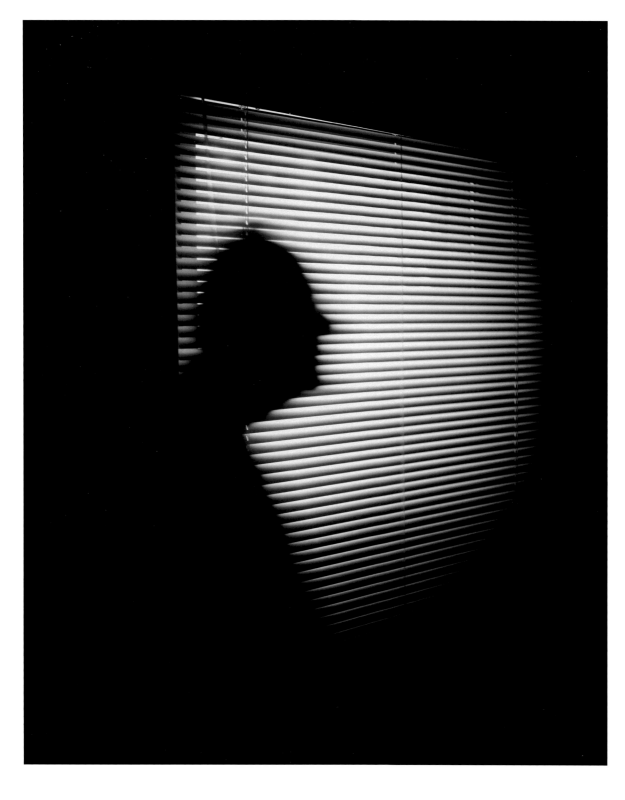

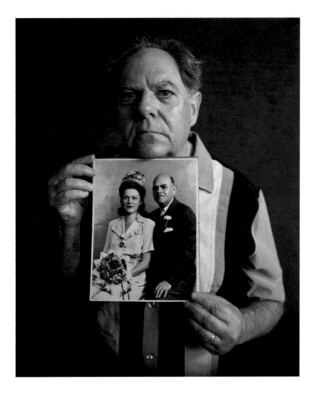

The amazing acuity of my father's auditory ability always astonished me. It seemed that he would hear things from rooms away. I have no idea how he spatially knew where things were. But I couldn't leave things out of place either. One set of skills my father developed before his blindness was the capacity of touch. His business was in very fine embroidery on women's fancy gowns. He used to test his seamstresses' products by touching the stitch. He became a Braille genius and knew how to touch the dots with astonishing speed and acuity.

He had a strategy about almost everything. He had a deep voice that reflected his level of experience. He respected people who confronted him verbally. He couldn't drive, so all his buddies would visit at our house on the weekends. Six or eight of these older guys would discuss the issues of the day. He tried to convince his friends to support the civil rights movement and the Freedom Riders financially. He was a cause maniac. My oldest half-brother said that he thinks our dad gave away three-quarters of all he ever earned to his workers and to different political causes.

I learned to respect who my father was intellectually. There was not a lot of overt affection. I don't really remember hugging and kissing him much. I think there was a tension throughout the family about his capacity to show emotion. My mother, his second wife, being twenty-five years younger, didn't bargain for this life with a disabled man. Although I admired my father for his beliefs and abilities, emotionally he was not a deep well.

While some kids took music lessons, I didn't. Some kids were athletes. I wasn't.

My skill set was the English language. I was raised to serve my father as his second set of eyes,

try to fool him, as if he did not know his own son's voice. So in a way I was a victim of their derision and taunting.

I don't remember getting into a fight about it, as much as feeling that I was doing the best I could to fit in. I would lead him up the streets, his white cane sweeping ahead, and my right arm was his passage.

If I were to describe my father, I would say "brilliant, forceful, compelling—even in small groups." He was responsive to good questions that demanded good answers. There were people who did not believe he was blind because outwardly he did not appear blind. His eyes looked normal. He was not clumsy. He did not fall over things. He knew where everything was. He cooked his own breakfasts.

as his reader. He would get handwritten letters from his immigrant friends. I struggled through them. I was frustrated and would sound out the words the best I could. He was so curious to know what his friends were saying. That first summer of reading to my father was not a happy time. As I went into age ten and eleven, my reading to him became more frequent and longer.

My anger and frustration with having to read for my father transformed into an appreciation in adulthood. My capacity to read well, write well, and speak well was rooted in those duties that started at age eight. Little did I know that his blindness was a gift to me. It was not like a birthday present but a life gift. A birthright present.

There was a summer retreat of the Industrial Home for the Blind called Burrwood on northern Long Island, and my father was invited to go there for a summer. I went with him for an extended weekend. That was the first time I was with other blind people. I have very distinct memories of what that felt like. There were about forty in attendance, from teenagers perfecting their Braille skills to elders like my father. What was amazing was their everyday activities of eating, passing from one room to another, even being in the bathroom. All the men whistled while they stood at the urinal to defend from any poorly aimed visitors behind them.

These were new friendships, new relationships for my father that endured past that summer. I think my turn toward teaching and then professional child advocacy was rooted in my perceptions of these other blind people and their abilities rather than any other singular reason. My profession is coaching, inspiring others to be more effective advocates to take on a cause and give it voice.

There is in all of us a fear of darkness, of the unknowing, of not having a clear view of where you are. Blindness for a sighted person is a fearful condition. I think there's an assumption by the sighted that blindness is more than it is. That it bleeds into other disabilities such as mental incapacity. Blindness is not Kryptonite. It does not incapacitate somebody. Great achievements can be accomplished, given the right opportunity and environment.

Blindness is a disability. But it's also a gift of growing other perceptions and honing the ability to listen more carefully. When a sense is taken away like sight, it does not decrease the capacity to learn, feel, and express emotions. To some degree it may even magnify the capacity to do that. It could mean the motivation to want to make a difference. I think that's the road my father traveled.

One of my most vivid childhood memories was walking into my father's room in August 1963. I was twelve and remember it being a very hot day in New York. My father frequently listened to the radio, but this was something unique. He put his fingers to his lips and asked me to be very quiet. He was listening to Dr. King's "I Have a Dream" speech live from Washington, DC. He was so attentive in those few minutes.

I don't ever remember seeing my father cry before that day. What King created was the testimony of why people need to be equal. Feelings matter, and my sense of awe and admiration for those words that came out of Dr. King's mouth were reflected in the tearful eyes of my blind father. It became the news of the day, the month, the year, the decade. My experience with it was very clearly as an innocent witness to something that had amazing impact forever.

GEORGE WHITE

I'll never forget it. It was August the first. I played on a men's baseball team, and I coached the ladies' team. After we played on Sunday, we would all go to the club and have a drink. When I got out of the car, I turned around and looked down the barrel of a twelve-gauge shotgun. When I was shot, it knocked me against the car. I felt the blood running down my face. I put my hands down and caught an eye in my left hand. Being scared and nervous, I jumped in the car. I didn't want him to shoot me again. The shotgun was the last thing I ever saw in my whole life.

I was taken to Bexar County Hospital. When I did wake up, I had a bunch of holes in my face. My head was swollen up bigger than a basketball. I told them, "Take the bandages off," thinking I could see. And they said, "Why?" I said, " 'Cause I'm going to kill this sucker that shot me." My girlfriend was there. She said, "George, you're going to be blind. You lost your eyesight." I said, "Nah. It's just dark for a little while." She said, "No, you're going to be blind."

I guess with the alcohol and medicine in my system, I just went wild. I was mad at the world. Every time I would wake up, I would start fighting. They put me on a floor where it was like being in jail, with bars. That same week, my girlfriend's son came to the hospital to see me. He said, "Come on, let's go downstairs and eat." I would stick myself in the side of the face with my fork. I couldn't hit my mouth. I was really upset. I was wondering how I was going to make it. That's when I really realized I was blind.

After I lost my eyesight, I picked up a bottle of whiskey. I wanted to die. I tried to think of so many ways to get it over with, but nothing worked. I cried at first. I prayed that my eyesight would come back one day. It never came back. The only color I saw was black. I was very depressed. I was running into walls and doors. I

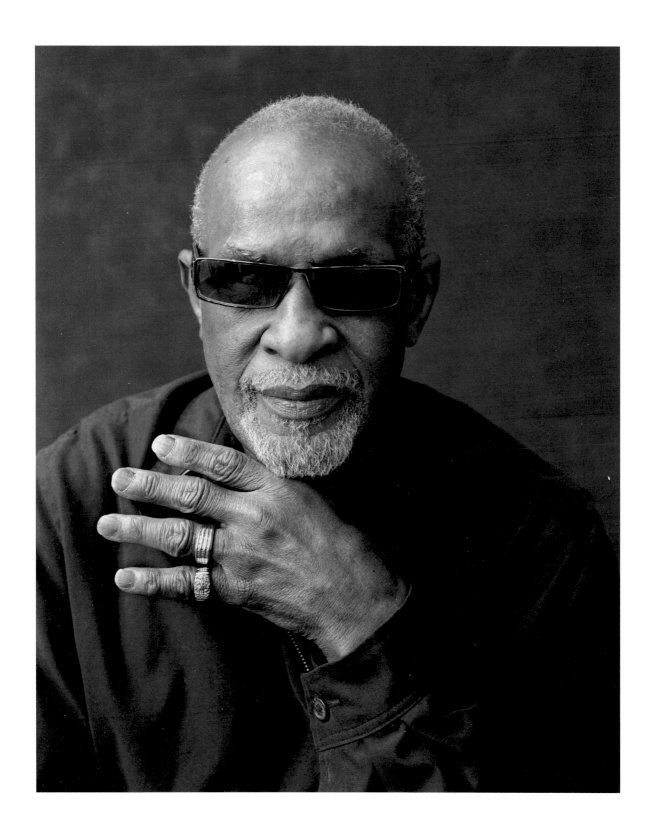

would hit my head in different places. I looked like I'd been in a car wreck. How was I going to face the world being blind? Nobody has ever seen me without a smile on my face, and dressed like I used to dress. I wore very expensive clothes. I wore silk shirts and tailor-made pants. As time went on, they bought me a cane. I couldn't handle people seeing me with a cane or holding onto somebody, because I was ashamed of it.

When I was growing up I had jobs cutting grass, thrashing pecan trees, and selling bottles. My dad cleaned thirteen washaterias a night, 365 days a year. I had to help him because that was our way of surviving. Sometimes the food got low. He was a good-hearted man, until he started hitting that bottle. On Saturday nights my father's friends came to our house to gamble. We could hear the men laughing, screaming, and talking crazy to each other. It was easy to hear who was winning and who was losing. We were really worried because if my dad won, we ate good. If he lost, we didn't. After a while the gin started getting to my dad. He started treating Mama like she was some kind of dog. I couldn't handle that, and I made him move away from the family.

What I miss the most is cutting hair. I was one of the youngest barbers to hit San Antonio. I wish I could see a head of hair right now. Many of the Spurs basketball players and Harlem Globetrotters would get their hair cut by me. Some of your singing people would get their hair cut by me. They heard how good I was. I wanted to be better than everybody else. Everybody else was cutting from the pocket. I cut from my heart.

My girlfriend is my whole life. We've been together off and on for the last forty years. We never wanted to marry because we don't want to mess it up. She dresses like a movie star and has a beautiful body to back it up. She is jet-black and has a pretty shine to the black. She has beautiful white hair, beautiful brown eyes, and white teeth. She loved diamonds on all her fingers. In memory, I still can see her. This may sound crazy, but I used to see my girlfriend with no clothes on. With my hands, I can still see her. She's perfect. I tell her she is God's gift to me.

The biggest misunderstanding about being blind is that people think we're helpless. I've had some people tell me that I should stay at home, that I didn't have any business out here in this outside world. Some people will not sit next to you or touch you if you're blind. They think blindness is a disease, and they might go blind. A lot of the public uses very ugly language toward us. They'll curse you out. A lady that came along in a car told me, "Get your blind ass out of the street." People will come up to you and ask, "Do you know what you're doing?" Recently I went to a backyard dinner party. I asked the lady, "Could I use the restroom?" She told me, "Yes, but don't pee all over my floor." That hurt. I don't like it, but you have to learn to accept it.

My girlfriend gave me determination. She said, "George, we've got to do something. You're lying around here smoking and drinking, with no money coming in. You got to get a job." One day she called and said, "Get dressed." I said, "Get dressed for what?" She said, "My brother is going to take you to the Lighthouse for the Blind to see about a job."

The staff is beautiful. I had never been around people that were teachers. In my twenty-eight

years working at the Lighthouse, none of them have ever treated me badly. I started out working as a general assembler. They taught me different things. Now I am a machine operator. Working at the Lighthouse has changed my whole life. They have shown me I could do things that I never thought I could.

Sometimes I play basketball with my great-grandson. When it's my turn to shoot, he takes my cane and hits the goal post so I know where to shoot. Sometimes I can make it. It's beautiful to play with him. He treats me like there's nothing wrong.

The biggest difference in my life was accepting my blindness. I don't need eyes to tell whether a person is happy or angry. I can feel it. I know when someone is honest, and I can tell when they're not. I hear people walking. If they get close enough, it changes the air and atmosphere. Blindness causes me to pay more attention to everything. I didn't do that when I was sighted. I have pictures in my mind. I can imagine the sun anytime and anywhere because it's very pretty going up and going down. At the San Antonio Rodeo, I can remember the grand prize cow that looked big and ugly. I can imagine the cow being a T-bone steak on my plate. I can imagine it now, but I can't see it.

I've lived on both sides of the street. I've been in jail and I've been on street corners. I've been blind and I've been sighted. I've been hit across the forehead with a beer bottle and I've been stabbed three times. Before I lost my eyesight, a friend and I were going to Austin to gamble. He got into an argument with this guy. I told my friend, "Just don't fight him. Let's get out of here." They shot my friend, and I had his head in my lap. He was trying to say something. We both were full of blood and he died. It made me think about quitting the streets.

The blindness did me a big favor, because I'm still here. The shotgun in my face got me off the street. I think I'm even better now than I've ever been, because I'm not doing what I did when I had eyesight. Eighty-five percent of the guys I knew on the streets are dead. I don't want to be the next one. I don't want to go back.

KATIE KEIM

My life began as somebody who was fascinated by water. I remember as a child jumping off the edge into the pool at the community center. My father rescued me each time. I didn't know how to swim and thought it was a game, and I would laugh.

I am drawn to large bodies of moving water, primarily oceans and sometimes even waterfalls. I love being gravitation-less. The sense of freedom and motion without gravity in saltwater makes me extremely happy. My father was a civil engineer in oceanographic research and design. He studied tidal and ocean movement against structures within the ocean, and how the water pressures work in and around those structures. I was twelve years old when my father died. It changed the direction of my family, but it also solidified what I admired about my parents. They were adventurers and risk-takers. I've always called myself a cautious risk-taker. Metaphorically speaking, I'll jump, I'll jump, but I want to know as much as I can before I jump.

I understand that I was born smiling. It's a permanent fixture. Even in my darkest times, smiling is just a part of me. I don't know how else to be. When I thought I was the most dour or angry, people said, "You're still smiling." I've tried to frown for long periods of time, but my mouth flips back up to a smile.

I grew up with excellent acuity of vision, meaning that I could see more than most people. I recall walking down the street with a friend and looking at a house across the street. I could see the screws on the deadbolt, when my friend with twenty-twenty vision could not even see the deadbolt on the front door. My vision at night was equal to that in the day. I didn't really know any difference between night and day.

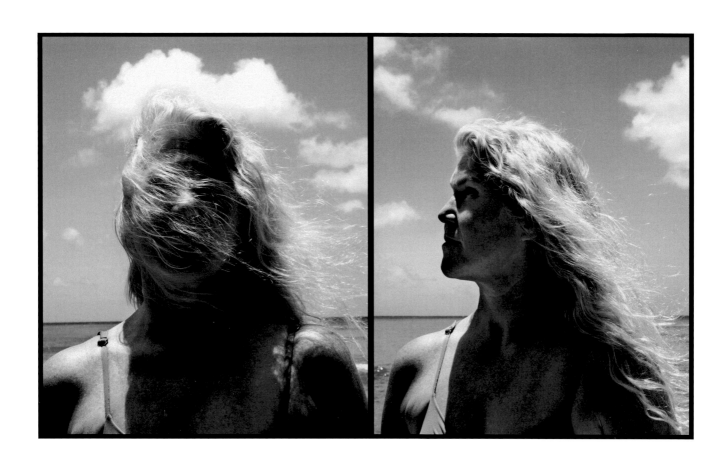

On my eighth birthday, my parents believed I had the flu, but within a couple of days I went into a coma. I was found to have what was called juvenile diabetes. Today it's known as type 1 diabetes. I have been taking injections of insulin since I was eight years old to maintain my life. The graduation of blindness didn't show up until I was twenty-eight. The diabetes led to the visual disruption called diabetic retinopathy.

At the age of thirty-six while I was living in Maui, Hawaii, I woke up one morning and could no longer see. There was no sunlight or interior light. I wasn't sure whether it was morning, but the birds outside told me it must be early daylight. In the sunlight, I could see some color and shapes and shadows. The shapes were not well formed and in motion. That visual acuity did not last long. By the end of the day I did not see color anymore. I saw very limited shapes and shadows. That's when blindness for me truly began.

After blindness came, I moved from Maui to the California Sierras where my mother had recently retired. I spent a huge amount of energy contacting retinal specialists. I was told over and over that nothing could be done. I was first in denial. Then fury. I experienced a kind of fury that was quite destructive physically. Not to myself but toward objects. I pulled out every pot and pan in the house and threw them all over the kitchen floor. I tore apart my mattress and bed frame, and I did this by hand.

During the first few months of blindness, my nightmares were very potent. I had recurring dreams of my world closing in on me. One dream was in red and black colors. Ants were crawling on the walls—and in and out of me. The other dream was in blue and green colors. Snakes were everywhere. The walls were snakes and they were crawling through my ears and eyes. The nightmares kept switching back and forth between those two dreams for a period of time. It was scary.

After the fury started to abate some, all my senses, including emotions, became wide-open to the world. I had no ability to close those down. The stimulations were constant, overwhelming, and frenetic. It was as if someone turned on headphones at concert-level volume. It was very frightening. I just could not be. It was so overwhelming. The sounds, the feelings, the sensations, all the ways that my receptors were wide-open trying to gather data to be in the world again. It made me aware of how many sensory receptors were being used to satisfy my need to be integral in the world without vision.

In those early months of blindness, I had to relearn spatial relationships. I was walking with my mother one day near her home. It was a soundless and windless day. I experienced walking by a large ponderosa pine tree and hearing that it was next to me through my arm and my skin. Not through my ears, not through my eyes that didn't work anymore, not through the smells or taste in the wind, but through my skin. I have no other way of describing it than hearing it through my skin. So the sensations started to come back to me in the realization that I had always heard them. I had always felt them. I had always smelled, tasted, and touched them. But I had always thought I'd seen them. I realized then I could still see without seeing.

My mother loaned me a pair of snow moccasins with tread on them. They were sitting outside my bedroom door. I realized in those first three months that my mother had not once cried in front of me. She was being consistent and stable, while I screamed and yelled. She just smiled and kept going. I was truly and suddenly in my mother's shoes. I did not want her to be my caregiver. I did not want to live with my mother for the rest of my life. That was a turning point of acceptance, and a willingness to do whatever it took to get back out in the world and live my life to the fullest.

I believe that our brain is the most important and amazing organ in our body. It has the greatest ability to adapt quickly to change. Our emotions are the biggest barrier to accepting what the brain has already adapted to in a split moment. It's not our brain. It's us, overanalyzing our circumstances that create the barriers.

My name is Katie. I live in Honolulu, Hawaii. I live in a glorious, fortunate spot right on the Pacific Ocean at the base of Diamondhead Crater. I am married to a wonderful man named Virgil. When I first met Virgil I felt the power of our shared love of the ocean. In many ways the ocean is what brought us together. Virgil also happens to be blind. We both, once upon a time, had vision. Our conversations were not initially about blindness but how we perceived the world and got around. He talked about using a long white cane with a metal tip, and how much more freedom it gave him. Virgil is a blind entrepreneur. He owns and runs a business here in Honolulu. He currently has forty-three employees working for him. I consider myself to be a designer. I have done the gamut from designing gardens to houses to clothing in the fashion industry. I also worked for vocational rehabilitation—helping people who had become disabled to redesign their lives and go back to work.

I don't wish blindness on anybody because our world is not set up to be a world for the blind. I was expecting two years for rehabilitation. That was what I set as a goal. I remember it took me seven years almost to the day of losing my vision, when I woke up and thought, "Oh, I'm normal again." "Normal" is a funny word, but it's the only word that describes being back in yourself and feeling comfortable in your skin again. I began the next chapter of feeling normal, and integrated in my community, equal to my sighted peers.

When you lose your vision as an adult, your brain and experiences are at whatever age you are. Suddenly you are a child again, relearning. It's like bringing two lines back together again, so they're merged instead of segregated. You have to relearn, so they're back as one. Blindness has given me a different form of stability, consistency, and an ability to use my innate strength of endurance in ways I never imagined.

I actually have 360-degree hearing. I've always liked watching people, but now I like to sit and listen to the world more than before. I find certain words in language to be very limiting. I'm going to use the term "echolocation" or "echo sounding" for lack of a better terminology. I think that everybody, unbeknownst to them, uses echolocation whether you're blind or sighted. I was always good at spatial relationships, but I had to relearn the meaning of specific sounds. I have a special

relationship with echolocation. It gives me an awareness of my space, and it helps me to integrate and be respectful to the space I'm moving through. I actually use it when I'm in the water. I can hear the depth of the water through echo sounding. I can hear whether it's sand or rock on the ocean floor. But that comes through listening and asking questions to understand space again as a blind person. Once I get beyond two hundred feet deep, I'm not very good.

I know that I'm only human, and yet I've always strived to be diplomatic with strangers interacting with me on the street. I find it very challenging, now that I'm blind, to maintain that diplomacy and not blow up when people are so rude and disrespectful. I understand that the majority of them are coming from the goodness of their heart. But honestly, it's an exhausting internal challenge every time I leave my home.

I walk up and down Waikiki every day where we live. I have this rule. I call it my 101 rule. If you happen to be the 101st person in my reality that day who approaches me and thinks you know what's best for me, grabs me, pokes me, asks me how it is to be blind, am I okay, am I angry, that I'm so amazing—if you're the 101st person, watch out. I might hurt you [*laughing*], because I'm so tired of my white cane indicating there's a difference, and therefore you have the license to interact with me in a manner that I find rude and disrespectful.

I am a highly visual person and always have been. I learn best by doing rather than by reading how to do it. Everything I hear, smell, touch, feel, and even the senses we don't have names for, turns into a vision in my mind's eye. I don't try

to make mental images. It just happens. When I meet someone there's a vision in my mind's eye of who they are and how they look. It's not in the finite detail of what an eye can see. It's more of an essence.

More than eighteen years later after blindness, I finally attained a lifetime dream of visiting Paris. Virgil and I had explored many neighborhoods of Paris and beyond into Normandy. On the last night in Paris, Virgil and I lay in our hotel room with the windows open, while a rainstorm was beating down on the city. As we lay there, through the sound of the rain and thunder and the wind, it was creating a huge amount of echoes. The sounds bounced off the streets and the buildings. The sounds created images in my mind's eye. It was incredible to lie there as two blind people, and see every step we had taken, every building we'd touched, every café we had sat in, as the storm circled the city and echoed back to us a vision of its beauty.

I don't think we have enough language to describe all we experience through sensations. I believe that we have more sensory receptors than science or medicine acknowledges. I live with that belief and understanding. If each of us was open to all the sensory perceptions that we have available to us, I know that we could live hugely full lives beyond our wildest imaginations.

There is a certain beauty in seeing what I lost when I became blind. And there's a certain beauty in blindness that I would lose in being sighted again. One is not better than the other. If I woke up tomorrow and regained my sight, I would not want to be known as a sighted person right away.

I would still wander the world with my cane, as if I were blind, so that I would have the opportunity to breathe easy into being sighted again. I know it would be a similar kind of shock. I have so adjusted to perceiving the world as a blind person that I would have to go through my own rehabilitation back to seeing again with my friends and family. I would not be able to deal with the demands of the world as a sighted person immediately. I know that of myself.

KAY (SILK) LITTLEJOHN

I am truly a God-fearing woman. My faith is strong. I'm a community activist and former president of the NAACP. My family calls me Silk. I have two children, three grandsons, a loving superwoman of a mother, five amazing brothers, and a host of family and friends that love me dearly.

When I was born, my parents were coming from Connecticut to Texas. My father got mad and pushed my mother to the ground and hit her. I was born into this world from domestic abuse. My mother was seven months pregnant and started having labor pains. My father saw a house on a dirt road with a light on. He pulled up, knocked on the door, and said, "My wife is in labor. I have three little boys. Can you help us?" My dad being from New York understood that there were racists in the South. The man said, "You can't come in but we have a barn out back. You can take her back there." So my father took my mother to the barn. I was born early, two pounds, and they put me in an old pigs' incubator to keep me warm. My first bed was my grandfather's boot box. I went from a boot box, to a dresser drawer, to a bassinette, to a baby bed, and into the arms of my mother and grandmother.

I'm the only girl of seven boys. I felt like I was always going to be a fixer. I helped my mom with things around the home. I grew up with boys who were angry and frustrated, because their dad had left them. And so I was a fixer. When I met someone, I didn't know the true meaning of love with a companion. I knew love with a family member, but loving a companion is totally different. I stayed with him because I couldn't fix myself. I couldn't fix my emotions. I couldn't fix the reason why I was allowing someone to abuse me. I couldn't fix the shame and embarrassment. So I stayed. I didn't know then that being a fixer was the most selfish thing I could do. People abuse when they don't have control. People abuse because they

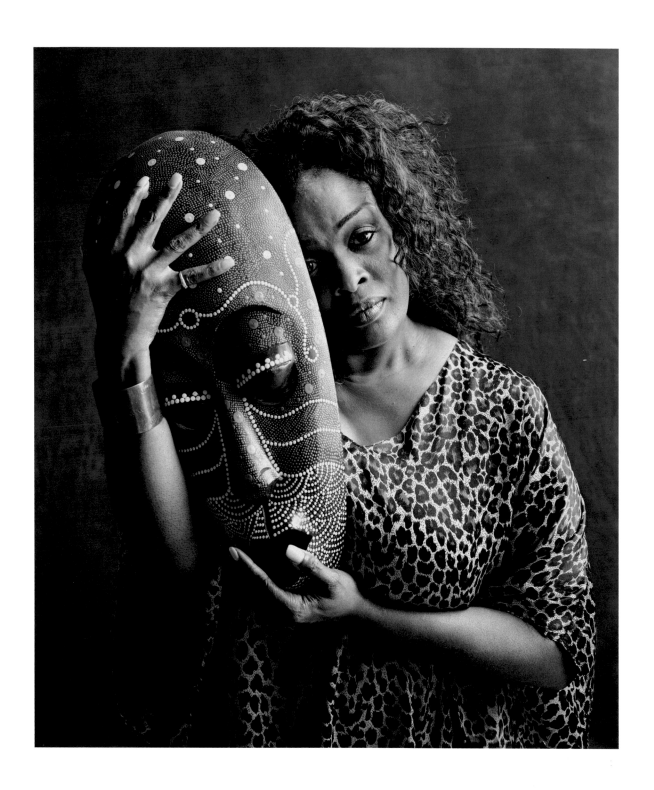

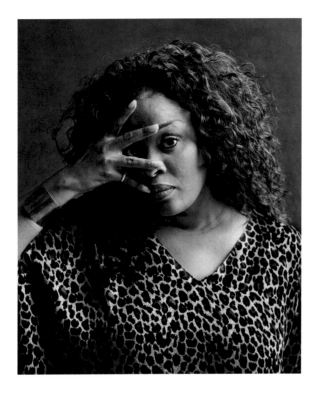

don't want to be alone. They instill fear in someone else, and that gives them power.

He struck me many times, spit on me, beat my feet with his belt, and used verbal profanity. One time in the shower he choked me, threw me to the ground naked, and kicked me. While we were driving, I said something he didn't like and he grabbed the back of my head and slammed it into the dashboard. When that person says they love you, then strikes you, your body just caves in. He said if I ever told anyone, he would kill me or kill my kids. I felt trapped. I felt enclosed. I felt I couldn't breathe. I couldn't do anything. You become a victim in your own dark circle. My vision was lost long before my eyes became dark. Domestic violence is a monster that's totally misunderstood.

The morning that it happened I had just gotten off work. I'm a cosmetologist. I did hair during the day and at night I worked for American Airlines. I had just gotten off work that morning, and he asked me to find his other boot. I looked everywhere, but I couldn't find it. I was tired. I was so tired. I was so tired. He didn't say okay or whatever, so I just got in the bed and lay down. I felt this hard, gosh, it was like an explosion—I can't even explain it. I've never been hit like that in my life. Bashed. He hit me in the back of the head with his boot. I felt cold and hot. It's almost like you're facing death. I called for my mother. I needed my mother. I knew in that moment my life was going to change.

Even when I was in the hospital, I didn't tell the doctors. I was still protecting him. Women don't lie to protect the man. They lie to protect themselves, their family, their dignity, and their pride. That's what they are lying about. He said that he would kill me, so I held onto his secret as long as I could. When you start losing your sight, it's like facing a firing squad. When you're in front of a firing squad and they say, "Tell me the truth." Okay, I told them everything. "This is what he did. Just save my sight. I just want my sight. This is where he hit me, this is how many times." You spill your soul.

I was in the hospital for almost a month. I was so depressed. The doctors said I had cortical blindness. The optic nerves were disrupted as a result of the injury to the back of my head. My eyes appear normal and are completely healthy. It's not my eyes—it's my brain. The last thing that my eyes saw was my family, the sunlight coming through the window. It was like that angel moment coming in.

Losing your sight is like being shot—not in your heart but in your soul. Because in your heart you die immediately, but in your soul you will suffer. At that moment I asked God for mercy. I cried every day. My eyelids were so sensitive that the skin was coming off. In those days, I was a blind woman. Darkness had taken over my whole body and mind. My days turned into nights. I didn't know the difference. I never thought about killing myself, but at the same time I didn't care about life. I didn't care if I ate. I didn't care if I bathed. I didn't comb my hair. I didn't care if I ever spoke to anyone again. Some people want food and water. I wanted my sight. I couldn't even hear my own heartbeat. Some people treat you ghostly, like you don't even exist. They come to your table and ask everybody what they want to eat and don't even acknowledge you. So losing your sight, that's a hard—that's a hard pill to swallow.

You don't know the depths of your soul until you walk around in darkness. As a little girl I was afraid of the dark. I realize now that I wasn't afraid of the dark but of being alone. Being blind forces you to have a deliverance of faith, because you don't know what's there. You must have faith, whether it's in yourself or God. I live in darkness, but I visualize the light. The light that you see in blindness comes from the heart.

I walk around with two people inside of me. There's the person that once had vision, and there's the person that doesn't. So it's a change. When I look back on those days, I thank God for taking me through those moments. Before, I couldn't understand another human being in their darkest moments. Now I can. How do you learn to live in darkness? Have you ever gone outside and just lay on the grass and looked up in the sky at night? If you focus on the stars everything around you fades—the streetlights, the grass, the trees—because you're just focused on outer space. If you keep going and going there are no boundaries. With blindness there are no boundaries.

When you surrender your silence—whether it's domestic abuse or blindness—it's an unbelievable lift. It's better than the warmth of the sun against your skin in the morning.

Blindness is not weakness. I'm not my blindness. Blindness doesn't mean that you can't adapt. A blind person is more of a chameleon than someone with vision. Blindness is an opportunity to live in a different realm. When it's raining, you hear all the different raindrops. When the wind blows, it's not just blowing—it's singing. You hear music in wind. You hear the trees *swisssh, swisssh*. It's almost like a band playing when you're outside and the wind is blowing. When babies cry, they're not just crying. They're talking to you. You take that for granted because you see it. You don't take time to hear it. Some things are good just the way they are.

I truly believe that everyone should have someone in their life that is blind. A blind person can give you more of a description, more of creativity, more of an unbiased decision than anyone else in the room. If you ask me, "How do I look?" I can tell you how you feel, and how you think you look, based on how you're talking. Everyone should have someone that's blind in their life. They should seek those persons out if they want the truth.

CLEO CARRANZA

My name is Cleo. I'm eighty-nine years old. I'm totally blind, and I live alone.

In 1942 I went to a recruiting office. I was seventeen. The recruiter asked, "How old are you?" I said, "I'm eighteen." So he said, "Okay, here's a piece of paper. Take it home and get your father to sign it." I grabbed the paper and ran home. My dad came home and I said, "I got this piece of paper, Dad, because I joined the Navy." He says, "You what?" He almost ate me with his eyes. He said, "I'm going to sign this paper, but I'm going to tell you something. You don't know who makes these wars." I said to myself, "Please sign it." And he signed it. I grabbed the paper and ran back to the recruiter's office.

I wasn't nervous because I've always liked the Navy. I weighed 119 pounds. I wasn't fat or skinny, I was just thin and strong. We got on a train the next day. It started snowing. It was October. When we got to boot camp, a bunch of guys outside hollered, "You'll be sorry!"

In 1985 I worked at Kelly Air Force Base. I said, "I think I'm going to have my eyes checked for glasses." I knew this optometrist. He checked the pressure in my eyes. He said, "You have glaucoma. Don't worry about it. There are all kinds of medicines, lasers, and other treatments." He recommended a specialist. I'd been seeing the specialist for about fifteen years. He did a lot of surgery on my eyes. Finally he put me on this machine and said, "I can't do anything for you. Your eyes are all scarred up. You're going to go blind." You know what? It really hurt me. I was shocked.

When I got home, I started thinking about my blindness. I said, "You know what, I'll just leave it up to the Lord." I used to turn lights on in my bathroom and bedroom. But gradually I said, "To hell with it." I just started using the darkness.

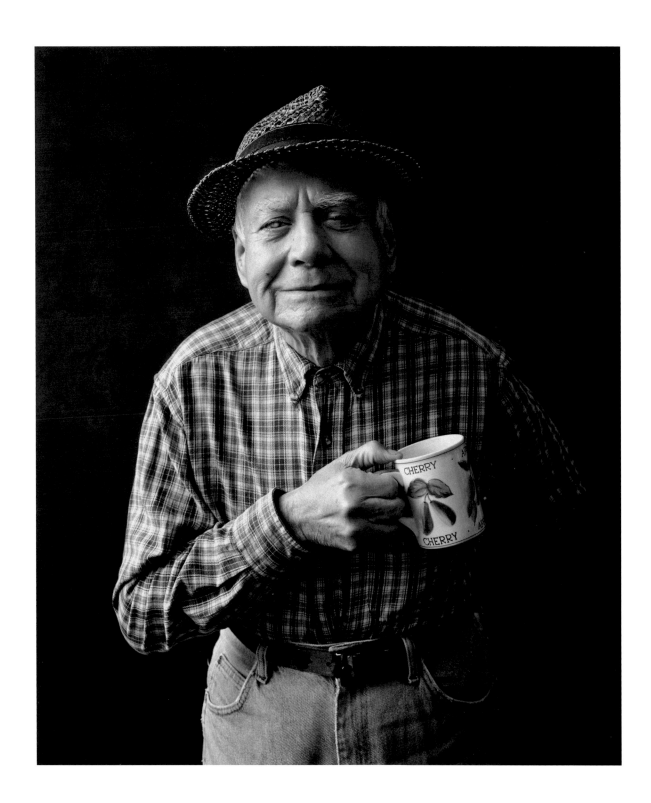

My daughter would say, "Dad, you don't have any lights on." I told her, "I don't need them." Just like that. I've been blind for more than twenty-five years. Someone could crash through my door and kill me. But I'm not scared. I'm not scared of the darkness. Blindness feels like you're in a dark world.

When I first moved into this house it was infested with roaches. I'm telling you, they were coming out of the cupboard. The roaches were everywhere. The people that lived here were probably dirty. I used to do my own cooking. I mostly use the microwave, but sometimes I use the stove to mash beans. I do my own housecleaning, and I hang my clothes outside. I vacuum my kitchen and bedroom. I mop with a little lick and a promise. I try to keep my house clean. That's my motto: keeping everything clean.

One time, a guy that had done some work for me asked if I felt lonely because I didn't have anybody to talk to. I said, "To tell you the truth, no I don't. I feel more nervous when I have people here." Sometimes I wish people would take off so I could be by myself. I didn't ask for the divorce. My wife put the divorce in. But since then, I got used to being alone. A lot of people don't like to be alone. They like to have somebody around. Time marches on. Monday, Tuesday, Wednesday, Thursday, Friday, and Saturday. Today is just another day, like a calendar.

I dream every night about many things. My dreams are visual. I see things. There isn't a night that goes by that I don't dream. When my dad passed away I would dream of him. I would visualize him. One time he was sitting at the edge of my bed. I asked him, "Dad, what are you doing

here?" He said, "There's a man outside, and he started a fire." And then he looked at me and said, "I'm going to put my shoes on and go outside." He looked thin and had pajamas on. That was the end of the dream.

I listen to the San Antonio Spurs basketball games on the radio. I can imagine the game and visualize the players. About two years ago my youngest daughter sent me tickets to see the Spurs play. I asked my grandson if he would take me. He looked at the ticket and said, "Oh my, Grandpa! This ticket cost six hundred dollars!" We sat right behind the press box. I'm glad I went with my grandson, because the stairs don't have a rail. I enjoyed the ticket very much because my daughter gave it to me with all her heart. Even though I couldn't see the game, I wanted to know what it felt like. I could hear them bouncing the ball. We had a couple of beers and bought some peanuts in the shell. I could hear the referee hollering at the players. I could hear the crowd yelling, and whooping, and hollering. I would yell, "Go, Spurs, Go!"

I'll tell you one thing: I do get lost. I even get lost inside my house. One time I got lost going to the mailbox. My good neighbor saw me and it was raining hard. She talked to me in Spanish. She said, "What are you doing out here in the street? Somebody's going to run over you." I told her, "You're my guardian angel." She took me right to the front door.

My last fall was in January. I fell right here where I stand. A cat came in, and I was grabbing him by the neck. I slipped and fell on my *pompis*. That's my tailbone. I couldn't get up. I crawled all the way to the door, grabbed that cat, and threw him out. I hate cats that come in the house. I just

lay there for twenty-four hours. I've been hurting ever since. I never forget that I'm blind. I think about it all the time. I've learned a lot by touching things. I know that the radio's there because I touched it. I can visualize it in my mind. When I go outside I can smell rain. It's not raining, but I can smell it coming.

I can't walk fast, because when I walk fast I get lost. Touching is how I find my way around the house. When my daughter takes me to the grocery store I always tell her, "Let me touch it." I touch it, and I can tell the size and shape. If I touch the microwave, I know I'm at the kitchen counter. If I go to the living room, I have to touch the walls to keep straight. I always veer to the left for some reason. I have to accept being blind. At first it was very hard to accept. As long as I can walk, I'm satisfied. I walk a little slower because of my age.

I'm not optimistic about life. I've lived all these wonderful years, even though my younger years were really hard. But I've lived a good life. Maybe I'll make it to ninety. Every time I go to sleep, I always say the name of the Father, the Son, and the Holy Ghost. In the morning when I wake up I always say, "Thank you, Lord, for letting me live another day."

I gave a speech one time at the Low Vision Club. This lady called me and said, "Cleo, I want you to make a speech, because you're a role model." I said, "I am? I didn't know that." She said I could speak on how I do my work around the house. I told them I do my own laundry. I clean my kitchen. I do my vacuuming, mopping, and a little cooking. I heard one of the ladies say, "Oh, he hangs his clothes outside." I said, "Yes, I do, because I don't have a dryer." After I finished, they all clapped.

The happiest period of my life was when I was a little boy because I had my mother. She passed away when I was about six. I can't remember her voice, but I do remember her face in my mind. I don't know what happened. She just died and my dad remarried. I can remember we used to eat together. My mother would make the beans and corn tortillas. What I liked about being a little boy was being with my family. If my mother would have lived, I think my life would have been different. Why is that? I don't know. I just know it would've been different.

RAY PAZ

As far as I can recall, nobody's ever asked me what it's like to be blind. I've never known what it is to see light or a face or anything, for that matter. Often words are inadequate to describe experiences. Some of the questions I'd like to know more about are: Do things always look the way they feel? What is a rainbow? What is color? What is light? One of the things I really have trouble grasping is what a storm looks like or how it moves. Would it be something you could feel with your hands? I think about these questions, and sometimes they show up in my dreams.

The first time I began to suspect I was different was when I bumped into things when other kids didn't. Everybody else seems to avoid the coffee table or the tree, and it made me mad. I would cry more from being frustrated than hurt.

I was four years old when I found out I was born blind. That was one of the most pivotal moments in my life. It made sense even though it hurt like hell. I remember my mother saying, "The Lord made you blind. All that means is that you can't see with your eyes the way I see with mine. But it doesn't make you less than anybody. You still can do the same things that we all can." She then put my hands physically on her eyes so I could touch her eyes. She said, "You can do things with your hands, and with your ears, and with your nose." But the more she tried to explain it, the more I felt inadequate. I finally asked her, "So what exactly is wrong? How was I born blind?" She said that I was born without retinas. I resented the word "blind" for years.

Mom began preparing me before I went to the School for the Blind. She told me I was being sent away not because I was a burden or a bother, but because I was special. I finally went to the School for the Blind at four and a half years old. I lived in a dormitory, which was one great big playroom/bedroom. I learned quickly that

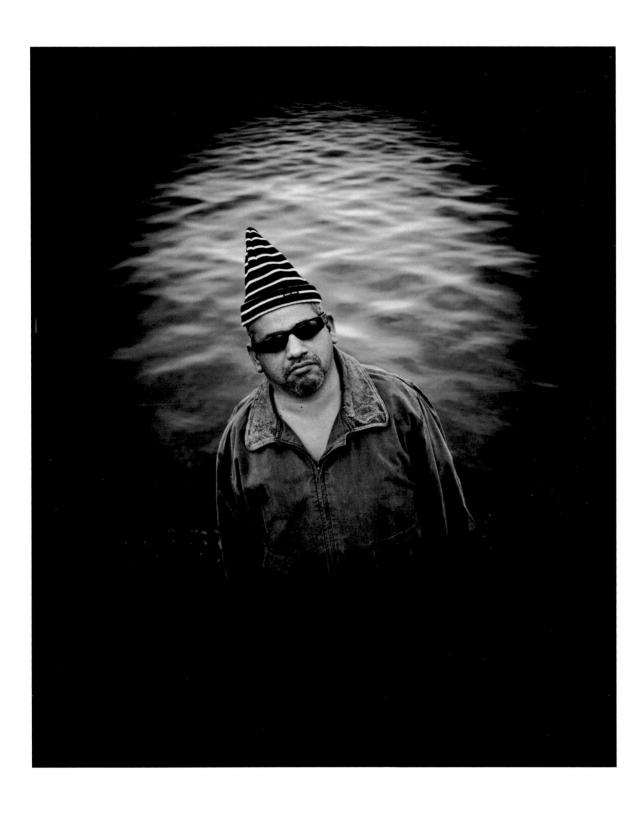

I was only one of about thirty-five children who were also blind. It was very difficult because I was so far away from home. I missed my toys and my bedroom. I missed Mom's cooking and her loving.

For a long period I was extremely angry at being blind. I took out my anger on teachers and even friends. Talking on the phone or having Mom's letters read to me was very important. The way I dealt with being homesick and lonely was to make up my own fantasy world. I must say I got pretty good at it. I had fantasies of traveling to make-believe places. In my mind I would go to the North Pole with Santa Claus and his reindeer.

Both sighted persons and blind persons have vision. Vision is more of an awareness—where one is and where one is going. A sighted person and the blind person both know what a table is, what carpet is, what a wall is. I can see with my hands. That doesn't require sight. I can imagine walking along a beach. I will hear the sound of the water. I hear the birds or other people talking, whether they're in the distance or up close. I feel the sand under my feet or the rocks I may step on. I'll smell the breeze and salty air.

I don't think I see black as a sighted person would know it. To know the color black, a person would have to know what white is. Intellectually, I know that white and black are different because they've been described to me. My experience is that there is no black or white or sense of light or dark. There are no pictures, no images, or anything in my eyes. There's just nothing.

After God, Mom is the center of my universe. Right now Mom is eighty-seven, and one thing that I am most worried about is losing her loving support. I have nightmares sometimes. Mom's

been the major reason that I know how things are, and what things look like. She would tell me, "Your eyes don't work but your brain does—use it. Don't wait for life to come to you—go get it." She understands blindness. Mom is a fireball, a ball of life. One of the main things she's given me is the will to live, the will to stand up for what's right, the will to fight for something I believe in. She's extremely positive.

I can remember when kids have called me names. Once they said, "Oh, no, here comes the man with the white eyeballs." They ran away. It made me feel like a monster. Kids don't know better. I think my eyes look white. They don't have the colored part that sighted people have. When I don't have my sunglasses on, it seems to frighten some people. Not a good feeling at all.

One thing cracks me up, and I don't know why people do this. I'm at a restaurant and the waiter will ask the person I'm with, "What does he want?" I don't know why people seem to think that blindness equates with being mentally slow or challenged. Some people speak very loud to me. I'll answer, "I'm not deaf—I'm just blind." When those things happen, they don't bother me anymore. I just laugh.

I was in Selena Quintanilla's band for about six months. At the time, Selena was twelve years old. So there was not much we could talk about because I was twenty. Selena's father, Abraham, was looking for a keyboard player. He liked what he heard, and I was in. At that time it was called Selena and the Dinos. Even though Selena was the main attraction, we all sang. After Selena was murdered, a movie with Jennifer Lopez was being put together. Abraham asked me to be in the

movie. The part I played was her keyboard player when the young Selena was singing at the state fair in Harlingen, Texas.

Sound is as important to me as a face or sunlight is to a sighted person. One of the chief ways I remember a person is by the cadence or pace of their voice, and how they put their sentences together. It usually tells me how someone feels about themselves. One of the questions I get as a blind person is, "How do you get around? Why do you snap your fingers?" I like to say that I snap my fingers so I can jam to a good song or follow the beat. But that's not the only reason. That sound lets me know when I'm approaching an object. I can hear an echo. *Ta-ta, Ta-ta, Ta-ta* [*snapping fingers*]. That sound lets me know when I'm approaching an object. It's called echolocation. A car has a different sound echo as opposed to a wall, or a fence, or a post. When I snap my fingers in a room, I get not only the size but also the height of the ceiling. I learned echolocation on my own. Making those noises is how I learned to get around.

As far back as I can remember, my dad would purposefully put me in situations that he knew scared me. He would stand me close to noises that were really loud—for instance, an electric saw or different types of machinery. He would put my hands on a train track while a train was coming. He would always yell when I would act scared, or he would tell me, "You're crying like a girl. I'm going to have to break you of that." Sometimes he would invite his friends over. He would either hit me or put things in front of me so I would fall. His friends burned me with a cigarette. Not enough to leave marks, but it was enough to scare me. And they would all laugh.

"Beauty" is a very interesting word. To me beauty is warmth that one can feel in a person. Beauty can be a sweet smell like fresh-cut grass. I think the sound of children playing on a playground is beautiful. A majority of sighted people take things for granted. They tend to focus on outer appearances rather than the inner beauty or overall scope of how things are.

WANDA AUSTIN

I do remember one night looking up into the night sky and realizing that I could no longer see the stars. My vision loss was so gradual. It is like a puzzle in my mind. "How long do I have to see? When is it all going to go?"

I knew I was in big trouble when I walked into my kitchen and turned on the light but couldn't tell whether the light was on. I thought to myself, "Oh, this is not good. Girl, you are in trouble." I knew I'd crossed a line. When I was in the process of losing my sight, I had a consistent dream of being chased by this unknown thing. It was terrifying. It was something menacing me. It was very scary. I didn't know what it was. When I became blind, that dream stopped coming.

When I sold my circuit TV magnifier, the man who picked it up said, "I really hate to take this." He knew what it meant to me. When he left, I went to another part of the house and cried. It was a deep, sorrowful cry. It was like this lightbulb went off in my head. I thought, "Wow. No wonder I feel like crying. This is the way I felt when my father died, that same empty, painful feeling inside." That was the moment I recognized that I was grieving over the loss of my sight. It's like a transition as you move from one phase of life to another. It was an enlightening moment.

My name is Wanda Austin. I live in Tarpon Springs, Florida. I am a forever learner. I just can't get enough [*laughing*]. I can't wait to read the next book, and my books are all on audio. I just delved into them like I was diving into a wonderful swimming pool and swam in the learning process.

Going to guide dog school to get my guide dog was one of the most terrifying experiences in my life. I was so scared. I didn't know what to expect. They took my cane away and gave me this dog. It was like, *yikes!* We were allowed visitors on Sunday afternoon for two hours. My first visitor said, "What in the world has

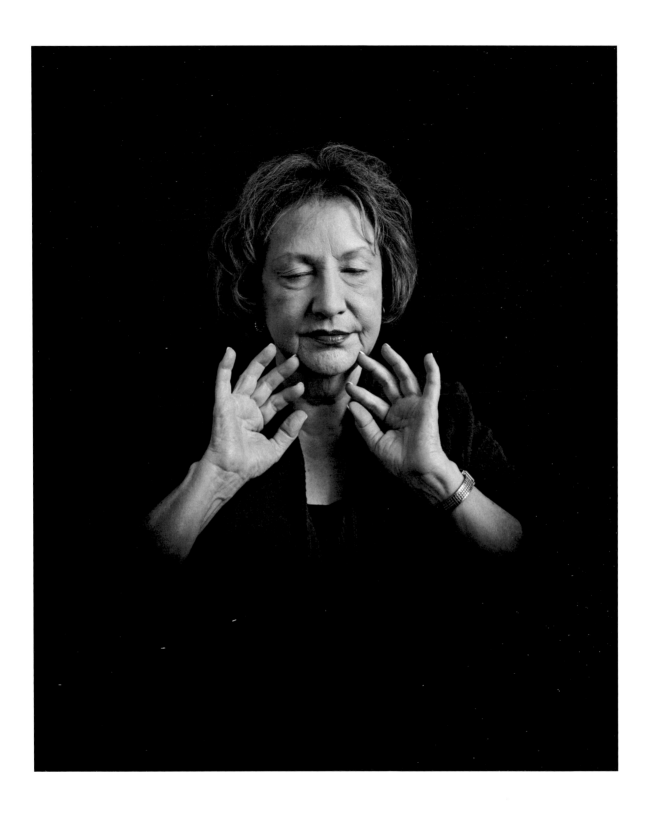

happened to you?" I was covered with scratches and bruises [*laughing*], and I looked like I'd been through a war. It was hard work, but it's a developing relationship. They told us at the guide dog school that it takes six months to a year to become a good working team. I found that to be true.

I think Caroline knows me, and I know her. She anticipates my needs, especially when we're working. At home she's a wonderful watchdog. I feel so much safer. I had an experience two weeks ago. I was walking to get into a cab, and suddenly Caroline did a body block in front of me. I thought, "Hmm, what is she blocking me from?" I called to the driver, "Is there something out there she's not wanting me to encounter?" And he said, "Yes, there's a car parked with the bumper hanging over the edge of the sidewalk, and there's nowhere for you to step." Well, I would have fallen on the car.

She's a wonderful companion, a loyal friend. She follows me from room to room. Whether or not she's in the harness, she's close by, and she loves me. I know that. And it's my privilege to care for her. We work in tandem.

I really didn't think about being a licensed mental health counselor until after I lost my sight. I identified a need through my own adjustment—and that was the need to help others in this adjustment process. I only had a high school education. I acquired my bachelor's degree first. I was totally blind at that time. I went on to acquire my master's degree in mental health counseling. I did a three-year internship and passed the state boards. I got through the process because I worked very hard. It came from hours of study just like any other student. A student needs determination to finish.

I love the word "flourish." It represents blooming and blossoming in some respects. I love to see my clients bloom and blossom. That brings me such joy. As a licensed counselor, some of my clients have been shot in the face or beaten and left for dead. The physical trauma that caused blindness is very difficult to deal with because it happened suddenly and unexpectedly. I see a lot of macular degeneration, diabetic retinopathy, and glaucoma. There have been some clients who went into surgery seeing just fine and woke up blind. Something went horribly wrong. There are many, many different causes of blindness.

I really like the cognitive therapy approach in my counseling practice. It focuses on our thought processes and how we can change them to view our situation differently. One discovery I made was Erik Erikson's developmental theory. This theory describes the stages of development people go through from childhood to old age. It really resonated with me. I went through these development stages, adjusting to blindness—not as a child but as an adult. Relearning trust. Learning to find your identity. When you lose your sight, you have to figure out who you are again—because life is different and what you do is different.

I see a lot of depression and anxiety. Anxiety often comes when people are just so overwhelmed and don't know what to do. Anger has many levels. I talked to someone yesterday who was consumed with anger about what had happened. It was like a life lost. If a person is hurting from losing their sight, they might be hurt about relationships pulling away from them; they might be hurt about the loss of their income, hurt about their inability to

perform tasks that were so easy before. These are often underlying a person's anger.

People need hope to move forward. I view hope as the fuel of life. If you run out of gas in your car—you don't go anywhere. And when you run out of hope in life—you get stuck. It's the energy of life. It keeps us going. I look for leverage. Every single word can mean something. Sometimes it's just one word that pops out during their statements. "Bingo—there's my leverage" [laughing]. That's why it is just so important to really, really listen.

Sometimes while I'm talking with a client, they might reveal they're having suicidal ideations. They just want the pain to go away. I perform a risk assessment and develop a safety plan. I find that I can talk and listen, as well as be understanding and empathetic, but sometimes that's not enough. I like to give people tools when I work with them. So I reach into my imaginary tool chest [laughing] of techniques that can give a person the leverage they need in their life to make a difference. It might be a way to learn to unwind and relax. Sometimes it's just a tool to help them understand themselves a little better or to change their mood. Giving people tools often makes a difference in having hope. If you can get a person to change just one or two aspects in their behavioral patterns, it can change the way they think.

When I went blind, I still could see in my mind's eye. I am a very visual person. Just because I lost my sight does not mean I don't have vision. I don't see shadows. I don't see images. I see something like a chalky black in my mind. It's just nothingness there—until I walk into a wall [laughing].

That's when I stop. If I'm pouring a cup of coffee, I visualize touching the pot to the cup and pouring it. It helps me not to spill things. When I do my makeup and hair, I visualize every tiny aspect. I go to the closet and visualize all my clothes. I know what the world looks like. I know what red looks like. I see so many images in my mind that I sometimes forget I can't see.

When you pay attention to what you hear as opposed to what you see, you hear more than others do. It's not that your hearing gets better. I hear things differently than someone who is distracted by what they're seeing. Whether it's happiness in someone's voice, or sadness, or identifying sounds in the home that no one else heard. You just become more aware of your surroundings.

Prejudice is a horrible thing. People don't always know I'm blind. I was in a store, and this clerk asked me to sign some piece of paper for a charge. She said, "Sign here." And I said, "I'm blind, can you please give me some assistance?" She had been talking to me in an absolutely normal tone of voice. But as soon as I said that word "blind" she said, "Oh, I'm so sorry. Bless your heart."

I could be in a doctor's office, and the doctor will talk to the person with me—and about me—because I'm blind. They don't think I can hear or think or talk for myself. In those situations I do speak up. I say, "Excuse me. You can speak directly to me." I'm firm, not rough—so they know that I mean what I say.

The public needs to be educated about blindness. Blindness does not mean that you cannot be happy. It does not mean that you cannot make a difference in this world or a difference in people's

lives. Blindness is loss of sight. If a person loses a thumb, it is not a weakness of character. Unfortunately, the public thinks that blind people are clueless, incapable, helpless, and incompetent. Many times people talk to you like you're in the second grade. They think if they yell, you can somehow understand them better. Sometimes I say, "You don't have to yell. I can hear you very clearly when you talk in a normal tone of voice." And they'll say, "Oh, okay." But then pretty soon they're talking loud again [*laughing*]. It is a direct reflection of the public's misunderstanding of what blind people are capable of doing or about even the essence of a person.

One of the characteristics of my style of counseling is that I am nonjudgmental. I believe you need to accept the client for who they are and go from there with them. When I hear people express hopelessness, it makes me feel heavy. I'm very careful. I think it's dangerous to push a client. I walk with the client, giving them skills and suggestions if I feel they're ready. But if they choose not to follow through, there's a reason. I've seen people when the timing just wasn't right—but six months later it is. If a client is overwhelmed, I might suggest not to let their emotions drive them, and to find a balance with logic and reality. Logic says, "Well, I did it this way before, what's another way to do it?" That is where logic and creativity join.

To move forward, one must accept. I don't like to use words like "must" and "should"—but it's imperative to come to a point of acceptance. You can't just say to someone, "Well, you'll feel better when you accept this" [*laughing*]. I wish it were that easy. But it comes day by day. Acceptance is crucial, and there is this tug-of-war inside. When a person starts to accept the reality of "Wow, this has happened to me; I don't particularly like it, but it happened," the acceptance gives them the empowerment and the energy to move on with their life.

I think blindness was a good thing that happened to me [*laughing*]. That sounds really strange. Would I like to see again? Absolutely. But blindness gave me the opportunity to develop gifts. Blindness actually made a positive difference in my life. I'm so much more empathetic now. I understand people's hurt and pain because I've been there. I like being able to go to a concert and actually hear the music rather than see it. There are certain things that you hear when you don't see. I never see myself grow old. I look in the mirror and I see what I remember seeing [*laughing*]. Losing sight sometimes expands a person's awareness. It gave me the impetus to reinvent myself, because I didn't walk away from who I was. Blindness added depth to my life and the ability to listen and to help. So if anything, my thinking process has improved.

I don't think you ever graduate from blindness. It's always with you. Transportation is one of those challenges. Falling over a dog bone that I didn't see and hurting myself is a challenge. I'm mindful of every step I take, whether it's here or at home. I don't think anybody who sees well can imagine how much energy it takes to live without sight. It requires a continual awareness of what you're doing, continual awareness of your surroundings, continual awareness of every step you take to keep you safe. Everybody has challenges.

When you have an avalanche of dishes that break all over the place in the kitchen at 11:30 at night—and you're the only one who can clean them up—that's the reality of not seeing.

Well, at least I can feel for the pieces of broken glass. It's very important to understand that blindness doesn't have to define you. It involves the way you function. Everyone's perspective stems from the way they experience the world. So I think it is just a perspective. It's our perspective that's so important—how we view the situation and live our lives.

JUANITO CASTILLO

My birth certificate says John Eric Castillo. But onstage everyone knows me as Juanito Castillo. My life, cares, wants, needs, and craves are nothing but music. It's all I've done since I was three. It's all I'll do until the day I die.

When I was born they put me in an incubator and gave me oxygen. The oxygen was a little too much for my small, one-pound, ten-ounce self. They ended up damaging my retinas and optical nerves. That left me with light perception. I can't see shadows or colors or faces. I can only see when there's something bright that's on or something bright that's off. I adapted to being blind just naturally. I knew something was missing. I also knew I could work around it. I've lived twenty-two years like this, and hope to live a few more.

When I was six I was a mischievous little lad. I was known in school as being restless. I guess doctors nowadays would say that I had a case of ADD [attention deficit disorder]. I never really got in trouble, other than being loud and banging my toy drum set while everyone was taking naps. By the time I was fourteen I knew exactly what I wanted to do. I wanted to do nothing but write, create, and record music. Teachers mocked me for the next four years, but some wished me well. And a couple of them said, "You'll never make it."

On my eighteenth birthday my dad withdrew me from school. That was the best birthday present I could've ever asked for. That was what I wanted—total freedom. You can't be taught soul through books. You can only be taught soul through street smarts, going through some pain, and suffering. You can't play the blues without feeling the blues, and that's something scholastic teaching will never give a musician. I wanted the real feel, the real rice and beans.

Echolocation is a blind person's sonar. I do certain click sounds with my mouth. I can hear the echo bounce back. The closer you get to an object, the shorter the

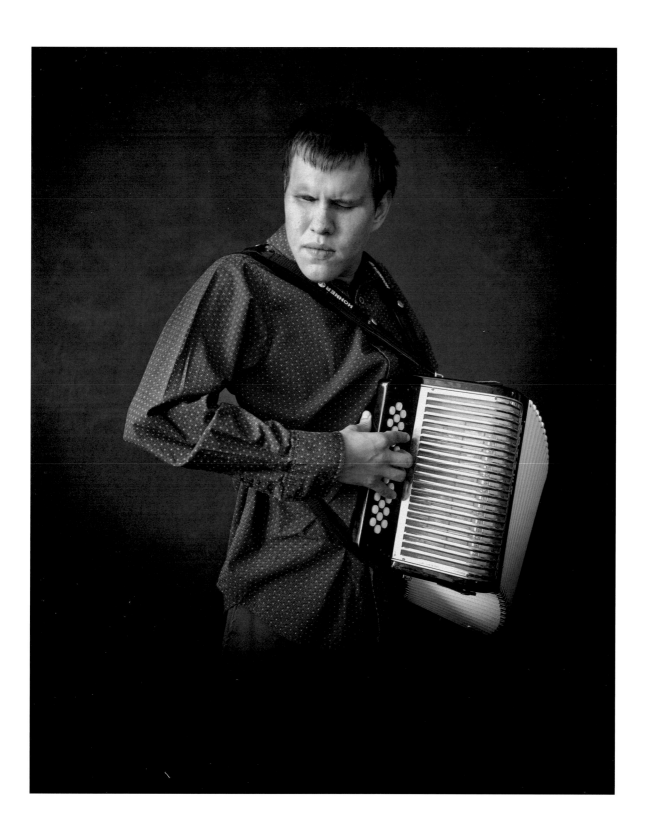

bounce is going to be. So I use it on a day-to-day basis walking outside. I learned it by wanting to ride my bike and not wanting to crash into any more cars. I can locate the distance between myself and a wall, mailbox, or car. I can scout a whole room and determine the size of the space and more or less where I have to go. I can even hear when a person is moving. It's almost like not seeing a shadow but hearing a shadow. My teacher was the oldest teacher since the "dino" era: common sense.

When it comes to beauty I can definitely determine what's beautiful on the outside, thus inside. I'm not going to speak for all blind people when it comes to beauty, because everyone has their own perception. To me, the visual meaning of beauty is more superficial—and it doesn't necessarily give you the whole book.

I believe a lot of people fear taking chances, but it's not through their own fault. Maybe they were told they were a nobody. Maybe they saw things that they shouldn't have seen. That might just make you shy. Yes, I do have my "nice to meet you" shyness. I'm a big shy boy without an instrument in my hand. However, I'm never shy when I'm playing music. Music is with me 24/7, 365 days a year. It's always there. Even in my dreams music is there. Some of my songs come out of dreams. All I can tell you is the truth is in the notes. The notes never lie.

I had this girlfriend, and at one point she was tremendously mad at me. She lightly smacked me on the face with love and a slight amount of anger and said, "Babe, you only hear what you want to hear and only remember what you want to remember." I thought about it for a minute and said, "Ain't that the truth, ain't that the truth."

I honestly believe visual people get so entrapped in their vision. If their eyes didn't see it, it didn't happen. A person entrapped in their vision can only see what they want to see. And that's actually a big human mistake. Sometimes blind people only hear what we want to hear. We all have to pay attention to the rest of our senses. I've always said, "You got to look between the lines and you got to look behind the masks to see what's really there."

I like to think I have a pretty good intuition about people. Blindness is a disability if you let it be a disability. We can still work. We can still hold a job. We can still do a little bit of manual labor. We'll need a little help with the visual part. Everyone is disabled in one way or another. I truthfully believe, deep down in my heart, that the public thinks us blind folk are deaf, mentally retarded, or paraplegics. They underestimate our brainpower. We can still think, hear, smell, and sense you. There are many misconceptions about the blind community. They think we don't know where we're going. I walked into a store one time with my bass player, and we were going to get an eighteen-pack of beer. The store clerk says, "I'm sorry, gentlemen, y'all can't get no more beer because he's too drunk." He thought I was drunk simply because I was holding onto his shoulder. And I said, "Well, I'm freaking blind, I'm blind. What do you expect?" Another thing, the public thinks that we can't live on our own, much less have a family. The only difference is our eyes do not work. That's it, and our sense of touch is way more sensitive.

If some great doctor said, "I have the power to give you sight. Do you want it, yes or no?" I would say no, unless they gave me an on-and-off switch. While I think it would be good to see, it could backfire. Color might just be too much for me to handle. Also, I'm afraid that I might become such a jerk and it might go to my head. I am definitely ecstatic being the way I am. I think I've got a pretty good sense of the world. I would want my vision only if it came with the power to turn it on and off. I would like a little free trial. If I like it, I'll take it. If I don't, take it away.

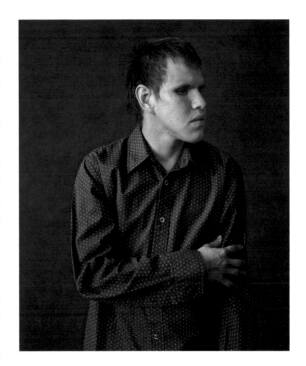

I can't see in my dreams. I dream with light perception. There's one dream I had in particular. I was lounging around. I got a craving for some creamy chocolate cake. I dreamt I was standing in the kitchen and right in front of me was a chocolate pastry. *Mmmmmm.* It was fresh out of the oven. I took one good bite of this pastry and, oh my God, it was exactly the way I thought about it. Just as I was going to take a second bite, the phone rings, and my dream abruptly ended. I remember I woke up in such a grouchy mood, because I wanted to get to the lemon in the middle.

My best friend used to be able to see before she went blind. She would cry to me at times. She told me, "I want to see again. I want to see colors. I want to see what I'm missing." I never ever, ever, ever have time to feel sorry for myself. There is too much to do and too little time to do it. I know the sun rises in the east and sets in the west. I can tell you exactly where that is. Music was what took up all of my time. I could pretty much do anything I wanted, except walk in strange places. I don't think anyone should throw themselves a pity party, because at the end you might get a couple of people to join your party—but you'll still be the first one coming and the last one going.

What I'm trying to say is that not everything is always going to be perfect. We're all "flawful." We all have room for improvement. There is an urgency to live while you can. I believe that no matter what you do, moderation is the key to maintaining yourself and maintaining your sanity. I can deal with some imperfections. Not every drum set is going to be in tune, and not everyone is going to have duct tape. So you got to work with what you have. It's the only way that you'll fulfill your purpose in life, without being spoon-fed the baby food.

OLIVIA CHAVEZ

I was mugged once when walking home in broad daylight. I realized just by the sounds that I was in an alley. I had this chill down my spine and thought to myself, "Something is about to happen." I thought, "Just keep walking," and I started to speed up. All of a sudden, he grabbed me and then let go. He didn't force himself on me or anything. He stole the wallet from my purse. When I reached the street I was disoriented. Yet I'm not afraid to walk alone. It scared me for a while, but it didn't stop me.

My name is Olivia, and I'm sixty-four years old. I was born and raised in El Paso. I earned a master's degree in counseling at the University of Texas. I'm a project manager of services for the visually impaired and deaf-blind children. I have a passion for working with children and for advocacy. Advocacy is important because it gives me accessibility and equal footing with others.

I don't remember going blind, but the cause was malignant tumors that formed behind the retinas. It's called retinoblastoma. My mother told me that shortly after my birth she noticed my eyes did not appear normal. I had headaches. She told me that I would hit my head on the floor or on the walls because of the pain. My eye surgery occurred on my birthday. I was two years old when both eyes were extracted due to cancer.

My mom tells me that shortly after I came home from the hospital, my eyes were both bandaged. She never hid me. Mom would take me to the store and people would ask, "What's wrong with your daughter? Why are her eyes bandaged? What happened?" She would explain that I had cancer and had to have some surgery. They said, "You must have done something wrong, and God punished you." Or they would say, "Well, if she had cancer, why didn't you just let her die? How is

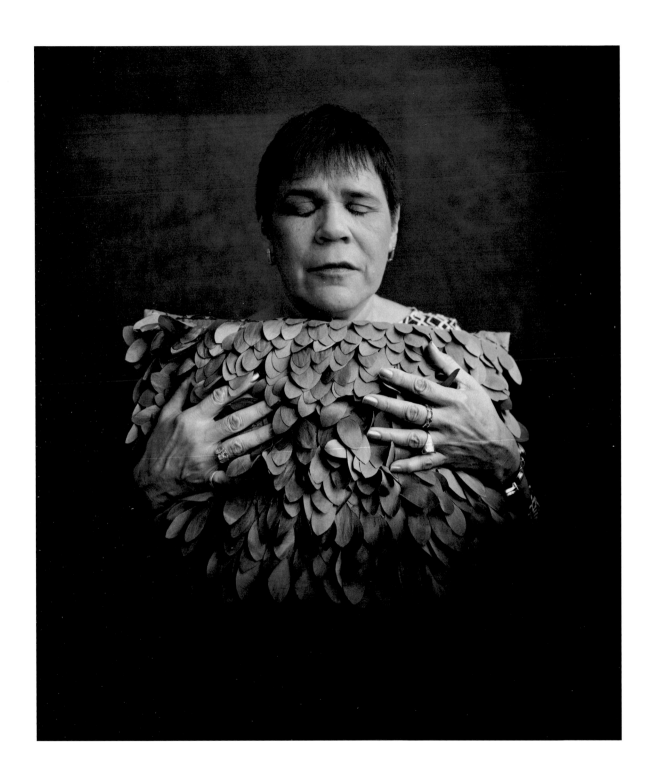

she going to live that way?" My mother would use some expletives (not to be repeated) and tell them to leave me alone and to go away.

We had a very humble home. We didn't have water. We had a community toilet and faucet. We filled up pails of water for drinking, cooking, and bathing. We had these big tin metal tubs, and we would heat up the water to bathe. My father worked for the railroad and made decent money. However, he spent most of it on drinking. We had enough food then, but later it became harder. We would stand in line at the church for a burrito and a few beans. I think mom sacrificed a lot for us. I remember her fainting a lot. Thinking about it now, I believe she was not eating so we would have enough. My father was in and out of our lives, and they divorced when I was about ten.

For the first five years or so, I didn't really understand blindness. I'd ride my tricycle all around the block, and I never had to touch the wall. I'd ride right down the middle of the sidewalk, and I could tell where I was by the air current. When I didn't hear an echo coming off the wall I knew it was time to turn. Later I found out that the people in the factory would all look out the windows. They would say, "There goes the little blind girl."

When I was five I was sent to the Texas School for the Blind. It was very hard because the culture was so different. I was brought up eating beans and potatoes—and tortillas were the fillers. They introduced me to very different foods, and my stomach just didn't adjust. Even to this day I will not eat Salisbury steak. I spent a lot of time in the infirmary. I didn't speak much English. I was always crying. I was a Spanish-speaking child and was punished for speaking Spanish. At that time

I knew only a few basic words in English: "please," "thank you," "bathroom," "water," and "food." That's all the English I knew.

The only visual memory I have is my mother's face, nothing else. I guess it's because during the first years I was so bonded to my mom. Her face was oval and smooth. I remember her nose was thin, and she had long hair and wore a braid. It's difficult to distinguish something visual versus how something feels by touch, although intellectually, I know what it's supposed to be. Vision just doesn't make sense.

I use my other senses to access my environment, to communicate, and to learn. The public needs to know that aside from not seeing, we're just like everyone else. We have the same aspirations and ambitions. We have faults. I knew a man in Fort Worth who murdered someone, and he's totally blind. Some people think that we're little angels, but we're not. We're angry types, we're optimistic types, we're depressive. I have the same feelings that you do.

I like where I live because of the many interesting sounds, and some bring back memories. The trains remind me of my father who worked for the railroad. He used to take us to the railyard, and I climbed onto the cars and explored. I like the traffic because it sounds like ocean waves. If you really listen, it sounds like the whoosh of waves coming in and out.

I've never felt ashamed or embarrassed to be blind. I had a very rare cancer, so I've never felt guilty. There are challenges. I have felt isolated sometimes because of my blindness. I've thought that if I could see, maybe people might be more accepting or open. Many times conversations are

centered on how I read or how I get around, but they're not interested in my life. It's more like a curiosity.

Blindness doesn't mean hopelessness. Blindness doesn't mean I'm broken. The public is afraid of blindness. In fact, research shows that people would rather have cancer than go blind. Many think I might be offended if they use words like "see," "look," or "vision." I'm not offended, because I do see in my own way. If you say "lake," right away I start thinking of the sounds. I can think of the cool water, the smells. If there is grass around, I can feel myself walking on it, encountering different vegetation. I might hear the wind blowing through the trees. I love that sound.

 If I'm walking down the sidewalk, I use echolocation. If there's something in front of me, I sense it. It's like radar, but it's not always on. If I'm not focusing or looking with my ears, I can crash into something. So I always use my cane.

One day as I boarded a city bus this lady started talking to her friend and said, "Oh, poor thing, she's blind. How sad it is to be blind." I was in one of my moods, and unfortunately I confronted her. I said, "Ma'am, there isn't anything poor about me. I'm educated, I have a profession. What is it that you do? I bet I make three times your salary." The lady didn't respond. I noticed that everyone on the bus stopped talking. It went totally silent, and I was uncomfortable. But I was furious. Later I felt badly. I had overreacted and felt ashamed. I'm not perfect, but my buttons had been pushed too many times that week.

I feel that I don't live in the dark, because my other senses give me information and happiness. I am fortunate to have a good brain. I always enjoyed learning and still do. I'm a lifelong learner, and more people are probably in the dark when they stop learning. Darkness isn't necessarily negative, because it's a time when you can reflect. It is a time when you can be quiet and slow down a bit, maybe think of being more humble.

A few years ago I took a trip to the Grand Canyon. I remember so much about it in terms of the weather. We had sun for a bit and we had extreme cold, but it was such a peaceful feeling. Standing at the rim I could feel the vastness, the enormity of the canyon. Even with the breeze, it was quiet. Something came over me. I felt a chill. I was shaky but not scared. It struck me as a spiritual feeling. I don't know if it's the same feeling that someone who sees feels, but that's how I felt. I felt small.

MICHAEL McCULLOCH

My mother's name is Machi Watanabi. She is Japanese, born and raised in Tokyo. She moved to the United States after marrying my father, who was in the military. My mother was not a complainer. Not only did she go blind, she had cancer early on in life. She adapted into American culture, learning everything from cooking to the language, and becoming an American citizen. She was very courageous in the face of many adversities, including discrimination. When the Vietnam War was starting there was a lot of animosity toward anybody Asian-looking. I received a sense of independence and a strong will to survive from my mother.

I remember seeing the movie *Moby Dick* as a child. I guess it really impacted me. Whenever a storm would come in, the wind would start blowing, and it would get dark, I imagined that I was in the *Moby Dick* movie out in the ocean. I would feel the rain and the wind on my face. I would imagine the waves were splashing up over the bow of the boat and pelting me. I would do that as long as I could, until my mother called me in from the storm.

When I was sixteen my mother went blind from glaucoma. Basically she went from one day being fully sighted to the next day being pretty much totally blind. Our home life changed drastically. I was the oldest of three children, so I had to help with many of the things that my mom was doing. I helped make sure everybody got ready for school each day and those kinds of responsibilities.

There are two basic types of glaucoma. There's one that hits you overnight and you lose your vision quickly. That is what my mother had. It's called acute glaucoma or narrow-angle glaucoma. I have a form called open-angle glaucoma that is a more gradual loss. I was twenty-eight years old when the glaucoma was first diagnosed. I really didn't notice any symptoms. As peripheral vision starts to close

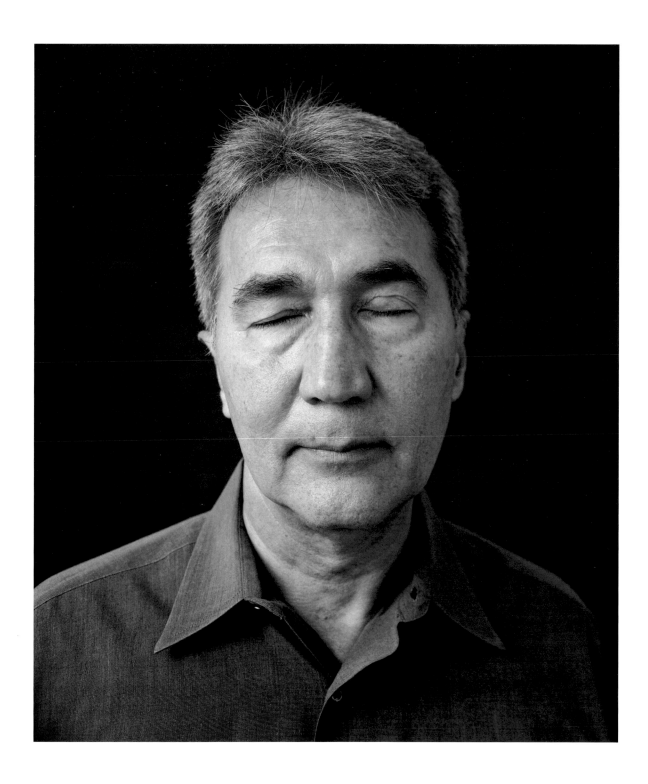

in, most people compensate by moving their eyes around and looking in different directions. It's very hard to detect. It damages the optic nerve. If unchecked, it starts reducing your peripheral vision down to a pinpoint and eventually to nothing. I'm classified as legally blind. My left eye is totally blind, except I have just a little speck of light perception. In my right eye I can see light. If there's enough contrast, I can make out some shapes. If the shape is moving, then I assume that it's a person. If it's not moving then I don't know what it is.

After I lost the vision in my second eye, initially I was very depressed. I went through a period of six or seven months of not doing anything. I didn't work, didn't go out of the house, and didn't socialize at all. During that depression, I did have a few suicidal ideations. I thought, "What is the point of going on, if I can't do the things that I was accustomed to doing?" I never really planned anything. I did experience a stage of anger. I asked why it happened to me. I was angry at God and with my mother for passing the gene on to me. I guess that's all just part of a normal grieving process.

The one thing that kept me even partially motivated was my strong faith and prayer. At some point I heard a voice as clear as we're speaking now. I felt God was saying, "Okay, this is long enough. You've been here sitting in the dark by yourself. I need you to go out and serve me and others."

Another thing that helped was a group of special friends. We would meet every week. They would either come over to my house or take me to where the meeting was held. We would discuss what was going on in our lives and pray for each other. They would not let me be on my own. Through the support system and my own faith, I eventually came to a point of acceptance.

Blindness is not living in darkness, because I do have some light perception. I'm able to see some shadows. I still rely on my visual memory. Last week we had a full moon, and I went out a few nights and could see a little speck of light. To be able to see that speck of light was enough to bring back a good memory of having seen the full moon.

I don't consider myself disabled, it's more of a nuisance. Blindness is not the end of your life. It does not define who I am. I can be in a room with a group, and no one would know the difference. I've adapted. I can sit in a restaurant, put away my folding cane, and order without using the menu. Blindness has made me think a lot more about the world, and it has changed my perspective of reality. I think it has caused me to be more patient. The way I view others has changed since I lost my vision. As a sighted person, the initial assessment of a person was mostly based on physical appearance. Now I first listen to a voice. I can determine whether a person is shy, outgoing, or whether they're hiding something.

Sounds can be very beautiful. Laughter is a beautiful sound, especially the different tones. Many sounds in nature are beautiful. I like to go for walks in the park to hear the insects, different birds, and animals. I depend heavily on listening. When I'm waiting for transportation, I'll sit and just listen to types of conversations, dialects, and the different pitch and tone of voices. I never would've done that as a sighted person. For the most part, I can pretty much do everything that I did as a sighted person. There are limitations, of

course. I cannot drive. I've had to adapt. A lot of movies are now audio described, so I enjoy those just as much as I did as a sighted person, if not more.

I really got interested in technology as a small kid. I would take my gadgets apart and try to put the parts back together. I would want to see how it worked. In high school and throughout college, I would build my own computers. After I lost my vision, I got involved with Apple products, the iPhones and iPads mainly. Early on, I found out that the iPhone had accessibility features built into the operating system that allowed the blind to use it just as anyone with sight would. I realized it was really a big boon for the visually impaired community.

I conducted a workshop at the University of Houston. People that came to the group were really interested. So we formed a users' group called the IOS Blind Users' Group, or iBUG for short. We've been meeting on a regular basis every month. I set up a weekly telephone conference, and people would call in with issues and problems they were having with their Apple devices. Now people call in from all around the country, and we examine different apps that can assist and educate people with disabilities.

Sight into Sound Radio picked up our conference call recordings and created a weekly radio program that goes out worldwide on internet radio. It's called the iBUG Buzz Radio. I spend a lot of time thinking about non-work-related projects. I work forty hours a week, so I spend the rest of my time on different blind-related projects.

As far as a philosophy, I tend to hold to the golden rule. I treat others as I want to be treated. I

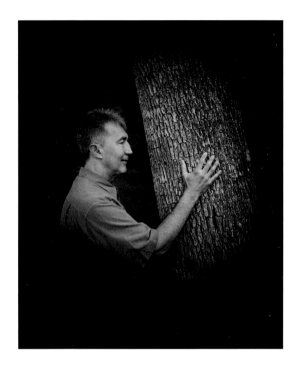

believe that everyone has value and has the right to live to their fullest potential. At some point in life, everybody is going to have some kind of disability. I guess in one word, blindness has given me compassion. I continue to strive to be more compassionate, to empathize with others regardless of their situation. After I lost my vision, unbeknownst to me, it has provided so many new opportunities.

My name is Michael McCulloch. I'm a neuro-space engineer working at the Johnson Space Center for the Boeing Company, the Space Exploration Division. In my particular job, I lead a group that develops procedures for the astronauts and the ground controllers. We tell them how to assemble and install any of the equipment that goes up on the space station that the Boeing Company develops and builds.

CALVIN WHITEHEAD

My nickname is Skin. They call me Skin. When I was born I was real skinny, so they just called me Skin for short. I have worked all my life. I've had different jobs, hands-on jobs. I'm good with my hands.

When I was boxing I was like fourteen or fifteen years old. I fought for the Golden Gloves. Well, you have to be quick with your hands and fast on your feet. I done got knocked down. I've done knocked some people down. It's an up-and-down game in boxing. I set them up with my jab and step to the side and hit them with an uppercut or overhand-right combination. Yeah, you got to roll with the punches.

When I first met my wife, I was over at my aunt's house. My wife was moving in that day. I was helping her move some boxes and stuff. She couldn't pay me, so I asked her to cook me a meal. It was delicious. Chicken, some green beans, and potatoes. The way to get to a man's heart is through his stomach. She was nice. We dated and dated. She loved me for me. We were real compatible. Only thing was that she was tall and I was short. She is a tall glass of water. She's 6′3″—I'm 5′8½″. She said she will always look up to me. No matter how tall she is, she will always look up to me. You may not believe it. My last name is Whitehead. Her last name is White, her maiden name. So all we had to do was put the "-head" on it.

I never thought that I would wake up one day and wind up blind. Never in my life. Well, I could tell my sight was getting bad, because I started misjudging things. You know how you see things but you don't see it? My eyesight gradually started getting worser and worser. I couldn't see at night. Just darkness. I had retinitis pigmentosa. The doctors said in my adulthood, I was going to lose my eyesight. And I just said, "How? It can't be." I thought the whole world was coming down, crashing down on me.

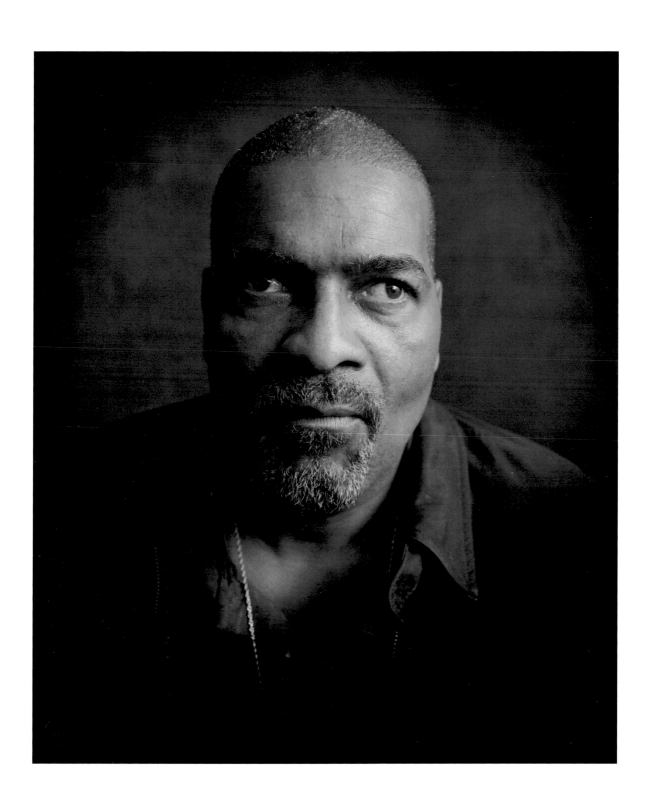

First, you got to get past the *fearedness* of being blind. A lot of people think it's the end of the world, because they lost their sight. Life goes on. I'm not afraid of being blind. I done got over the pain, the loneliness, and the emptiness. I don't want anybody to have pity on me. Just treat me like a normal, everyday person. It's not a bad life. Yes, it's a good life. You just have to get out there and get past the *fearedness*, and just challenge it. No, I'm not afraid of challenges. I always tell people, "I'm not blind. I just can't see."

Blindness is an adventure into another world. I had to learn again and become independent. It's not worse, just different. I'm lost for words on how to explain it. My hearing has gotten better since I lost my sight. I can hear a lot of different stuff because I pay more attention. There's a big difference. I take my cane everywhere I go. When I tap my cane, I get an echo that's going to let me know if I'm in an open or closed area. I got a pretty good sense of direction. I know where I'm going. I guess it's just instinct.

I've never been hit by a car and never had a bone broken in my body. I'm pretty good on my feet. That's one thing about being blind, your senses can pick up on things. When I meet a person, I can pick up their vibes. I can tell whether a person has got a good spirit or a bad spirit. I try to stay away from the bad spirits, because they mean you no good. It's just something I learnt, since I've been blind.

I had some people holler and want to know what I'm doing outdoors. People tell jokes: "He can't see. He's blind as a bat. Here comes the blind man." Some people think that because we're blind we're not important. That's not right. You got some peo-ple that will talk over you. You can be talking, and a person just cuts you off. We're still human. Nobody wants to be labeled. I wouldn't hurt nobody's feelings, no matter what their condition is. There is no reason to be bitter about blindness. I always say, "Just because you're disabled, it doesn't mean you're unable." Life has to go on.

When I accepted my blindness, I wanted to get some help from different organizations. I got help from the Texas Commission for the Blind. I had to learn to read all over again. I got my Braille and mobility training. I started looking for employment. I made employee of the year from the Lighthouse for the Blind in Fort Worth. My good work ethic and personality were acknowledged. My wife and I stayed at the Radisson Hotel, and they gave me a nice big wall plaque.

What I miss the most about not having sight is driving, being free to go places. It's not that I'm trying to hide something from my wife. She ain't got to know everywhere I go. Sometimes I might want go out and be alone. Even going out and having an ice cream cone, sit in the ice cream parlor by myself.

I know people that are in worse shape than I am. And if they can pass through the pain, the pain will pass. My life philosophy is to form your circle and keep a bunch of negative stuff outside your circle. Only put all positive things in your circle. Being positive makes you more productive in life. Whether it's good, bad, up, down, or ugly. What you put on your wheel will come back around. Put good on the wheel and good will come back. Put bad on it and it will come back bad. My parents embedded a lot of stuff in us. Good seeds, not bad seeds.

I say to people when they speak to me, "I'm blessed and highly favored. I'm blessed and highly favored." So I try to stay prayed up, you know. With so much hustle and bustle going on in this world, I just stay prayed up. Well, we do a lot of singing, praising, and worshipping. We sing a lot of old church hymns. They play instruments, the drums and guitars. I'm out in the pew, singing out there with them.

Here's a song called "I'm Going to Stay on the Battlefield, the Battlefield of Life" [*singing*]:

Whoa, say, I am on the battlefield for my Lord,
You know that I promised Him that I,
I will serve Him till I die.
Truly I will.
Anybody, anybody makes it.
Surely I will.

My parents grew up in India. My father is from a very small farming village called Muppalla, and my mother from a seaside coastal village called Chirala. My dad sailed to the United States on the *Queen Mary* with just thirty dollars in his pocket. It was quite an amazing journey.

He had scarring from tuberculosis, so he was held up in Staten Island. He wasn't sure if he would be sent back, so it was pretty harrowing. He came here to get his PhD in botany and subsequently became a cell biologist at M. D. Anderson. He made significant discoveries in the area of cancer cell division and is quoted in many high school textbooks. This country gave him these opportunities.

Family is extremely important to me. They are my lifeblood. They know I have some physical limitations, but their attitude shaped what I am today. I've encountered unpleasant things in the world. My family has never doubted me, and I have never doubted myself either.

When I was two months old, doctors diagnosed my brittle bone condition called osteoporosis. They told my parents that I would be a vegetable, that I might be hydrocephalic, and that ultimately the condition would cause the loss of vision. The doctors performed a surgery to widen the optic canal. Unfortunately, they damaged the optic nerve in my right eye. As a result, I have no vision in my right eye and marginal vision in my left eye. I can see shapes and colors in a very minimal way. I'm able to see things better when there is more contrast; however, I have no depth perception and I cannot recognize people. I use my visual memory in some sense. I see things in dreams.

I am physically weak because of my brittle bones, but emotionally and spiritually I'm very strong. I have broken nearly every bone in my body at least once. I

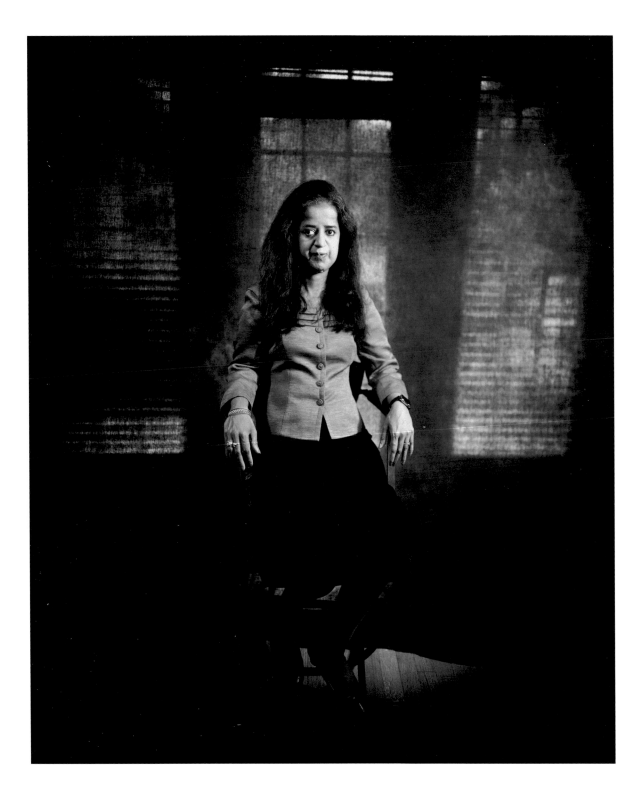

have injured myself just getting out of a car. My cat jumped on me and broke my arm. I have broken my femur like three times. I was in a body cast for much of my childhood. My mom and dad would carry me around the house because I got bored looking at the same ceiling.

I have broken the upper arm, my femur, tibia, fibula, and shinbones. I've broken the ulna and radius on both arms. I've broken all my toes. I've broken both forearms at the same time, so when I read Braille that makes things difficult. I made adaptations for that situation. It's a challenge. The bones are very slow to heal because I don't have normal bone marrow.

Last year I took my little dog for a walk. She saw a squirrel and pulled on my walker, so I took a fall. I broke five bones. The doctors had to do surgery on two of my legs at one time. I was completely immobilized. It really tested me, but I was trying to be strong. Because of the repeated fractures, the doctors have installed metal plates on my legs and arms, so I guess I'm the bionic woman. My little nieces used to call them zippers, and those are my scars. I really don't like women that cry. I just don't like that whole weakness thing. I wondered if I would ever recover. But with the support of my family and a belief in myself, I was able to. I am very fragile, and it affects how I interact with people. I've had friends say that they won't hug me because they don't want to hurt me.

I started learning to read Braille when I was a child. I resisted. I was throwing books across the room. I wanted to be like the other kids and read with my eyes. My dad is not blind, but being the wise man, he learned Braille first and then taught me. He made me do it, and thank God he did. I would not have the education and the meaningful profession today if it weren't for my dad.

Every week my mom took me to the Lighthouse for the Blind to get books in Braille. I was excited and read everything I could. I've been reading Braille since, and it has become automatic. When I read, I feel the dots and envision the words. Often the Braille letters or numbers have colors associated with them in my mind. A seven could be red or an eight could be yellow. It helps me remember a phone number or how to spell a word. I did not know that was a weird thing, and never knew people didn't have that same association between letters, numbers, and colors.

I read *Little Women* when I was in fourth grade. The story was so powerful. I loved the connection of those four sisters, their mom, and how they led their lives. They tried to be moral characters. There is a right and a wrong. What do you have without morality? It should be your guiding principle.

When I was fourteen we visited my parents' family in India. One of the beliefs in Hinduism is reincarnation. Karma is your fate. Some people believe that disabilities, whether blindness or disease, is a punishment from God for sins you committed in a prior life. My grandmother said that my blindness was a curse from God. I was totally devastated. My parents always told me I could accomplish anything. My disability has always been a part of who I am. I don't think my grandmother was trying to hurt me. She had seen what blind people go through in India—begging and those kinds of things. I remember trying to run

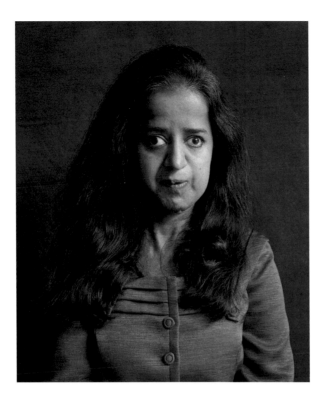

away from the village where my dad grew up. I did not have a cane back then, so that was not wise. I was really, really mad.

I was always the mediator in my family, so my dad encouraged me to pursue a career in law. As an undergrad I went to Rice University. I have always been interested in writing, and I love reading. When I first got accepted into Stanford Law school, my dad said, "You should never look back with regret. I want you to pursue your dreams. If I could leave India and come ten thousand miles to another country, I think we can go to California." My mom and dad made a big sacrifice and moved out to Palo Alto so that I could attend Stanford. My dad took an early retirement from a career that he truly loved. They took care of me. At all hours, he drove me for study groups at the library and read the materials that were not available on

tape, so he had to read a lot of boring legal textbooks to me.

When I got accepted to Stanford, they gave out a mini-biography of all the students that were going to be in my class. I swear, I thought there had been a terrible mistake. These people had been engineers, doctors, world-class journalists, researchers, and businessmen. What did I know coming straight out of college? Two-thirds of our class had real-world work experience, so I learned a tremendous amount from their life experiences. Stanford is a small environment, very cohesive and supportive. It was a great fit. It felt good.

I went to a dinner party at my sister's house, and she invited different friends. One was a well-known Indian physician. I told him I went to Stanford Law School. He asked, "Did you go to a special school?" I said, "No, there's only one Stanford

Law School." He was implying that there must be some special one for blind people in wheelchairs. It was an insecurity on his part to think that a blind woman, who has all these problems, can't be accepted and graduated from one of the top three law schools in the country. That's what many people think. He thought, "How could this possibly happen?" instead of saying "That's great."

Humility is really a big deal to me. I don't go around telling people I went to Stanford or that I'm an attorney. I don't just volunteer that information. I think it's an important part of who I am, but it's more important to be a good person, an honest person, a happy person, a good friend, a good citizen, a good daughter. Those roles are more integral to who I am.

A person can have a meaningful, rich life without sight. There are so many other ways to experience the world around you. Touch, smell, and hearing. All these experiences together form memories. It's just an amazing sensory experience to feel the sand under your feet, the wind in your hair, the sea breeze, the birds and seagulls calling. I think my blindness has forced me to be more aware of sounds. Since I have to rely on hearing, I may be a little better at listening to people's tones of voice or their moods. It gives me a better sense of what they are really trying to say. I use touch a lot because it forces me to be a lot more organized. I rely on where things are located spatially, so I'm feeling one thing in relation to another. I'm constantly gauging the distance between things. I do know what's going on, but I have to develop my perception in a different way. I often try to sympathize and empathize with what someone is saying.

People try to attribute my extrasensory abilities to the fact that I'm blind. I don't think I have any extra skills. I've just tried to pay attention more and to use the abilities I have to my advantage. There are a lot of misconceptions about blindness. People believe that we are somehow dumb or ignorant of what the world is. People believe they need to protect us or that we need to get out of the public's way just because we are breathing air. Blindness is not ignorance. Blindness is not stupidity. Blindness is not isolation. I think part of being an advocate is living your life and doing the things everyone else is doing. I'm not sitting in my room bemoaning my fate. I'm making the best of what I have every day. I've always considered myself to be an incredibly optimistic person.

I think beauty is honesty and clarity. The simplest thing can be beautiful. We live in such a complex world with so many layers of understanding. Some things are just beautiful in and of themselves. I love the smell of jasmine. In Indian culture, they will string jasmine flowers together for women to wear in their hair. The smell stays on your pillow and reminds me of summertime. I think spoons are very beautiful. I collect spoons, all with different shapes, etchings, and carvings. I can spend hours touching the different spoons, and they take me back in time. I play the piano and love the sound of notes and how they progress, and the beautiful harmonies and melodies.

I use a power wheelchair now. I have started using a cane, which has increased my ability to navigate independently and not be afraid that I'm going to tumble off the curb or a flight of stairs. I use my right hand to control the power wheelchair

and my left to navigate the cane. It's pretty amazing that I'm able to do things by myself. It's been exhilarating. In the past I was never alone. It may sound a little selfish, but sometimes you want to do something all by yourself and it's exciting. The cane has allowed me to perceive the neighborhood as I roll down the street. I can hear birds, the kids playing in the driveway, and the dogs barking. It gives me the freedom to get out of my house and be more connected with the community.

Four years ago I got involved with a group and started to have more of a social life. We go to movies, restaurants, and plays. They are also visually impaired. It's been a new experience. Given my brittle bone condition in conjunction with my blindness, my family has been very protective. But they also know that I need to live my life, and they can't lock me up in a little doll case. I have to experience life, so they're willing to trust that I know what is safe. I've been very grateful to them for that.

My name is Sandhya Rao. I am forty-six years old. I work for the U.S. District Court in Houston as a staff attorney. I have worked there for twenty years. I do legal research and writing and work on civil rights and habeas corpus cases. I'm part of the American judicial system. It's a lot of responsibility and a challenge every day. Reading and writing are the two things that I love to do best, and I do it every day. I work on cases where inmates challenge the validity of their convictions. I deal with issues relating to the Fourth Amendment, which is illegal search and seizures, and the Fifth Amendment, concerning confessions. I also deal with the Eighth Amendment—the imposition of cruel and unusual punishment.

DOMINIC HELM

As a young boy we lived across the street from the ocean on Galveston Island. There is something so universal about water. You can put it in a teapot, and it takes the form of the teapot. Water creeps along and if you put something in front of it, it just finds another path around the object. At nighttime I would leave my window open so I could hear the waves crashing on the beach. I would listen to the ringing of the bells on the ocean buoys. They make music. The ocean sounds at night were comforting and made me feel safe.

I am biracial. My father is African American, and my mother is white of European descent. My father did three tours in Vietnam and developed a drug habit that had a major effect on their marriage.

I remember the night my dad came over. I was probably about five years old. My mother had to go to the store to get some milk for my brother and me. My dad was telling my mother to give him the money. She knew if she gave him the money that he was never going to come back. She said, "Why don't you play with your sons, you've haven't seen them in a while." He was playing with me and it was fun. Reluctantly, my mother gave him the money. As he was leaving I said, "Dad, I want to go with you, I want to go with you." He called me Pooches. He said, "Pooches, you stay here, I'm just going to the store, I'll be right back." He shut the door, and that was the last time I saw my dad. I looked at my mom, and she placed her face in her hands and started crying. I never had the chance to meet him again, but I've never held any anger toward him.

I have never liked labels because I have seen what divisions they cause. I prefer the term black American, because I was born in the United States. When my mother was filling out paperwork at my school, she would classify me as white. I asked her, "Well, if I'm black, why do you put me down as white?" She told me to

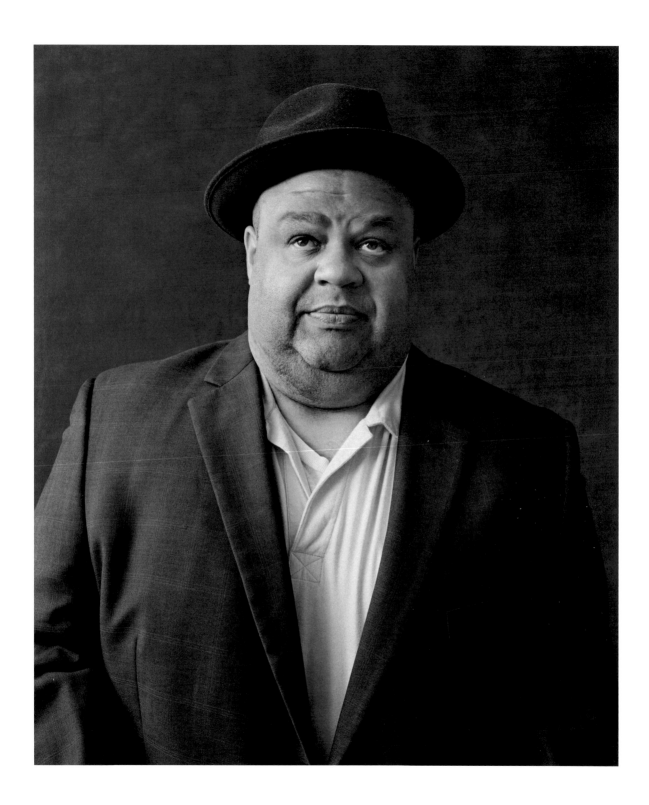

shut up. Later I came to understand that in order for me to be accepted into the good schools, she had to put me down as white. My mother cautioned me about my mixed race. "You have to be careful because you are black." Blacks still didn't have a lot of rights, and it was dangerous. Even though I was light skinned, I was still considered a "nigger" by some people. I did experience racism growing up and it hurt. My mother had instilled in me to be respectful and not to be hateful like them. It's never good to hold hate.

I lived in the Catholic orphanage for six years in early childhood. My mother wasn't able to take care of us while she was going to school to get her nurse's degree. When she dropped us off, we cried and screamed for her to come back. At the time it was scary. I adapted and learned to trust the nuns that were taking care of me. They were like our mothers. A big part of my belief system today is what I learned from the nuns, my mother, and reading the Bible. In the orphanage at nighttime, we would catch lightning bugs and put them into empty mayonnaise jars. We would fill the jars with grass and put holes in the lids. We would pretend we were flying with them. The jars were our lanterns. They would light up the pathways for us.

I went blind very quickly—in a matter of three weeks. It was five days before my thirty-third birthday. The technical name for my blindness is idiopathic intracranial hypertension. It was a combination of swelling and bending of the optic nerves, the effects of a false brain tumor, and the macular portion of my eyes hemorrhaging.

I woke up from sleep, and I was in total darkness. I was scared. I was never able to see again. I felt very lost. I was angry and depressed, because I didn't know how to live as a blind man. My biggest fear was not that I would never see again, but that I'm never going to be able to read books or magazines again. I started having dreams and nightmares about different ways of committing suicide, and that really frightened me. I felt that I was going to be a burden upon my family and friends. I woke up thinking, "Wow, that's really stupid." A big thing that got me through this was my faith. I had the sense that I didn't need to be afraid of what's happening to me. All I see in front of me is total pitch-black. I cannot see any colors. However, I can still visualize colors. I can still visualize my mother's face. I've been blind now for sixteen years. Blindness is a new way of thinking and living.

I attended the Lighthouse and the Criss Cole Rehabilitation School for the Blind. They were very supportive, very caring. I learned a lot from my instructors and other people who are blind. It gave me great confidence. In a weird way it was my blindness that has allowed me to go to college. Growing up poor, I always dreamed about going to college but didn't think I would have the opportunity. I have earned an associate of arts degree and master of science degree in sociology—all focusing on blindness.

When I hear the word "blindness," I think about the physical attributes of blindness of not being able to see. But from a sociology point of view, it's not just a physical disability, it's also a sociological disability. Go into your neighborhood and businesses and ask yourself, How come there are no blind people that work here? So, in essence that's where the lack of awareness comes in. If the people within our communities are not seeing the blind

people, then they themselves are socially blind to blindness and the perception of blindness.

In the beginning I didn't feel like I was a whole person because I had lost my vision. Thinking back on that now, it was really dumb. I learned I can do anything. I kept reminding myself to adapt, adapt, adapt. I feel like Atlas, as if I have the weight of the world on my shoulders. I'm willing to carry that weight, if it opens the door for other blind individuals. Blindness does not care about your age or gender or the color of your skin. It doesn't care whether you're rich or poor. Blindness happens.

My new identity is "a blind man." Society views blindness in a negative way. The problem with identities is that it generalizes. Society doesn't see me as a professional or an artist, they don't see me as a man. They're not trying to get to know Dominic. They just think, "Hey, there is a blind guy."

My blindness has taught me to pay more attention. I use echolocation. I tap my cane and listen to the sounds bouncing around. When there is an opening, sound travels farther. I listen to the sounds and it tells me how far I am from a wall or from a person. Blindness has allowed me to experience life in a different way. I hear the sounds of my cane as it makes constant contact with the pavement. I feel the textures of concrete or grass.

I experience the smells from the neighborhood. I never noticed that before. The sensation of touch is a whole new and amazing experience—being able to feel the coolness of the breeze, the texture of the grass, and the vibration of music. My niece tries to sneak up on me. I can feel her presence. I can feel when someone is staring at me even though they're quiet. I can feel that. I can sense that.

I miss the freedom of getting in my car and going someplace, whether to the store or to the beach. I think one thing I've learned after losing my vision is that society moves at a fast pace. Blindness has taught me to slow down. It was difficult in the beginning, but it's gotten easier. Once you get the basic skills you need, it's a piece of cake. I don't think about being able to physically see anymore. And actually, I think that if I were to get my eyesight back I would be afraid. I've gotten so accustomed to not being able to see that it would be difficult to readjust to vision again.

I have a tattoo on my left arm, just on the inside of my forearm. It's a word that I took from the New Testament, and it says "Illuminates," meaning enlightened. Being blind has allowed me to learn from my experiences. The word "illuminates" is a symbol of not being afraid—to be enlightened as I travel on my journey through life.

SANDRA CONTRERAS

My name is Sandra. I'm twenty-four years old. I know I have dark brown hair and eyebrows. I can feel that I'm really skinny. I do have a scar on my forehead although I can't see it anymore.

I work at the San Antonio Lighthouse for the Blind. I'm a machine operator, and I do buckles. I do about a thousand a day. I like working there because they believe in us and I feel accepted.

I was really active as a kid, running, playing, joking, and hiding. I thought it was a good hobby just running nonstop. I enjoyed feeling the wind on my face and that no one could catch me. I felt a freedom when I ran.

My uncle's name was José. He never had children. He was always a happy man. He would go to church every day, Monday through Sunday. He couldn't work, although he would pick up cans from the streets, and that money he would spend on us at the ice cream trucks. He loved us so much that he would never let my parents spank us. He just wouldn't let that happen. He would sing to me before I went to bed. I've never met someone so special in my life.

All I remember is hearing my mom screaming. My uncle's lungs closed up. I saw when he couldn't breathe. The ambulance came over, and after that he was dead. For some strange reason I just couldn't cry. It was just like I wasn't in my body, but I was still watching everything. I was eight years old when my uncle passed away. A couple of weeks after my uncle died, when I looked at the blackboard in class I couldn't read anything. Everything was just blurry. In the beginning, I was not worried because I thought I needed glasses. I was in the third grade.

My parents took me to an eye doctor, but he couldn't find anything wrong. He thought it was a trauma after seeing my uncle die. The doctor did not believe me.

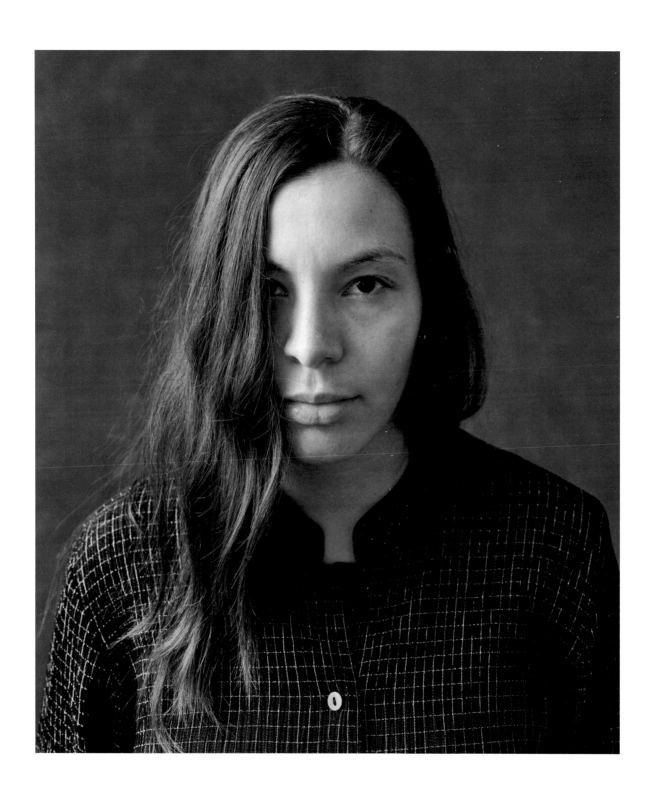

He said I was faking it. After that my parents didn't believe me. They would just tell me that as the days go by, I would be able to see better.

There were times when I got frustrated because it was so hard. One day I could see, and the next day everything was blurry. I was the only one in class not doing anything, because I couldn't see the blackboard. I couldn't take notes. When I tried to read, I would have headaches. My eye condition impacted my life in every way. The teachers put me in special-ed classes because they thought I was a slow learner. I just felt so horrible.

Well, at times I did believe I was faking it. Since everybody was telling me that, I believed it too. I would sometimes stare at books and at other materials to see if I was able to read them, but I just couldn't. I would cry maybe every single day. I didn't understand what was going on. I had to be strong, because no one else was going to do it for me. I felt alone in the world.

Whenever the students would try to make fun of me, I would hit them. I had to defend myself. I would direct all my anger toward them. I made them scared of me so that they wouldn't tease me. To be honest, through all my school years I had no help at all. Not teachers, parents, nobody. It was really hard being a kid and telling someone to hear and to believe me. A lot of times, I would be sitting in my desk and couldn't do anything. Sometimes I would just stay home. No one would listen to me.

When I was twelve my dad would make fun of my vision. Later my sister had the same eye problem that I had. Everything was just blurry to her too. That's when my sister was on my side. I felt stronger when I had at least one support in my life. I spoke to a lady through the Division for Blind Services. I told her about my eye condition. I told her that the teachers never helped me at all, so that's the reason I got behind in school.

When I was eighteen I finally got diagnosed by an optometrist. They did an MRI and a CT scan. He told me that I had a white spot in the back of my eye and that there was no blood running through. So that's the reason why glasses won't help me and why everything is blurry. I have Leber's hereditary optic neuropathy. It is a disease that is passed on from parents to their children. I felt a lot better knowing what I had. It was nothing that I was faking. I felt that someone finally believed me and that I was not lying. I'm considered legally blind, which is almost the same as blindness. Blind means you can't see anything. Legally blind means I can only see things as blurry.

I'm lucky because I can still speak, I can still hear, and I can see some but not a lot. Something is better than nothing. I have to pay more attention to sounds. I don't feel helpless. I have really good awareness. I can hear and feel what's around me. Hearing is one of the most important things in life. Hearing the trees move around is a sound most people don't pay attention to. Ocean sounds are relaxing. Hearing nature sounds or even a kid's laugh is comforting. When someone talks to me I really pay close attention to the sound of their voice. It helps me recognize the person just by the sound of their voice and their way of expressing themselves. The sound of a voice tells me whether they're sad, they're mad, or they're happy. It really helps me distinguish their attitude.

When there's something that I don't know, I touch it and feel it. When you touch an object, it's like your hands could be your eyes. When you see

things you could be wrong, but once I feel something I'm able to understand more. It could be described as the weight, the shape, or the structure of an object. I've learned how to appreciate life more, and I'm thankful.

I worked at a cafeteria. I would serve the customers whatever they liked. A lot of the time it was really hard for me to distinguish the food. The good thing was that the food was always in the same place. So I memorized every single item, unless they would switch the food around. I stopped going to work and never told them that I had an eye problem. It was really exhausting.

When I started dating, I never told the boys I had an eye problem because I was embarrassed. I would do my best to hide it. Sometimes they would ask me, "How come you don't drive?" I would make up long stories and they would believe me. There were some times when the boys would try to show me something. I would just say, "Yes, yes, yes." But I really didn't see it. I would just pretend I saw it. I was afraid of telling them, and now I realize there's nothing for me to be ashamed of. It is just part of life. It's not something that I provoked or anything to be embarrassed about.

When I was young I was really angry for about five years. I've changed. What I like about myself is that I'm always positive. I never give up. I have learned how to live with my eye problem. Now nothing scares me.

I love music. I love animals. I have two dogs. Princess is really kissable. She just loves licking people and she obeys. Panda is more of a hyper dog. He never gets tired, and he's a cute doggie. I think dogs are a lot nicer than people. They are always with you, whether you did something good or bad. They're just really loyal, and that means a lot to me. Animals won't judge my eyesight. They won't judge me as a person and won't judge anything about me.

RAÚL GAMEZ

I really enjoy getting out and walking. It's neat to walk independently and do things at your own pace. It gives me a chance to think about my life. I think about how I could handle different situations. I think about my friends. I think about work. I think about what I'd like to have for dinner that evening.

My name is Raúl Gamez, and I will be forty-six this year. I live at home with my mother. I work at the San Antonio Lighthouse for the Blind as a general assembler. I work in the department where we assemble office products, like mechanical pencils. The cause of my blindness is retinitis pigmentosa and a detachment of my retinas. I lost my sight when I was two years old. I've been blind since that time, except for very little light perception in my left eye.

My grandfather was blind, my grandmother was legally blind, and I have three cousins who are blind. My grandfather worked at Kelly Air Force Base and always had a house and a car. He was a very successful person, and I think that's what really helped me. He was a good inspiration. He showed me that I can do something with my life. Many times I think of what my grandfather told me: "As long as you're talking, you're not learning a thing. When you listen, you learn all kinds of things." I believe that. You have to, because listening gives you wisdom.

I don't think blindness is really a disability, as long as you're able to live and travel independently. I don't see myself as helpless at all. I believe that a lot of people are afraid of the blind. There's nothing wrong with my legs, my feet, or my brain. I'm just blind, that's all.

Well, some of the most common questions people ask are, "Do you know where you're at? Does your cane have a laser in it that tells you when you're going to hit

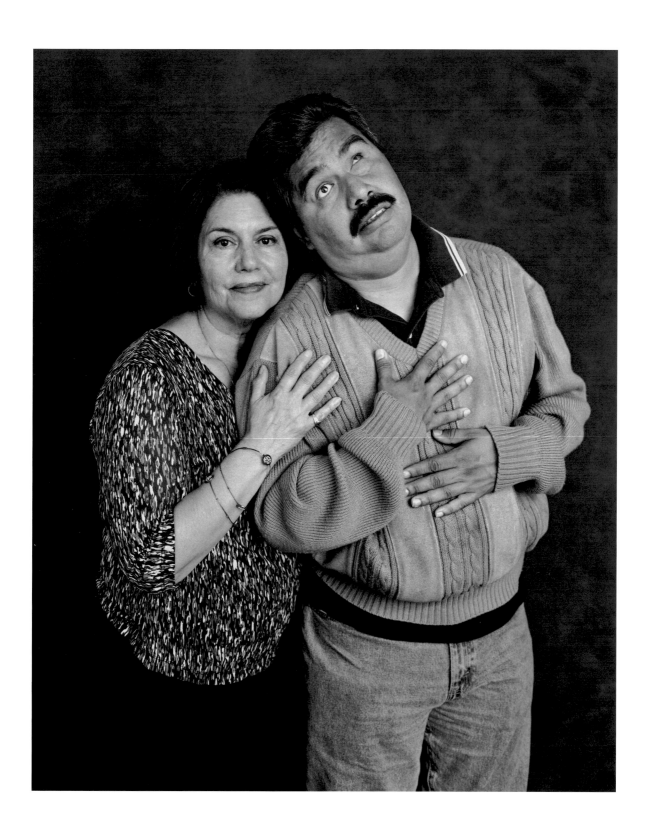

something? Why are you always on the street? Why don't you have somebody guide you around? Where is your dog?" One guy told me, "*Muévate, pendejo.*" Not a nice thing to say. It means "Get out of the way, asshole." A lot of times people will tell me, "*Vete por tu casa,*" which means, "Go home or stay off the streets." It makes me feel bad in a way, but I just let it in one ear and out the other and keep on going. I never lose sleep over negative comments. I never let them bother me.

I try to walk at least a mile a day, every day, by myself. I choose different routes. Sometimes I'll walk and somebody will offer their arm, and around we go. On my leisure walks, I can hear just about everything. The sighted world misses out on so much, because they focus on just using their sight. I can hear the sound of birds, the sound of dogs, the sound of a train. I can hear the leaves on the trees when the wind blows. I enjoy that. That's a peaceful sound. Sometimes in the evenings, I can hear an owl howling way off in the distance. The sounds are there, and they are beautiful.

Often when I'm out walking, I try to use landmarks such as curbs or cracks in the street. I feel with my cane and my feet. I notice how some streets are paved and some streets are brick. I can hear the sounds that the cars make when they go from brick to asphalt. It's a big difference. I can tell when I'm getting near a set of railroad tracks, because the street begins to rise. When I walk near the grocery store, I hear baskets rolling around in the parking lots. Sound plays a big role in my ability to get around and to be independent. When I walk in areas where there are tall buildings, by tapping my cane I can hear how the sound echoes off the buildings. I will know how close I

am. Also, I use a sense of smell to tell what the surroundings are. People pass by wearing perfume or cologne, and it will tell me if it's a woman or a guy.

I live at home with my mom. She's never told me that I could not do things. She's always said, "Yes, you can do this, yes, you can. Anything is possible." She's always been a big inspiration to me. She's positive and always trying to brighten up the room. I try to not let fear stand in my way. My mom can be very funny. We use a code system and letters to describe things. When we're at the store or in a restaurant and I hear a woman's voice, I want to know what she looks like. So my mom will say "S" (which means the girl is slim) or "G" (which means the girl is *gorda*, that she's kind of heavyset). I start laughing because of the way she describes things. She's real good at telling how old a person is, or how much they weigh.

Becoming blind is not very hard. Of course, it's easy for me to say, since I've been blind all my life. I think anyone who is losing their sight needs to keep an open mind and try not to look at the negative side of blindness. There's no reason to be depressed. There's no reason to be angry. There's no reason to be bitter. It's just that you've got to learn to work with it, and you'll do great. It's a beautiful life, and life can be beautiful. One of the big reasons I like to be sociable is that it gives me the ability to learn more. As a blind individual, we never stop learning. We're never too old to learn. Every day, as long as I'm able to get out and do something, I feel that I can learn something new.

I do enjoy sex, and of course we're all victims of it. None of us would be here without it [*laughing*]. I'll tell you a story about when I went to a gentlemen's club. The dances were ten dollars before 2

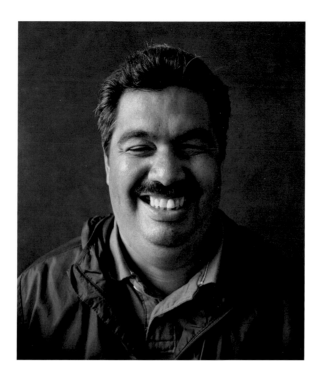

p.m. I remember going there one time and hearing the music. I'm sitting there getting into the music, and the girls come up to me and they can see that I'm blind. One girl said, "Well, I know we're not supposed to touch, and I know that there's a law against it, but I'm going to help you out here."

I meet women when I'm doing my walks or on the city bus. I don't care much for the bar scene. You can learn a lot about a woman by listening to the way she speaks. You can learn a lot about how they look, by shaking their hand or by taking their arm. And some of the women will start taking my hands and putting my hands on their body, and that puts you in that different mood. And, well, one thing leads to another—and there you go. Of course, the most important thing about the women I meet is what's in their heart, the way they think, their outlook on life.

I don't really have any memory of sight. I often think about not being able to see trees and, of course, the pretty women. I do visualize in my mind about having sight. I often think that if I could ever win the Powerball lottery and win a really big amount of money, I would put aside a million dollars. If there's any doctor who can perform some type of surgery that could give me eyesight (and it don't have to be perfect), I will give them a million dollars. Even if it was slightly blurry, that would be fine. That's what I would do. But I would not be disappointed if it never happened.

Having good mobility and a good personality allows me to be very independent. I'm free to do what I want to do and go where I'd like to go. It gives me a sense of freedom to feel the wind and to enjoy those things. I do feel free.

I don't know what happened to my biological parents. The records from the Department of Human Services said that they were migrant workers. My biological mother was a fortune-teller and a tarot card reader. My father was a used car swindler. When I was about three months old they took me to a shelter and never came back. I became a ward of the state. I have never met them in person. However, I have talked with my mother on the phone. She told me that she believed in Satan and the reason I was blind was because I didn't worship Satan. I just said, "Well, I'll just continue to be blind, because I'm not interested in worshipping Satan." I never before or since have felt such a presence of evil. It was very scary.

I became blind at birth. I had a condition called congenital glaucoma. When I was eleven the ophthalmologist performed a bilateral enucleation. They removed my real eyes and replaced them with prosthetic eyes. The doctor felt that for my self-esteem it would be a better road to follow. I've never had any vision at all. I've never seen dark, because dark is something. I've never seen faces. I've never seen the ocean. That doesn't mean that I haven't flown across the ocean or been outside when the sun is rising. Seeing isn't the only way an experience can be obtained.

My foster parents are two of the most wonderful people that anyone would have the opportunity to meet. My foster father has a heart bigger than life itself. His love for children is absolutely authentic. My foster parents had forty-six children over time. Some of the children had disabilities, but the majority did not.

At age three I was taken out of their home because my foster mother was sick. I was placed into another home for six to eight months. We ate the same thing for breakfast, lunch, and dinner. We were told to address them as Grandma and Grandpa. The woman had some real problems. She would wrap my long hair around those old metal mops, dip my hair in Pine-Sol, and then mop the floor with

my hair. Someone caught her and I was removed from their home. The man was involved in some inappropriate sexual behavior—not only me, but with some of the other kids.

My original foster parents petitioned the state to get me back into their home. They absolutely supported, loved, and comforted me. My foster parents did not emphasize blindness and treated me the same as my sighted siblings. Everybody was on the same playing field. I felt very normal. My foster parents never sheltered me, and they gave me the gift of independence. When I was eleven my foster mother and I went to visit my home-room teacher. I heard my foster mother whisper to the teacher that I was blind. I was taken aback. While I knew that I was blind, I wasn't raised to be anything different. I asked, "What is blind?" I didn't know what "blind" meant, even at that age.

I am very much aware of where I am in space. You could take me to an unfamiliar place and never have to orient me to anything. I would listen for open spaces of sound. I also know when an object is in front of me. I don't hear any better than you do, but I rely on my hearing as much as you rely on your vision. Echolocation means that you are able to hear sound bouncing off of buildings and the ability to hear openings to hallways or recessed areas. When I'm walking down a street, I know when there's a parked car because the sound is different. When I first started orientation and mobility training, I was a horrible traveler. I've had to learn how to travel and use a cane.

Being lost has never bothered me, because I have a good awareness of where I am in space. I pay attention, so I can usually retrace my steps. When my daughter and I were in Paris, she got lost and was having trouble reading the map. I was able to retrace our steps back to the hotel. I see time and distance differently. I don't know how many feet you're sitting away from me now, but I know I could walk over to you in less than two seconds. When I think about how far something is, I think about how long it takes me to get there.

I love to hear the sounds of my daughters' voices on the other end of the phone. That really thrills me. I like to hear the wind blowing or the early morning sounds of birds and locusts. If I hear something in your voice that doesn't sound quite right, I'm going to be a bit alarmed. My husband used to tell people when we were first married, "If I just breathe the wrong way, she gets upset." I can't see things physically, but I certainly have insights. I'm perceptive about people and about situations.

It is amazing to me that there's this vast visual world out there. I don't know how a sighted person does it, because there's so much to look at. I don't know how a person can keep their eyes on the road. I don't know how a person can walk through a mall. I would be exhausted every day. Visually, I wouldn't know what a dog is. I could touch a dog and say, "This is a dog." However, if I were presented visually with a picture of a cat or even my children, I wouldn't know what it was. I would not take sight if it were offered to me, because the learning curve would be tremendous—and life's too short to start all over.

For me, blindness means that I have to take a different road map than you do to get things done. There are a plethora of misconceptions about people who are blind in society. I'm not less of a person because I'm blind. People used to tell me when my girls were little, "You are so fortunate that you have these little girls that can help you." And

I would say, "Who do you think taught them?" They're just waiting to find out where their next meal's coming from, or whom they can spend the night with. I went to lunch with a young lady I worked with the other day, and she parked her car a good ways away. She said, "Well, I'm going to get my car and come get you." I said, "No, we can both walk to your car." She said, "Oh, really? You can walk that far?" The public believes that if you are blind you just can't function.

What do I look like? That's really an interesting question. I've always been told that I have dark hair and green eyes, and that I'm short with long eyelashes and a round face. When I was in college there was a young man who asked me out for a date. This gentleman had muscular dystrophy but could still drive. He drove and drove, and I couldn't figure out why we were driving so long. He finally stopped at an all-night IHOP. Afterward we continued to visit on the phone, but we never got together again. After several months he informed me that he couldn't deal with the fact that I'm dark-headed and blind. That hurt my feelings tremendously, and I struggled with issues of self-confidence.

When I was twenty-seven, I met a couple from Bridgeport, Texas, that changed the very fiber of my being. We became a family. They eventually adopted me as an adult and became grandparents to my girls.

My name is Judy Jackson. Blindness doesn't define who I am. I work for the Internal Revenue Service as a collections representative. I am fifty years old, married, and most proud of the fact that I've been able to raise two phenomenal girls. I tell them all the time that I am proud to be their mom and to watch who they have become today.

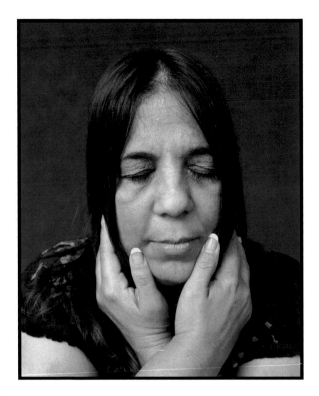

The theme of my life is relationships—because they're so critical. There was a time in second grade when I would want to play with these little girls, but when I would come near them, they let out these high-pitched, blood-curdling screams and would run off. That would make me so sad. But it appeared as though they were afraid of me because I was blind. I remember thinking, "When I find a really good friend, I'm going to always be loyal. I'm going to be so good that they won't be afraid. Nothing will shake that." Loyalty is a character trait I value like integrity. I think patience, wisdom, and understanding all have a common thread. When you have the wisdom to understand why something is the way it is, then you can be patient.

Growing up I didn't know I was colorblind. Yellow I could see. Red I could see. I never saw orange. I never saw green or blue. Blue and green were the same. Pinks and purples were very close, if not the same. But my favorite colors were black and white. My grandfather was a black-and-white photographer. He told me, "Well, if you do black and white it just keeps it simple and takes the guesswork out. Why would you want to make things more complicated?"

My name is Kellie Givens, and I'm thirty-eight years old. I am married to my college sweetheart, and we have been married seventeen years. I have two children. I was born and raised in Louisiana and loved being outside. We lived for hurricanes, because it meant we were out of school and we got to have parties. We had a bayou behind our house, so every now and then we would have an alligator on our front porch. I learned to watch where I was walking and to be aware of my surroundings.

My night vision was the first to go. I never knew I had a problem until somebody pointed to something they could see but I couldn't. I never knew I was supposed to have peripheral vision. Even in high school I couldn't see the ball when we were playing tennis. I made a deal with my coach: I would clean her office if she didn't make me play.

When I was eighteen I was turning left on a four-lane highway. It was dusk and I didn't see anything. I assumed it was clear and pulled out right in front of somebody. Everybody asked me, "Why did you pull out in front of the car?" I did not see the car. It was enough, even as an eighteen-year-old, to scare me.

I ended up seeing a retina specialist at the Eye Foundation Hospital in Birmingham. He determined that it was retinitis pigmentosa. He said, "What we are seeing is a degenerative disease. You are going to lose your sight." Just like that. I

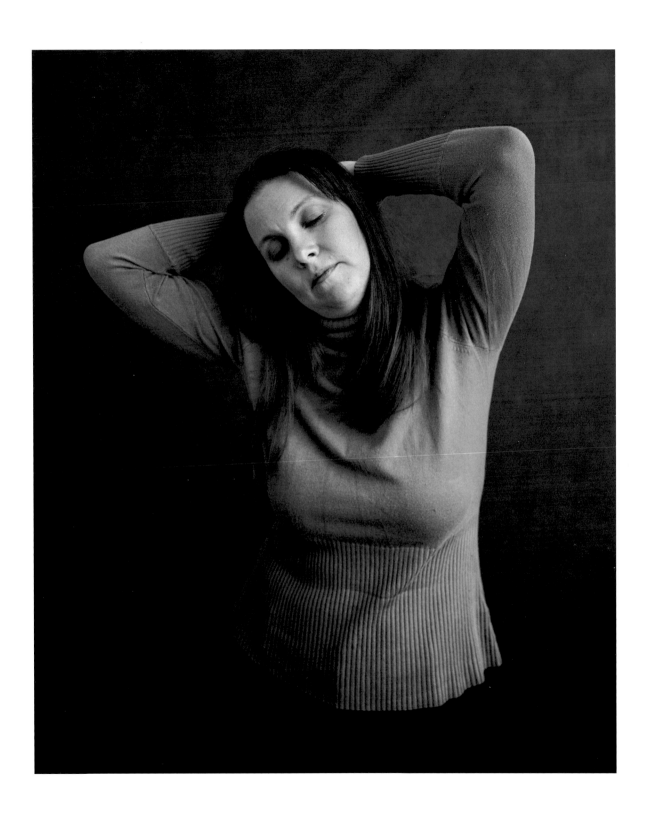

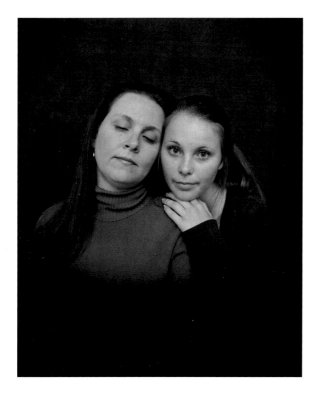

I was planning my wedding at the same time, so it was very stressful. In the perils of it happening, you learn a lot about yourself. I hate to ask for help, and I still don't. But if you want to reach that goal you've set for yourself, you have to ask for help. When you're almost ashamed that you need help, that's a sign you have too much pride. You can't do it alone.

I was raised never to quit. My grandfather and I were very close. He flew planes in World War II. I grew up quoting John Wayne. I didn't grow up watching *Cinderella*. I can quote *Flying Tigers* with John Wayne, and that's what my grandfather and I did. So I can honestly tell you that I was never angry. I've been sad. I've been frustrated, but to me frustration is not anger. I'm not someone who wastes time, and anger is a waste of time.

My son likes to sneak up on me, but he never gets away with it. Even if he's holding his breath, I can feel his presence. You don't have to hear somebody. You just feel that there has been a change in the air. You just sense someone is there.

Being blind has made me more aware of my surroundings, the people I associate with, the decisions I make. I can hear a number of conversations happening at one time, and I can usually follow three, four, or five, depending. It happens automatically now. We were at a dinner party recently seated at a very long table. There was a man seated on one end and I was on the other end. His wife seemed very lovely, so automatically I thought he must also be lovely. He was not. I just kept finding myself listening. He treated the waiter rudely, but he did it in a way that wasn't obvious. There was something about the tone of his voice that I just did not like.

didn't say anything. I did not cry right away. We literally just sat there, and it was very quiet.

I went to Auburn University and majored in prelaw. My biggest fear was the struggle with reading. It was humiliating to be the last one finishing an exam. In a matter of a few months, I had a very steep drop-off of my vision. It just happened. Like a snap of a finger, it came out of nowhere. Their disability department was fantastic. They set me up within several days. They said, "Here's what you're going to do, here's how we're going to help you, this is what you're going to focus on." Before I knew it, I was taking orientation and mobility. I was going to Talladega to the Helen Keller Institute that spring. I reenrolled in twenty-one hours and finished.

Sighted people miss a whole lot. It's not because I can hear better, it's just that I pay attention. I guess over time my brain has said, here is what you can do. I might not see a fake smile, but I can hear the fake sincerity in their tone. Everybody has that ability, but too many people are so caught up in their sight that they don't really listen.

My husband and I look like the happiest married couple ever, because we are always holding hands. Which is hysterical, because we could be in the middle of an enormous fight, but I still have to hold his hand.

Whether or not I have a cane or a dog or a person, I try to draw as little attention to myself as possible—not for my sake, but I do care about my kids.

My children are literally my life. I love watching them succeed. They are very athletic. My daughter, Mary, plays soccer. If she's driving down to score a goal and I hear people saying "Go, Mary, go!" of course I'm going to scream. I was with this woman who knew that I was blind. She actually said to me, "Kellie, it's almost like you're lying because you're cheering for something you can't see." I chose to take the high road and did not make a scene. But trust me, I felt like saying, "You f——ing idiot, what is your problem?" I'm always going to be my daughter's biggest cheerleader.

My dog's name was Sparkle. I'm tender-hearted toward animals, because I know they feel and how they love you unconditionally. We bonded very quickly. The freedom that Sparkle gave me was immeasurable. She was very ladylike and sassy. She walked at hyperspeed. There couldn't have been a better a fit on the planet. When she got sick she started losing weight, and then she died. I don't want another dog yet. I can't imagine trusting another dog the way I trusted Sparkle. I have never experienced grief like I did when Sparkle died.

Blindness is not a lack of intelligence. It's not a weakness. It's not an inability to understand the world around me. It's just that I have to understand it differently. There are going to be things I can't do anymore. No matter how hard I try, I will not drive a car. But I can do other things better. It's a disability, but it's not a negative thing.

I'm not perfect. I have pity parties, but I try very hard to hide it from my children. I never want them to see their mom as weak when it comes to my blindness. What if something happens to them later in life? I want them to be able to handle it. I don't ever want them to look back and say, "My mom sure did cry a lot." That would be awful. I want them to look back and say, "I don't remember my mom really being blind—I just remember her being my mom."

There is a passage from one of Emily Dickinson's poems:

Hope is the thing with feathers
That perches in the soul,
And sings the tune without the words,
And never stops—at all—

I love that passage because it relates to blindness. Blindness never stops, and I can't stop either. The second you stop, perhaps you're going get a little lazy, or you're going get a little depressed. If you let that happen it will slow you down, pull you down, hold you down. You have to have a forward motion all the time. If you don't, you're going to get left behind.

JOHN WIMMER

My mother was definitely a hippie. I grew up in southwestern Oregon. There was a movie filmed there called *River Wild*. That was my backyard. There's something unique about living close to nature. It inculcated me with a deep appreciation for its beauty. I enjoyed being unsupervised and having the forest and mountains as a playground. I remember a lot of naked hippies in beautiful swimming holes. I think they were trying to find themselves and their niche in the world.

When I was four, I found an old deadfall tree bleached white by the sun. When I climbed over it, I saw a green valley full of orange poppies. I thought, "Wow." It was just one of those moments alone. People don't appreciate where they're from until they leave.

I was chastised for not making eye contact when I was about six. I didn't have any central vision growing up. My vision was a little bit better at night. The doctor thought I had rod and cone dystrophy. My stepfather told me that I would eventually go blind. If I was incredulous, it was because I didn't like his delivery. It was meant to try to manipulate me into living someone else's perspective. I think many people have a dysfunctional relationship with the perception of power. Early in life I was in denial. My vision loss was very gradual. I can't see my face in the mirror anymore. I can't really see colors anymore.

I was willing to try anything, and I had a neighbor that played T-ball. I didn't think I was going to be very good at it, but I wanted to try. If I gave up, I wanted it to be my choice. I think I was in the sixth grade. It had been raining and I thought the meeting was canceled. My stepdad went to the school and told everybody that I'm blind and can't play baseball. Later somebody told me what he said. I was sullen and wouldn't respond to my stepfather. He made me stand up on the porch

168

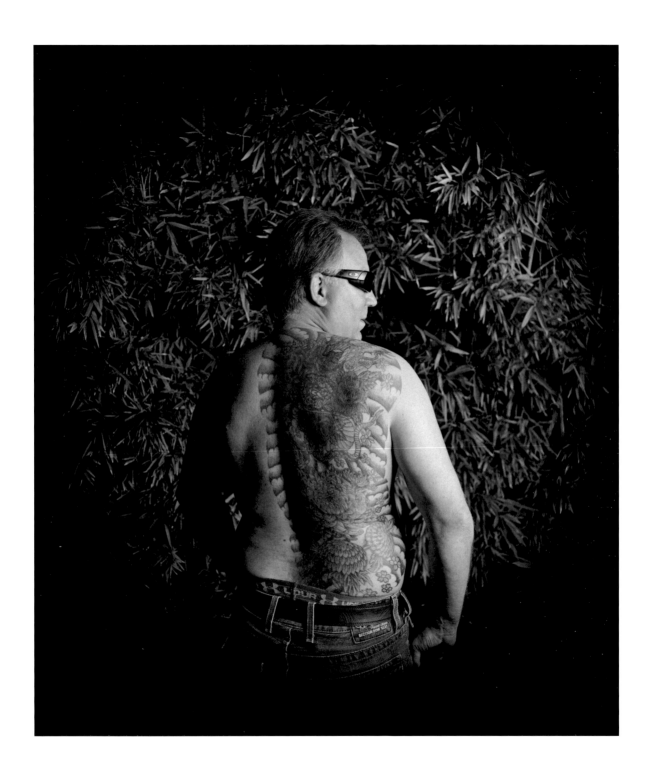

and threw wet tennis balls at me in a rage as hard as he could. He did it more than once. I don't know what he was trying to teach me. You don't have to be tough to beat up a crying ten-year-old. He would say, "Here comes old bumbling John." He was being as cruel as possible. Why would somebody want to do that? I'm very glad that I'm not that kind of person. I've had all kinds of people trying to break my spirit, and it was a tough thing.

I think the public has an overreliance on stereotypes. There's an idea from Zen Buddhism: "Empty your cup." How can you learn anything if your cup is already full? You have to be prepared to receive. People have a misconception that blindness is darkness. Some crack the joke that I must be good with my hands in regard to women. People make the assumption that I can hear better. Some think I must be faking or lying about my blindness. One thing that I find very frustrating is the assumption that blindness means incompetence. It can be excruciating if you hear it everywhere you go. Hemingway wrote, "The world breaks everyone and afterward many are strong at the broken places." This quote speaks of adversity. It doesn't matter if you're living in a gated community or in some sort of war-torn part of the world. It may have a different flavor, but all of us are going to suffer. Life is going to kick our ass at some point. How we cope with it says a lot about our character.

When I was sixteen I was something of a rebel. I was riding with a friend, and we were pulled over by the police. We didn't do anything wrong. They didn't like that I spoke back to them. They slammed me down on the hood and put me in handcuffs. I think I weighed about a buck fifty-five at the time. They charged me with disorderly con-

duct. When I got to the police station the officer writing up the report said, "Mr. Wimmer, you're not educated, are you? I can tell from the way you speak that you don't have an education." He wasn't trying to be mean but calling it like it was. That always stuck with me. I didn't want anybody ever condescending to me again because of the way I spoke. I decided I was going to embrace learning.

I like to travel. I was a competitive wrestler. I'm intellectually curious and always have been. I have some very good friends and count my wealth in relationships. I've climbed Mount Hood. I've climbed the highest mountain in Colorado. I've climbed the highest mountain in New York in the dead of winter. The thing I'm most proud of is my bachelor's degree in history and minor in modern classics. I absolutely love history. It's an incredible exercise for the mind. I like the Greeks for their literature. Thucydides just moves me. His eloquence and his ideas are every bit as true today as they were then. A quote from Thucydides: "Hope leads men to venture." Hope is not just a coping mechanism for adversity—it inspires.

When it comes to my guide dog I am lost for words. In some respects my life started when I got my guide dog, Rasha. I found it very difficult to interact with humanity in a meaningful way. I wasn't all that welcome. The assumption that I was incompetent was very frustrating. Without Rasha, I'm that jackass that'll bump into you and does not make eye contact. With Rasha, we're something special and powerful. She guides me up mountains and keeps me safe. I get around the world and through crowds. I trust her with my life. It's an incredible bond. There's a freedom that was missing up until then.

Blindness is not an absence of stimuli. People put too much emphasis on sight. Vision is powerful but limited. Sounds are incredibly moving to me. I experience sound as an expression of nature's poetry. When I was backpacking the Rogue River, we were out miles from anywhere. I heard this Canada goose honking, coming up the canyon. There were very steep walls on each side, and he was getting closer and closer. As he flew over, I heard the individual beating of each wing, which was just so cool. There is magic in the way the forest breathes. I can hear the trees swaying and creaking in the wind. Nature can be a symphony of sound. There's always something out there—even if it's the sound of my own breathing or the bite of a brisk wind on my skin. Curiosity drives me. Somebody once said, "Curiosity is lust of the mind." And it's true.

In many ways it's incumbent upon all of us to play the hand that we're dealt to the best of our ability. I have an abiding affection for the underdogs of this world. I know just what it feels like. I believe that there's wisdom in history and in the writings of the ancients. There were many brilliant men and women who have lived to put their ideas to paper. It's there for all of us. The best things in life are free, but they won't come for free.

You've got to struggle. Life is meant to be lived fully, and it would be miserable at the very end to realize you lived an unfulfilled life. My world is so much bigger than it used to be.

I didn't get to know my biological father until I was in my late twenties. He spent almost all his life in prison. From the time he was eighteen to fifty-eight, he only had five years free, and three of those were with my mother. I think he was on the run in California for a stabbing or some armed robberies. I associate it with a young, hungry energy.

I remember once my father was talking with this older gentleman, a former Marine from North Carolina. This man looked at my father and asked, "Is this your boy?" And my father just smiled, and I could hear the smile in his voice. He said, "I don't know, man, but I sure claim him." It made me feel good.

Throughout most of my life, people used my father against me. More like a moral hammer to beat me with. I don't think a person necessarily is a sum of their mistakes. For some, I'm sure he was seen as a dangerous man. I knew a very charming man. He was a kind man. He never lied to me. However, he made a lot of bad choices—and in this world our choices catch up with us.

SYLVIA PEREZ

My parents were absolutely shocked when their first child was born visually impaired. We do not have a family history of retinitis pigmentosa. In my mid-twenties I received the prognosis that what vision I had would be gone by the age of thirty. I cried and I went through all the stages of grief. How can this happen to me? I've been a good person. Eventually I came to understand that I could do it. I remember my orientation and mobility instructor said, "Look, you have a choice, you can either look blind and carry a cane or you can look drunk and not carry one." Adjusting to blindness emotionally is far more challenging than adjusting to blindness physically.

My name is Sylvia Stinson Perez. I am the executive director and chief operating officer of the Lighthouse for the Visually Impaired and Blind in Port Richey, Florida. Our mission is to provide the blind and visually impaired with the skills needed to achieve their maximum independence.

I was born to young parents, twenty and twenty-one years old. As a little girl, I was the oldest of five children. I remember doing cartwheels in our backyard and playing with my brother and sisters. We grew up low income, and life was always a bit of a struggle. My parents really instilled in us that if we worked hard, we could accomplish things. I don't think of myself as a blind woman. I am a mother, a wife, and a leader of an organization. I'm also a daughter, a sister, and a friend. I'm all of those things. Blindness just happens to be one of my characteristics.

When I was growing up, I remember feeling like an alien on this planet. My classmates ostracized me. They treated me as if I was contagious. I just couldn't see the board or play baseball. I went through most of high school without saying a single word. The teachers were not prepared to work with students with a visual impairment. I learned to listen so I could survive. I did that from the day I started school through the day I graduated.

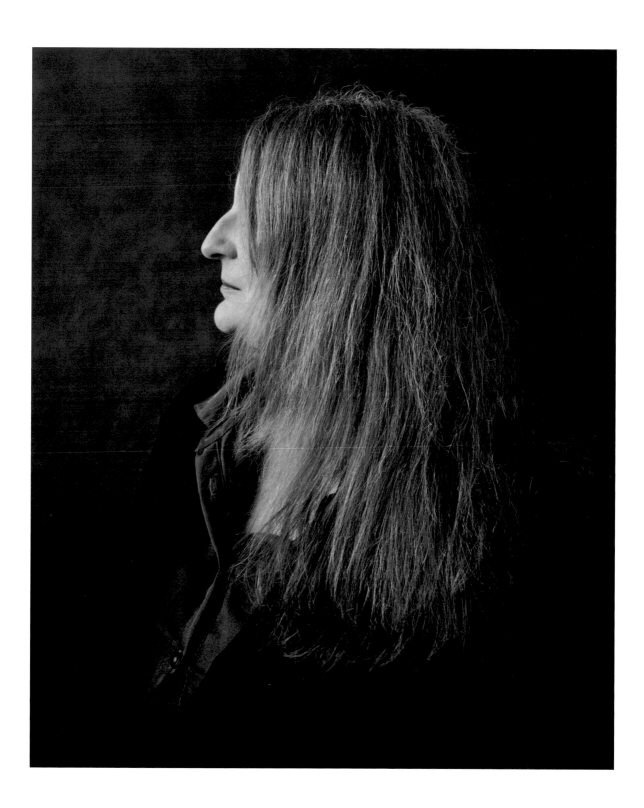

I decided I was going to be a different person. When I went to college I said, "I'm going to be outgoing, I'm going to make friends, I'm going to make something of myself." I ended up moving in with some amazing roommates who treated me as if I was just another person. One roommate said, "I think you should go into social work." I went into the social work program, and I got my degree. I actually went back to school and got two additional master's degrees, one in visual disabilities and the second in business administration.

Dating is scary when you're visually impaired or blind, because you have an automatic impression that people are going to judge you right away. When you're dating you have this feeling that you have to act and look perfect. There is a feeling that you aren't worthy. When most blind people go on a date, they eat very little because they're afraid to embarrass themselves. I have been married for almost twenty-four years. For many years I felt like I was a nuisance because I needed my husband to drive me places. I can't drive to the grocery store by myself. I worked really hard (even in my marriage) to prove that I could be independent. My husband never treated me like I was a nuisance, but I worried that I was.

It is really hard to lose your sight. It's learning to think differently, learning to be innovative and creative. Those are essential. It takes a lot of energy to be blind, because your brain has to be constantly thinking about everything you're going to do. I actually learned Braille when I was thirty years old. It's all about attitude. There is a lot of memorization to learn how to feel. I read Braille notes for speeches and read books in Braille. Braille is an important part of my life. I would say that most of the time I forget that I'm blind. Subconsciously it's always there; your brain is in constant action.

I am blind, but I am also very visual. I want to know what everyone looks like. I want to know what they're wearing. I think most sighted people think that if you're blind, vision does not matter to you anymore. That all of a sudden you have these magical hearing abilities, and that's not true. I have a lot of visual memories, pictures in my mind. I remember many scenes from childhood and adulthood. I use mental imagery to get around. I know what streets, sidewalks, trees, and benches look like. It helps out a lot to be able to create images to fill in all of the information. When most people read a book, they create images of what they're reading. I do that as well, but I also do that with life.

There is no respect for people who are blind—and that is a reality. Many times we are treated as if we also have an intellectual disability. There is a pervasive belief that blindness is one of the worst things that can happen. That you could hurt yourself or hurt others. Blindness is not the end of the world. Blindness does not mean that you cannot be a good mother, a good wife, and a good friend. Blindness does not mean that you cannot have a fantastic career.

One of the most serious issues still facing blind people is the belief that they are not equal, which causes many blind people to isolate themselves and not live up to their potential. What makes me really angry is that over 70 percent of people who are visually impaired or blind do not work. Blindness could happen to anyone. Every single person is imperfect. We all have challenges. It absolutely amazes me the ridiculous things that people ask me, like "Do you actually work? Do you put on

your own makeup? Do you dress yourself?" I often hear people tell me I'm amazing—but it's not a compliment. I don't want to be considered amazing because I can cross the street without getting run over. My challenge is that I can't see. It doesn't make me less intelligent, less capable, less competent. It makes me more courageous, more determined, and more independent.

I need to always be figuring out how not to make mistakes. I do have crazy blind moments, and I have learned to laugh at myself. Shortly after we were married, my husband and I were in the grocery store. He went one way, and I went another. When I went back to find him, I walked up and just grabbed this guy, gave him a pat on the butt, thinking it was my husband. It was definitely not my husband. And here comes my husband, laughing. I learned from then on that I'm going to have these funny crazy blind moments.

There is a lot of information that you can gather from the world by listening. I can even gather information about people's attitudes. I can hear it in how they're breathing, their intonation, even silences and pauses. I can hear people's discomfort and anxiety. I can tell when someone is listening to me or looking away. There's something about the way they turn their head. I can tell when someone's rolling their eyes, looking in another direction, or texting, even though I can't see them.

If I'm walking down a sidewalk, I'm aware of what is under my feet and how the textures change. Being aware of those things impacts my ability to get around. I also use sense of touch without having to physically touch something. I can feel a wall or a post because the air changes. The space and air around you is constantly changing.

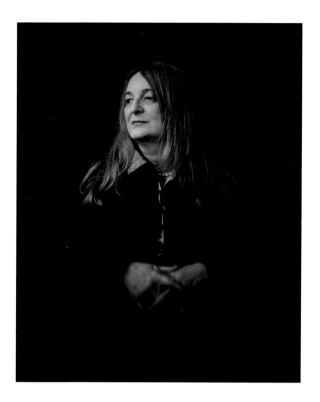

When I'm walking I can feel people that are near me. Many times they won't say a word. I think they just freeze. It's just shocking that people won't say anything.

Sighted people can learn from people who are blind. There are many ways to fully experience the world and to be aware of all the nuances. It's my understanding that most of the information a sighted person takes in is driven by visual images. They know people by what they look like. Their experiences are visual. When you are blind, you have to judge from a totally different perspective. I think a blind person may be much more open to allowing people to be who they are and experiencing things fully rather than just visually.

VIRGIL STINNETT

My name is Virgil. I'm a forty-six-year-old Pacific Islander. I work in the food service industry as a Department of Defense food service contractor. I am a blind entrepreneur. I service our troops, which I proudly do because they are out there risking their lives for our freedom and our country. It fluctuates, but I normally have about forty-three employees working for me.

I'm married to a wonderful woman, and her name is Katie. We live in Honolulu, Hawaii, just outside of Waikiki, close to the foot of Diamond Head crater. We have the beautiful Pacific Ocean on one side and the incredible Kapiolani Park on the other side. So it's a great place to be outdoors, either walking or playing in the ocean. Every place has its own beauty, but I do believe where we live is paradise.

When I went blind, I was out in the middle of the ocean as a commercial fisherman. We were nine hundred miles from the nearest port. It's basically a livelihood catching big game, big fish, tuna, and swordfish. It's rough. It's rugged. Once you start fishing, you're constantly up a good twenty hours a day. It's just constant—constant hard work.

Being out in the middle of the ocean on a clear day and looking at the whole span of the ocean is just incredible. I look at myself and I'm this tiny little dot with this vastness of the whole ocean. It's very humbling. You really have to respect the ocean, because one minute she could be calm and glassy—then the next moment she could turn violent and be your worst nightmare.

Well, when it happened, I was going down to check the engine room to make sure that the fuel gauges were balanced. It was like somebody turned off the lights. I could not see anything. I think I was down there for a while before my captain said, "Virgil, are you all right?" I said, "Yeah. Turn on the damn lights." And he said, "They're on."

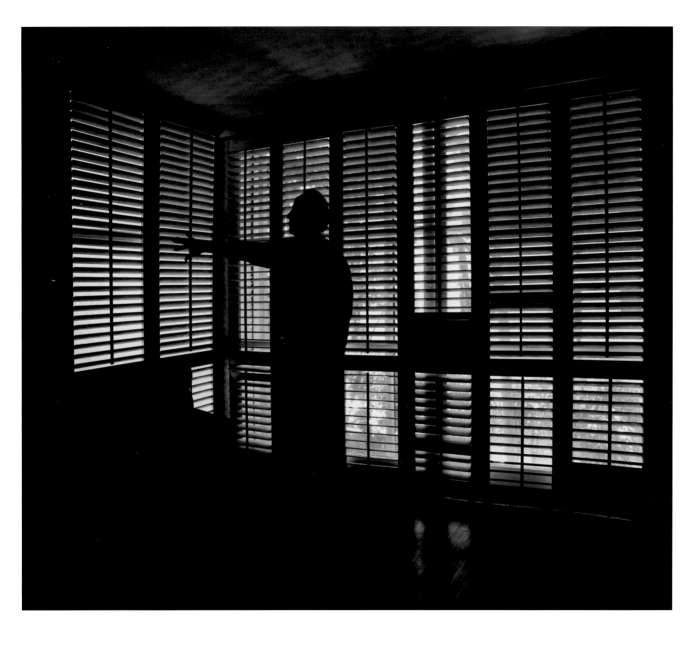

Detached retinas are sometimes called a boxer's disease. It's traumatic blows to the head. But that did not happen. I did not fall. I did not bang my head. It's a tear in the retina in the back of the eye. For some reason, it happened in both of my eyes.

As soon as we got off the boat I locked myself up in a motel room. I don't know how long I was there. It was probably the scariest thing on earth to me. I don't know if I cried, but I screamed. I got pretty violent. I hit brick walls. I would scream and holler at police officers, trying to get them to take me to jail. I didn't know what to do with myself. I did not want to commit suicide, even though the thoughts were there. At that time I thought to myself, "I can't do it anymore. There's no way I can do this. I can't do blindness."

The first year was the roughest. I've had at least five retinal surgeries, because my retinas detached every time. I think it impacted my doctor the hardest, because he couldn't fix my eyes. I could hear it in his voice that there was nothing else he can do. My doctor was the one that told me about Ho'opono. It is a blind center that could help me get around. As soon as I accepted my situation I realized that I needed to learn how to become independent. I went through the whole program, but it wasn't an easy road.

When I was going through classes at the center, I met my wife, Katie. What really caught my attention was this woman, also blind, who was walking down the halls tip-tapping with confidence. What do I holler? "Who's that mystery woman?" There was something magical about us being together. We had this instant connection. The winds of heaven blew us together. I was this old seadog

fisherman, and Katie was a mermaid. She just captured me and took my heart.

When Katie and I were dating, she gave me my first rigid cane with a metal tip. That was a moment I won't forget. I remember crossing one street, and I heard a building, the curb, just by the echo of the sound of that tip of the cane. I was like, "Wow!" The old cane had a nylon tip and was really heavy. My shoulders, hand, and wrist were sore. The new cane allowed me to walk with a longer stride, a better pace, and be more comfortable. Having the right cane is an extension of who you are. It makes you a better traveler.

At Thanksgiving this year I will have been blind twenty years. I didn't know a lot then. But today I understand there are opportunities, there is life. You can live a prosperous, joyful life even after losing your sight.

Katie and I have mentored many blind people. We bring them into our home. They become a part of our life and family. We see the joy in the ones that succeed and the disappointments in the ones that decide to give up. But we still continue to encourage them that they can do whatever they want. I guess the greatest example we can give is just living our life and being as normal as anybody else. That's the example we want to project.

The word "amazing" has become a thorn in my side. Almost every time I walk down the sidewalk people would stop me and say, "Oh, you're so amazing." Really? What am I doing that I'm so amazing? I'm getting out there, because I need to go to work or go to the grocery store. It becomes a negative word in my mind because I hear it so much. Am I amazing because I know how to pick

up my fork and eat? When people realize that my wife is also blind, they ask, "Who cooks for you? Who cleans for you?" Do they think someone has to wipe my ass? The public sees us as helpless. What gets me mad are those words that people use to say how wonderful you are just because you're living.

Talk about misperceptions. People think that because I'm blind, I can hear better. No. I've had ear tests before and after I was blind, and the results show my hearing is the same. What has changed is that I have become more focused on my surroundings. I now pay attention to the level and the quality of sound.

I listen to everything around me—people, traffic, sound change, echo change, or even the textures. When I'm walking down the sidewalk, I have to be really aware of what's around me. A few years ago I started running with a friend. We held a shoestring between us. He would tug it in a particular direction if I was veering off the curb. If it was loose, I had free room to run. I remember running and I said, "Did we just pass a wooden pole?" My friend looked at me and said, "How the heck did you know that?" And I said, "I really don't know. It's like I could feel it."

I am a firm believer that everything has energy—whether it's a dead tree, a pole, iron, or a person. Every object out there gives out something. I could walk by people and not even physically touch them but can feel their energy coming off of them.

Anybody can be successful, have a rich, fulfilling life, and it has nothing to do with blindness. I'm not saying you'll be able to see again. It's important to accept the condition that you're in, and learn to take the next step forward so you can live as fully as anybody else. You have to first undergo your own transformation of thinking differently. It's a transformation of oneself, one's attitude, and one's way of thinking.

The essence of who I am today hasn't changed. It is the closeness and a bond I have with family. I'm talking actual blood relatives, but that also carries over to people I meet and friends. I tend to keep a close relationship with all of them. I've always been that way. I still reach out to my families across the country and around the world. It's important to know who you are and where you came from.

ROGER MEYERS

My name is Roger. I'm fifty-eight and totally blind. I'm building a house in the country by myself. The house is located on ten acres of flat land. I've planted some mango trees that are about seven feet tall. I grew them from seed. I can imagine someday having flowering bushes and a few parrots or canaries around. I would like to be finished with my house, but I see it probably taking me another two to three years to complete.

I grew up in Nigeria and lived there until I was sixteen. My parents were medical missionaries. I remember the house where we lived, which had lots of different tropical trees. We had a sun tree plant that grew maybe thirty feet with flowers on the top. I couldn't see the colors, but I could see the stalk going up. When I was at the boarding school, some of the kids would have races with rhinoceros beetles. Some children had little bugs that they kept as pets. They would tie a string to their legs and let the bug fly around. I wasn't too impressed with tying the string to their leg, but it was interesting anyhow.

My parents noticed that I was having problems seeing when I was three years old. At first they tried to fit me with glasses, but they didn't do any good. They got a powerful lamp, so I could see the contrast of different colors. My parents were from the old school, so they would try to make use of all the sight the child had. They would read everything to me. I remember my parents from their voices. They tried to help me see the world, and would describe things that I couldn't see. My dad would read stories to all of us at night. His voice was low, and he didn't have a lot of pauses between sentences. He would make interesting comments in the middle of the story, so it would be funny. He would stop when there was something exciting happening and would say, "Okay, children, that's the end of the

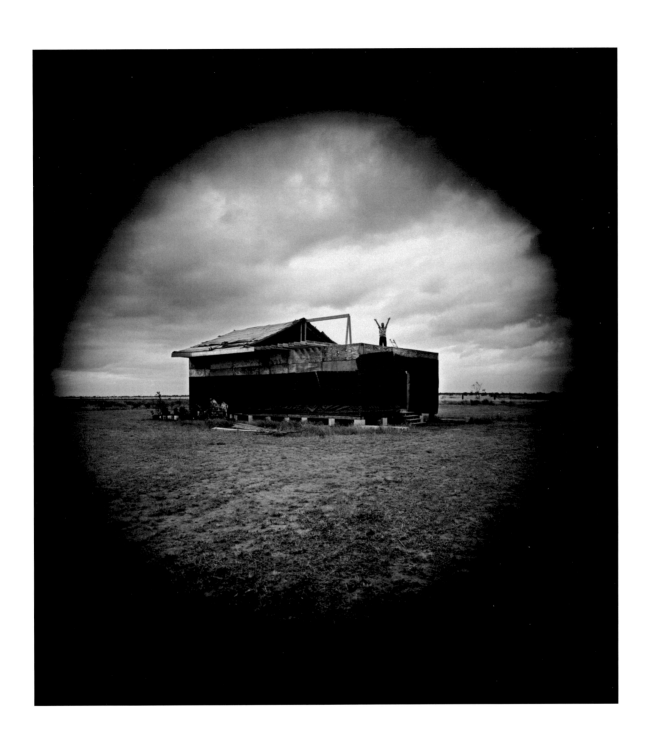

book for tonight." All of us would say, "Don't stop there, read some more."

As a child I wasn't upset with my vision loss. I don't remember seeing parts of a person's face, unless it was when I was in the first grade. I remember seeing the cartoons on television, like Kimba the white lion running across the screen. I realized that I was different from the other children, but when you're a child it's easy not to think about the differences. I just adapted to the new situations that came along. I think it's more like your lot in life. It's just the way things are.

I have retinitis pigmentosa, which develops when the rods and cones that receive light start malfunctioning. As you get older you have continuous losses and you have to adapt. Now I can see light and dark, but not much else. My grandfather was blind, and he taught me the Braille alphabet. He was an architect and designed his own house. That got me thinking about building my own house.

If a blind person likes to work with wood and they're very creative with their ideas of how to do things, I don't see any reason that a blind person can't build a house. I take precautions. I started building my house two years ago. I measured back from the paved road and put stakes in the ground. I made a rectangle twenty-five feet wide by forty-eight feet long. I visualized the house like drawings in my mind, so that I know where the doors and windows are located.

I've had some help along the way but not a lot. When I have an eight-by-ten-foot section to raise into position, it's very heavy, and so I had some help with that. I like to be as independent as possible. I'm not really afraid of falling off the roof.

When I'm putting tarpaper on the roof, I put a two-by-four all along the edges—so if I start sliding down my feet will hit the two-by-four instead of falling off the edge. I can take a two-by-two board (they're eight feet long) and probe with it like it's a cane to get an idea of distances.

People have told me that I should not build a house. That it would not be up to code or it would fall down. Some have told me that it is dangerous to live in the country with snakes, coyotes, and scorpions that I can't see. I've heard all of that, but I've decided I'm going to finish my house one way or another.

As I lost my sight, I had to depend on my other senses. I notice many things that other people do not notice. I can hear somebody opening a can or rattling paper. Many sounds become landmarks. When I'm walking I might hear signs that rattle, dogs that bark, or a neighbor's air-conditioner. If I'm outside I can hear echoes off buildings. If I'm near my house, I can clap my hands and hear the echo off my house. That will help me find my house. Sometimes if I'm near a tree, the tree will block sound from that direction. I can sort of tell where the tree is located. I don't think I'm actually hearing the tree. I'm hearing the blocked sound from that direction. One thing that bothers me is that people can see me but I cannot see them. Someone might be spying on me. That's a little scary.

I can see with my hands. Sound doesn't give you the detail that touching gives you. If I touch something I can tell what texture it has. I can tell the shape of the object. I can orient my direction by lining myself up in a doorway or to step off onto the stairs. Blindness has helped me be aware of

the tones of people's voices and see what kind of emotions or personality they have. It has helped develop my skills in listening and touching, which I would not have developed if I was fully sighted.

Blindness does not mean that a person cannot go to college, find a job, and live a full life. I graduated with a BS in biology and applied mathematics. I would record all the lectures. I graduated cum laude. I've worked as a computer programmer for a college. My brother and I started a pet shop. He took care of the financial transactions, and I would help select and order the supplies. I've worked at a print shop. I've also worked at the Lighthouse for the Blind.

I started having depression in my twenties. When I'm depressed, I feel lonely. Many times I'll try to distract myself by listening to news on the television, or I'll call different people to see if they have something positive to say. I think the depression has been worse than the blindness. People want to help a blind person. Nobody wants to be around a person that's depressed. You don't get any support from other people. Music helps me get out my feelings. The songs I play on the piano are mostly tunes that I've composed. When I'm creat-

ing anything it helps my depression. Whether I'm creating a tune on the piano or cooking or working on my house, it helps.

Faith is very important. It has allowed me to develop satisfaction and a purpose in life.

Living with nature is very helpful because it gives you a way to step back and find out what is really important. I think heaven will have plants and animals like earth. What will be missing in heaven is the hatred of people. I think people may or may not have all their senses. God will be able to restore someone's sight, if He thinks it's important. The senses are not the person. A person is their personality, their thoughts, and how they treat their environment.

I'm not a hermit. I wouldn't like being alone in the country. What I would like to do when my house is finished is allow the homeless or poor to stay for a week. They wouldn't be charged. They could just stay, and if they want to help out with something, that's fine. If they don't, they don't.

Blindness doesn't mean that you can't have friends, go to church, and do most things that you want to do. I don't really think about blindness much. I guess it's just become a part of me.

JEFFREY OLIVAREZ

When I was a teenager I loved working. I've always been a hard worker. In the sixth grade I volunteered to be a crossing guard. I would hold the flag out while kids crossed the street. It made me feel important. I used to have a newspaper route. It was a tough job—getting up at four in the morning and getting all the papers rolled and thrown before I went to school. I also did yard work, and in the wintertime I shoveled snow out of people's driveways. In high school I sacked groceries and cleaned the store. The dirtiest job I ever had was working on a hog farm. The hogs scream so loud and make such ugly sounds. They're always snorting and slapping around in the mud [*laughing and making hog sounds*].

My mom was a very good and loving mother when I was growing up as a teenager. As the years went by, she started drinking alcohol and would get drunk. My stepfather would fight with her and accuse her of being with another man. He'd be throwing furniture, dishes, and everything. He would shoot holes in the walls with his gun, making my stepbrothers and sisters cry and scream. There were times when they would be gone two days at a time, leaving me home with the children. When they were gone, I had to change diapers and always fed them and everything. I didn't have any freedom. My mother used to take my finances so they could go drinking. They would always be talking about whose eyes she clawed out when she got into a fight at the bars. It was really ugly. He used to beat on my mother and hold her down and punch her. Sometimes I had to call the police. I was scared of my stepfather at that time. He was wild.

I was really depressed about my mother and stepfather being alcoholics. It was really hard for me to concentrate on my schoolwork. On the last day of high school my principal told me I wasn't going to be able to go to graduation. To make

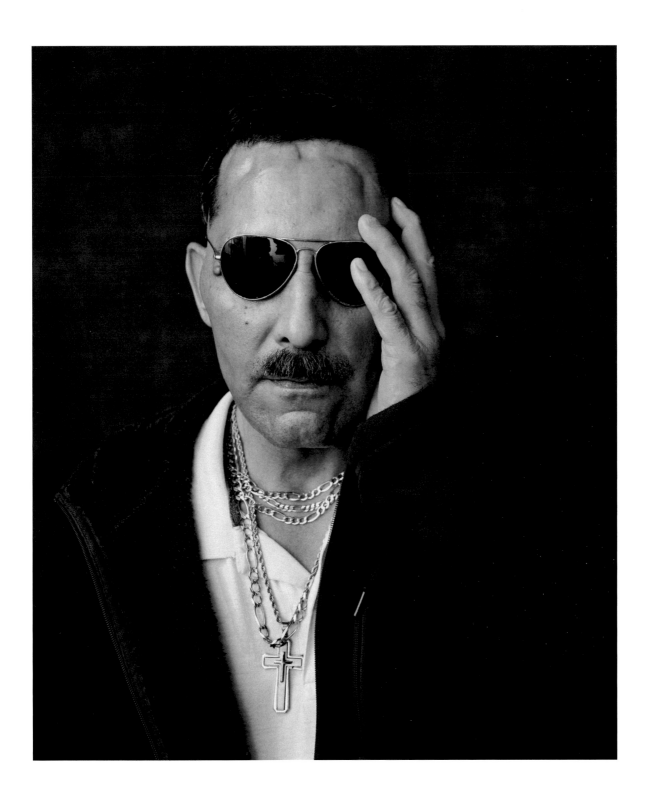

matters worse, I had just gotten my 1975 Buick Regal painted and somebody sprayed white paint all over my brand-new paint job. All those things made me really distressed, and I figured it was the end of the world. I just wanted to give up after all that had happened.

I knew my mother kept her gun underneath her mattress. When she left I got the gun and went upstairs to my bedroom. I was on my hands and knees in front of my mirror, holding the little pistol to my head. I was really scared. I wanted to take my life but wasn't sure if I was going to or not. My stepfather came upstairs, and he held a .22 rifle to my head. He was cursing at me, saying, "You motherf——er, if you don't pull the trigger I'm going to." The last thing I remember seeing was my stepfather forcing me to shoot myself. I don't think I would have shot myself if he hadn't come up to my room. The doctor said I would never see again, because I had severed my optic nerve and there was no way of repairing it.

After I lost my sight I was really depressed. I just stayed in my room most of the time. I didn't have any goals in my life. I just felt sorry for myself. I would have flashbacks when I'd hear loud noises or gunshots. It would make my nerves quiver. I didn't think there was any hope for me. My mother and stepfather started drinking more and more, and staying out all the time. They would leave me to take care of my brothers and sisters.

My grandfather saved me and gave me a new destination in life. He knew how depressed I was and convinced me to come to Texas to start a new life. When I came to Texas he got me a job at the San Antonio Lighthouse for the Blind. A few years later he helped me buy a house. I paid it off in ten years, but now my grandfather has Alzheimer's real bad. He can't even remember his own family, but I give thanks for all the good deeds that he has done.

I've been employed at the San Antonio Lighthouse now for twenty-six years this July. I was recognized for all my hard work, and I received the employee of the year award. I got to go to New Orleans for four days. It was a nice recognition. The Lighthouse has meant a lot to me. I feel secure knowing that I have a full-time job. I bought a house. I hardly ever miss work. I usually get perfect attendance every year. I love to keep all my bills paid, and I don't like to be in debt. I just learned to accept my life as I am. I don't have any more anger about being blind. I do the best I can and try to be as independent as possible.

Many times you can know a person's character just by the sound of their voice. It's really disrupting to me when I hear people with filthy mouths talking bad. Once, across the street I heard a little kid say, "Mommy?" The mother just screamed at her kid so loud that the little kid started crying. It really hurts me when parents treat their children like that.

Before I went blind I didn't really pay attention to all the sounds outside. Now that I am blind my sense of hearing has gotten really good and more sensitive. I'm able to hear everything. I pay attention to all the sounds of trains, cars, and planes flying by. I love to hear horses [*making horse sounds*] and birds whistling. I've gotten better at hearing echo sounds. I used to count my steps at work, but now when I'm walking down a hallway

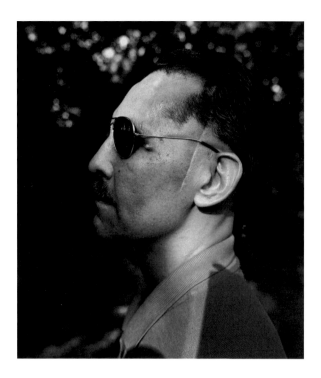

I listen for the different echo sounds. The echoes will tell me when to turn or exit.

I don't have a girlfriend, and I wonder if I'm going to be single for the rest of my life. I live alone and have been lonely at times, and that's why I communicate with the birds around me. I'm pretty good at imitating sounds of birds. I feel bad now for shooting birds when I was a kid. When they see me walking up to my house, they start whistling at me. I whistle back at them through the house. I do it every day when I get home from work. Sometimes these birds are my best friends because I like to communicate and whistle back at them. It's like they have somebody who talks to them [*laughing and whistling bird sounds*].

I loved my mother very much, and she died when she was only thirty-seven. It was really hard for me, thinking it was my fault. When I moved out she cried. She didn't want me to leave. One month after I left she got killed by her own sister. Her sister backed up over her with a car and killed her. I have flashbacks, and I think of all the good times and things my mother did for me. So now it keeps me motivated. My mother would be proud of all the things that I do. I always give credit to her for teaching me the things that I did when I was a kid. I always picture in my mind her talking to me today. She had her good points and bad points, but I always try to remember the good things about my mother.

FRANCES FUENTES

When I was in my very early twenties I became pregnant, and I had a baby boy. I was not married at the time. I didn't have such good luck with men. I struggled. The father was much older than me and knew better tricks. He was taking too much advantage of me, so I had to learn how to survive with my child, how to make do for him and for myself. I lost my sight when my child was eleven months old. I still remember his face. I touched his nose and his little ears.

Well, it happened one night after I had finished cleaning my house. I was reading the newspaper and started seeing things I had never seen before. The letters were green and moving. I started getting, like, real sharp pains in my eyeballs, and that made me even worser than worse. I knew it was something to be worried about. I went to see an eye doctor, and he said I would get over it. But I never did. So I just started going blind minute by minute, second by second. Later the doctors said that it was a rare disorder, and they didn't know the cause or the cure. That's how I stayed completely in the darkness.

When I first became blind I couldn't take it. I couldn't believe I was not able to see. If somebody would come to me and say, "Oh, you're blind," at first I used to get angry, because I didn't like anyone to know that I was blind. I used to live my life like anybody else that can see. My child was eleven months old. I used to cry my eyes out. It was so hard for me to be in the darkness.

When I lost my sight, people wanted to take my child away. They said, "You can't take care of your child because now you're in the darkness. You can't see if he cuts his hand, or a spider bites him, or he's choking, or if anything happens to him." So I had to fight for him.

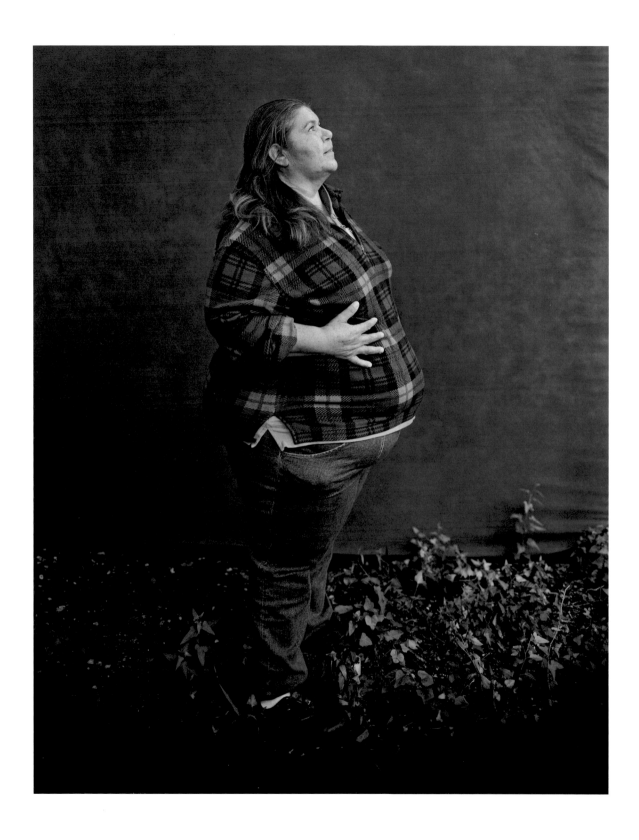

I fought with my tears. I started crying so much for my son. I had to show them how much I loved him, how much I needed him. Being blind, it's not an obstacle because my heart is not blind. Having a kind heart, a loving heart, is more important than being blind. I know it was water coming out of my eyes, but I could feel like it was real blood—because I love him so dearly. He was my main reason to live.

Being blind, I have to use my other senses. A mother could be even a better mother when she's blind. When you're sighted you just turn around and look at your child. But when you're blind you really pay close attention to the way he breathes and all the sounds he makes. There were times when my little baby would fall asleep on the floor and I would be looking for him. I would make sure to walk slowly—slowly—so I wouldn't bump into him or fall on top of him. I would hear his breathing [*makes breathing sounds*], so I knew he was right there.

I learned how to do all the things in my house like sweeping, mopping, cooking, cutting, sewing, and how to take care of my son. Being a good mother in the darkness is taking care of your child with all your love, teaching him all the good safe habits. I always play around with him. I would pretend to find little animals inside his hair. Like I tell him, "Oh, look, I think I'm feeling a giraffe in here." And I'll bring the giraffe out and then I'll keep on going. I would say, "Oh, no, there's a lion in your hair." I'd make him feel happy and make him feel that I'm there for him.

I'm just like Superman. Okay, Superman could look through the wall and see what's happening on the other side without stepping inside a house. That's the way I feel sometimes, because something could be happening on the other side of the wall. All I have to do is just pay close attention, and that's like a certain privilege from the darkness.

Being blind is not being helpless. I could even have a business if I wanted to. All I have to use is just my brain, and I don't need my eyes. Blindness is not an obstacle to survive in this world because there are many ways to move about. When I'm walking I can sense when I'm getting close to a wall or a person. I feel something is getting close to me so I have to be more careful. I walk slower and feel with my cane. If a person is passing me very quietly, I can smell the person and have a sense that there's somebody around. I can feel it all over my body.

When I was sighted, I used to listen to soap operas on the radio. I didn't see what was happening, I only heard it happening. If they say the wind was blowing, "*whoosh*." Or if a person dropped keys, "*klinky klink*." So you have to imagine everything you're hearing on the radio. You know if the person is happy or smiling or angry. You sense it by the sounds. I just use my imagination to see the world. What I saw when I was sighted, I can still see in my mind. I can see red and black and green. When you get used to being blind, it's just like being yourself again. I can move about and do everything that I need to do.

I know how it feels to be sighted and to be blind. When I was sighted I could see the world. And now that I'm completely blind, I just feel it, smell it, taste it. It's just like stepping from one dimension to another. It's just like me being bilingual. I could either speak to someone in Spanish or speak to

someone in English. Blindness is a different language. I know both sides, dark and light.

My little baby, as soon as he started walking, he knew I was blind. I never told him that Mommy is blind. When he would see me trying to find my way he would say, "Right here, Mommy, right here." He'll bang on the chair, so I could follow the sound. If he saw I was going to a table, he would hit the table. "Right here, Mommy, right here." He wouldn't stop until he would see me right there. I always hugged him and told him how much I loved him. So anytime he had any fear, he would always come to me, and he knew I was like the Incredible Hulk and nothing could hurt him. I told my son that I was his superhero and that I was going to defend him from anything.

When I was a young girl I did have a hard life. There were times we didn't have anything to eat, and I was abused in many ways. It wasn't just a slap on your face. It was an extension cord from a radio or a big piece of wood on my back. It gave me big bruises and sometimes blood. I was told I was good for nothing and when I grew up I would be a nobody. I didn't find out about having a birthday until I was a grownup. When I was in elementary school, it was me signing my mom's name on the report cards, because I had no one to show their face for me.

I never carried anger, because life is too beautiful. I don't have any enemies. Even though I had a hard life, I didn't carry that, because it would make me miserable. Being blind, I don't see no changes. It's just me, me, and me all the time. If you feel my hand I can feel you. And if I was sighted and you feel my hand, I could still feel you. So I'm alive. I'm alive. It's nobody's fault that I'm blind. It just happened to be. Maybe if I was still sighted, I would have done worse things. And being blind, my soul is safe. So it's better for my soul to be safe than to have my sight and be lost in the world.

ERNEST RAMOS

I've had two events in my life that have affected me dramatically. The first one was when I was struck by lightning, and the second event was when I went blind.

I was in Calaveras Lake fishing with some friends. There was a lightning storm moving toward us. It was a pretty intense and serious storm. Just as we returned to the boat ramp, the storm was on top of us. All I can remember is the brightest blue light and the loudest thunderous sound I've ever heard in my life. They said I looked like a zombie. No expression on my face, and my eyes were rolled back in my head. I was no longer breathing. I remember feeling that I was in a very calm place. The next thing I knew I was in the hospital.

After that experience, I didn't take things for granted anymore. I enjoyed everything around me—my friends, everyday life, sunshine, bad days, good days. I appreciated life in a much different way. After the lightning strike, I had instincts that I never felt before. Perception. Awareness. I could almost sense someone's presence. When I was around certain places, the hair on my arms would stand up. I could feel the energy. It was almost a sense of a magnetic field that I couldn't explain. It's changed me in positive ways. But my mom and dad, being conservative Christian people, said those were bad things that I had. They said that was the devil speaking and working in evil ways. I've kept most of those feelings to myself, because I didn't know whether they were good or bad feelings. I suppressed them for a long time.

I don't know whether the lightning strike contributed to my blindness. It might have; I just don't know. One evening I was watching TV, and I experienced a bright flash across my eyes. I didn't know what had happened. Everything became blurry instantly. I didn't panic. My friend Andrea came over, and I told her that my left

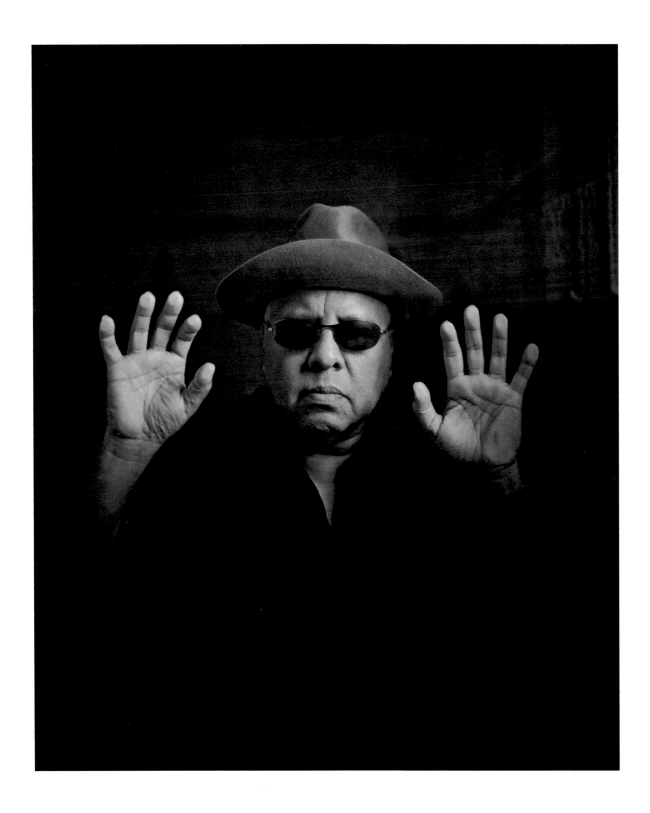

eye was tearing up and couldn't see clearly. She said, "That's not tears, that's blood all over your shirt." At that point I did get scared. They took me to the hospital, and I learned that the blood pressure in my eyes elevated to the point where some blood vessel burst. I had just gone through some treatment for a condition called narrow-angle glaucoma and thought I was okay. I started going to a retina specialist, and she told me, "You have permanent damage to your retinas. You are going to go blind."

When I first lost my sight, the first two weeks I cried. Sometimes uncontrollably. I stayed in my room, wondering what I was going to do. How can I live? I even had some bad thoughts. I was not sleeping or eating. How was I going to be the same person I was before? I wanted so badly to blame somebody, to take out my aggression. I remember crying so hard one night. I woke up the next morning, and it was like somebody snapped a finger: "No more." No more am I going to feel sorry for myself. I'm going to do whatever I need to do to be the person that I was before—and even stronger.

When I first lost my sight, I ignored my other senses. I didn't pay attention to sounds. I didn't pay attention to knowing that I could memorize the number of steps to make a turn into my apartment complex. I was still trying to think like a sighted person. One day I realized that I wasn't listening to what my body or mind were telling me. My mind was telling me to listen, feel, and smell. Acceptance is important—accepting that I was no longer going to be able to see. Once I started utilizing my senses to adapt, I realized, "Oh, wow. Why wasn't I paying attention to this? This is easier than I thought it was going to be."

Sounds are incredible now. When I moved into my apartment I could not sleep well. I could hear every little noise, the person above me in the apartment walking or turning on a faucet. I knew who my neighbors were just by listening to the sound of the car they drove or of a door closing. I could hear little things that gave me peace. A cricket, a bird. I started distinguishing different people by the way they walked. I could tell you who was coming. "It's Robert" or "It's Blanca."

The sound that's most pleasing and relaxing is the sound of children playing and laughing. The sound of a child laughing is so powerful and pure. Children don't have any preconceived notions. It can take away every bit of caution or anger or any emotion I might be having at the time and be at peace.

My senses are so acute now. I'm aware of everything around me. I hear every little sound. I feel my surroundings. Sometimes I don't think I'm able to rest. To be able to relax, I need to tune everything out. I need silence. Silence is crucial to me, which took time for me to develop.

Losing your sight can be real scary, because you feel that you're living in a shadow. Through time, I realized that being blind is not being in a dark world. Light starts to happen. I realized that I was living in a new world. It's the most incredible world that I never saw before.

Some friends who are chefs taught me how to cook healthy. I cook with pots and pans on the stove. I wash my clothes. I utilize an app on the phone to tell the colors of my clothes. The maintenance men in my apartment say my apartment is cleaner than those of sighted people. I want to be completely independent. Every day I learn more.

I love to go dancing because I love country music. I could probably dance better than 80 percent of the guys out there. I love to go on walks, to go to the beach, doing everything that I used to do. I find it difficult to find somebody that accepts me for who I am. Since I have lost sight, I've found out that the public thinks we're helpless. They think we just sit in our homes waiting for somebody to take us by the hand. They think we need help to cut up our food. They think we sit at home with nothing to do. What they don't understand is that we have the same will, wants, and needs as any sighted person. In fact, I have a stronger drive, because I want to be no different than I was when I was sighted. I just have to do things a little differently now. I have a stronger need to be part of everyday life.

Sound is not only something audible. Sound can also become an image. When you hear a ball bouncing off a floor, all of a sudden there is an image of the floor that came from the sound of that ball bouncing. I create images in my mind that I perceive from my other senses. Visualization is very important because it helps me still live in a sighted world. It makes me feel normal. I use the sounds that I hear. I'll use the wind that I'm feeling on my arm. All these things start coming together and start getting faster and faster to where every sense that I have starts to create an image in front of me. As I walk, those mental images become fluid, clearer, and easier for me to walk in a hallway or down a sidewalk. I see bright yellows, blues, greens, purples, and they are absolutely gorgeous colors that I never remember seeing when I was sighted.

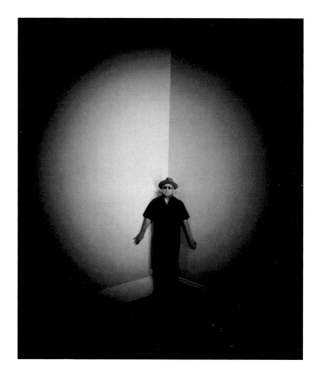

It's very difficult for a sighted person to understand what it is like being blind. When I talk to people that are curious about my blindness, I tell them simply, "Every day start with five minutes, close your eyes when you are at home. I want you to relax and don't think of anything, just listen." A crackling of the leaves outside on the trees. In those five minutes, you will realize there are sounds you didn't hear that were in front of you.

All our senses are with every single one of us, but we ignore them because we're sighted. We depend so much on our vision. When you're blind, you depend on every sense that you have. I feel the direction of the wind. You sense all of that. This is how I live every day of my life.

ROSEANNE RODRÍGUEZ

My name is Roseanne. I've been blind for fifteen years. I am currently working at the Lighthouse for the Blind. I've been there about nine months. I'm adjusting. This is the first job that I've had since I've been blind. I fit right in, and there's no going back. This is the first time that I've been semi-independent. I've always had my husband to depend on. Here at work, I have to do everything for myself. It's comfortable. I feel safe.

I would start by saying, "Why me?" How can I be blind? I did everything I was supposed to do growing up. I was obedient to my parents. I did well in school. I never hung around with the bad crowd. I didn't go out, I didn't drink or smoke. And yet I get paid with this. Sometimes life just takes a turn.

When I started suffering from headaches, I went to many doctors. My head felt like someone was hitting me with a hammer. I experienced a loss of hearing, throwing up, dizziness, and the sunlight was painful. No matter what symptoms I said I was feeling, the doctors said, "All you have are strong migraine headaches." I believed them. The doctor who performed my surgery said, "All this could've been prevented had they given you an MRI." Time was racing against me. It was an artery-vein malformation in the back of my head, preventing blood flow into the brain and the optical nerves. I was bleeding internally and had a brain aneurysm. At the same time, I was pregnant with my first child. I had an eye surgery to cut a hole in the optical nerve to drain some of the fluid—to keep it from pushing my eyeballs out of my face. I went completely blind in my eighth month, right before my son was born. I didn't have a chance to see him.

Being a mother and being blind has been an awesome feeling. It was a learning experience for both of us. From the first day, I've always been real close to him. I

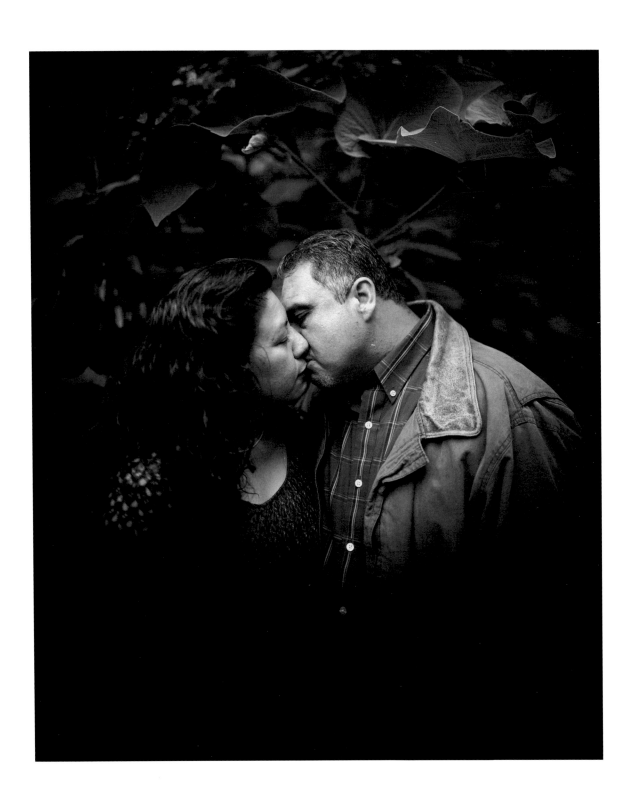

used to crawl on the floor just to know what he was doing and what he was touching. If he crawled, I crawled. If he ran, I ran. Whatever he did, I did.

As he started getting a little bit older, I would explain to him that I couldn't see. He had a whole lot of questions. My example to him was, "The batteries in my eyes ran out, like when your toys run out of batteries. That's what mama's eyes did, the batteries ran out." When we went to stores, he would ask the cashier, "Can we buy batteries for my mom's eyes so she can see—so she can see my face?" I would explain to him, "Oh, these batteries won't work for my eyes."

I dream all the time, every night, and in color. I see the faces of all my loved ones and how I remembered them. One recurring dream is about my son. I'm running to him. I see my son's body, the back of his head, his hands and feet. I have never been able to see his face in my dreams. Every time I try to look at his face, there's this white bright light shining upon him, and I can't seem to look through it.

I never go anywhere by myself. Not to the store, I don't take the bus. I don't walk across the street or even get our mail. If I am at home by myself and for some reason I went outside, I fear somebody might walk into the house quietly, and I would lock myself inside with that person. The fear that I have is because of the kidnapping.

When I was eleven I was on my way to school. I do remember seeing a man in a car. That day it was raining. It got really dark and gloomy. There was no one in sight. The man jumped out of the car and put his hands on my neck and pulled my hair. He beat me, put me in the car, and drove away. All I could think was, "This is it. This is it."

I was screaming and crying, kicking and struggling. He was driving pretty fast, but somehow I opened the car door and jumped out. I landed right in the middle of the street, face-first. He never came back, because some kids were coming from the neighborhood. I ran back to school. I was hysterical. I couldn't even speak. I just kept crying. All I wanted was to be in my room under the covers. My mom took me home, and I finished the remaining school year at home. Now being blind, I should take the bus on my own, but I can't. I have that fear I always carry with me.

I listen to things that I couldn't see before. It's all about how you pay attention. The sounds of voices tell so much. My favorite sound is the rain. When it's raining I put my ear by the window or door and just listen. The raindrops falling on every object outside create different sounds. The dripping is a little constant *glug, glug, glug.* It's like a song. If I sit still and quiet, I can hear footsteps. I can tell if they're dragging their feet or if they're using more of the heel than the whole foot. I can tell if they're upset or they're rushing. I listen for all the little details that people don't pay attention to. I can see so much just by listening.

There's not one day that I don't think about having sight. Every morning right before I open my eyes, I think, "What if today was the day that I could see?" Every day I think about it. Every day I think, "What if I blink and regain my sight?" If I was able to see again, I would pay attention to all my surroundings. I want to see the leaves move on the trees. I want to see the grass, the weeds, the little creatures that crawl on the ground, cracks on the walls, people's faces and their expressions. I would look at everything. At nighttime I would

sit outside and just look at the stars. Things that I never noticed before—definitely I would notice them now.

I am a woman of faith, so I believe that in heaven I will be restored. Here on earth, if we're blind, deaf, or missing any kind of limb, we will be completely restored in heaven. When God calls me home, I will be a healthy, sighted woman. I have learned a lot. I have accepted my blindness, but my heart will always desire to have sight. I am hopeful, and I am a positive person. With the blindness, I think I am more sympathetic to what other people go through. I never say anything negative to anybody. It's the only thing we have. Blindness has changed my identity. My family all see me the same. My husband sees me the same. But friends and the public see me differently. When I was sighted I had friends everywhere I went. When I became blind, all my friends disappeared. They didn't want to hang out with a blind person. It's sad. I'm still the same person as I was—funny, outgoing. I just can't see, and that's the only difference. I can still pretty much do everything except drive a car. But I have not one friend from the past. They didn't want any part of me, as if I were contagious. Blindness is not contagious.

There are three members in our family: my husband, myself, and our child, who is fifteen. Everything we do, we do together. If one is down, the other two help pick that person up. That's the only way that we're going to move forward as a family.

My husband does all the cooking, cleaning, ironing, and washing clothes. I wash the dishes, fold clothes, and dust. He is more than a hard worker. He manages to continue to work and bring the income home. I go and hug him and I touch his arm. I pinch him sometimes, and he says, "What was that for?" "To see if you're real, if you're alive. I don't know how you do what you do, and yet you're still standing strong, standing firm." He treats me as if I'm the only one and the prettiest woman on earth. And I know I'm not. But he treats me that way.

SHELLFORD CANTAN

I love the ocean. I love the sound and smell of the ocean. I love jumping in the water and just feeling the ocean. I can see Punalu'u Black Sands Beach right now in my mind, with a backdrop of some tall coconut trees. I love laying a blanket on the beach and sleeping next to the ocean. It's a beautiful sound, so calming and relaxing.

My mom's grandma was native Hawaiian, one of the few Hawaiians left in the world. I grew up in a small town on the Big Island called Pauhoula. It is a supersmall town that was the last sugar plantation. Our houses were real close together. It was so small that you practically knew everybody. Our island is more unique than the other islands. We have two mountains that have snow. We have a rainforest, deserts, and black and green sand beaches. So I knew we had a special island.

I first began to lose my peripheral vision and then experienced night blindness. Everybody could see what was going on in the dark, but I couldn't. My parents wanted to see what was wrong with my eyes, so they had me go to a doctor. He prescribed these thick sunglasses that made me look weird. Of course little kids are the most vicious, and they'll tell you what they think. They called me blind boy, blind bat, and all these names. I was mad and I got into a lot of fights as a kid. I was like, "Blind? I'll kick your butt. I don't care if I'm blind" [*laughing*].

My younger brother and I flew to Honolulu to see a specialist. We were sitting in the doctor's office, and he came out with my parents. He said, "Unfortunately, your two sons suffer from retinitis pigmentosa. Later in their adult lives they're going to be blind." I was twelve years old at the time, and it was kind of a shock. I went to church every weekend and had a lot of faith. I thought, "God's not going to let this happen to me." I didn't believe it.

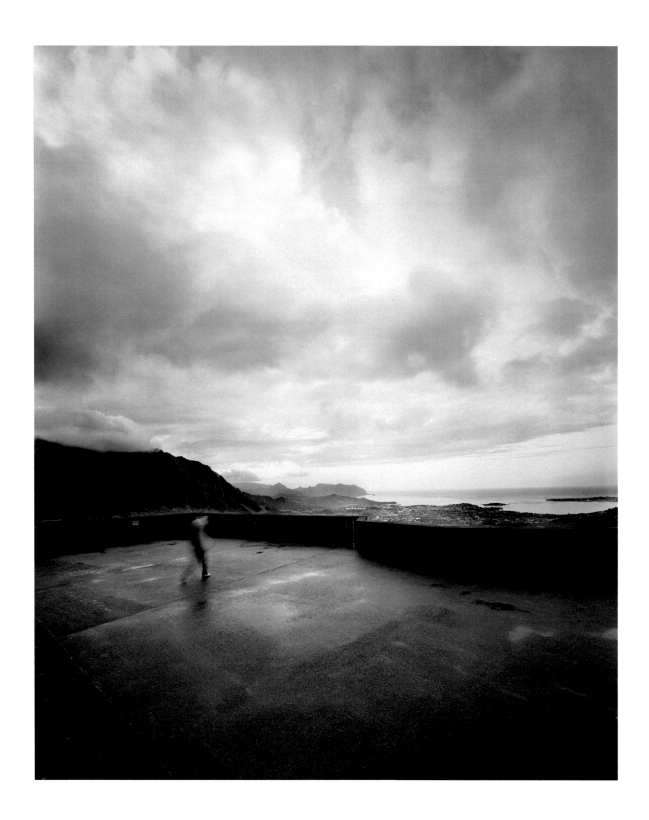

What my dad did for me meant a lot. He didn't treat me any different. He had the same expectations for me that he had for everybody else. He said, "You're not a stupid kid, and all your other senses work fine. Go out and do something with yourself. Being negative isn't going to get you anywhere. The only person who is going to feel sorry for you is yourself." My dad had the ultimate patience and never let me make excuses. I still had to go out and mow the lawn. Even though it took me eight hours to cut the grass, I still had to do it. It helped me understand that I was still expected to do certain things.

Blindness is not normal. I was embarrassed. I'm going to be the oddball. I always wanted to fit in. My uncle actually told me, "You got to get one of those canes. People will know what's wrong with you, and get out of your way. It will make things easier for you." I said, "Never. There's no way you will catch me using a cane." I guess you could call it pride. Now I look at it as stupidity. I've made a lot of mistakes in my life, and one was not seeking the resources that were available—especially going through college. I was in denial. Had I accepted the resources, it would've put me in a better position to avoid the hardship and punishment I was doing to myself.

Five years ago I still could see some shadows. Right now all I can see is light. I can tell whether it's daytime or nighttime, but I can't see shadows or colors or shapes or figures. I didn't lose my eyesight all at once. I gradually grew into my blindness. The worse my vision became, the more I adjusted to it. Everyone has strengths and weaknesses. I do basically all the same things that I did when I was sighted. The only difference is that I can't see now. When I drop something, I feel with my hands instead of looking for it. I listen for different sounds around me. I think I'm more aware now than when I could see. I notice specific sounds and smells—especially in the dark. I have dreams where I can see everything. I'm never blind in my dreams.

When I broke up with my girlfriend of seven years, I had to move back with my parents for a while. It really sucked [laughing]. I blamed the breakup on my blindness. I was depressed for nearly four or five months. I couldn't eat anything. I couldn't sleep. I was just miserable for a long time and didn't want to do anything. My mom said, "You got to get out and do something with your life." I think coming to Honolulu was a wonderful thing, because it got me off the Big Island.

I love being a teacher. It's just weird how I found my calling. I'm not one of those people that can stay in an office all day. I'm an active person and have to be moving around. I went to college for a semester and then finished the blind services program here. I guess they liked my personality. They liked my attitude, and I got called in to the supervisor's office. I thought I was in trouble, because sometimes I like to challenge people. I question a lot of things. They told me to sit down, and Sandy asked me, "Do you want to teach orientation and mobility training?" I said, "Are you serious? Yeah, of course I want to work." It has been the greatest experience of my life. It made me fall in love with the idea of teaching.

When I came to Honolulu, I was focused on gaining my independence. I knew my next girlfriend would have to take me for who I am. I would never again try to hide my blindness. I did get

into another serious relationship, and we dated for three or four years. We had a baby, and he was born early at twenty-five weeks. I went every single day and sat with him at Kapiolani Medical Center for eight months. I just sat there for hours. After work I'd go to the hospital and hang out with him. Eventually his eyes opened. I would talk to him. I would touch his ears. I felt his little nose and his hairline. I created an image in my mind of what he looked like. After his lungs were pretty developed and he was ready to come home, he caught pneumonia and his lungs collapsed again. I tattooed his full name—Jadan—on my forearm. He stayed in the hospital for almost eight months before he passed away.

One of my students asked the other day whether I experienced fear. I think the only fear that I had was "Who's going to want me as a blind person?" I was insecure and didn't have confidence in my ability to date. When my girlfriend left I was afraid that nobody was going to be there to help me. So I think it really motivated me to come to a mobility program like this one and to make sure that I was going to be in control of my own life. Right now I'm an orientation and mobility instructor for vocational rehabilitation in the blindness services branch called Ho'opono. In Hawaiian it means "to make things right." I teach the blind how to travel independently. I try to instill confidence in them. I challenge my students to have high expectations. I try to change the perceptions they might have (or that society has about blind people). Society relates the word "blind" to something so negative and horrible.

I've had all kinds of different reactions from the public when it comes to my blindness. People think I'm either super helpless or that I'm so amazing. I tell them, "Why am I amazing? I'm going out, working like you are." This one lady came up to me at a bus stop and said, "I feel so sorry for you." I said, "Why?" She was like, "Because you're blind. That's the worst thing that can happen to anybody." I said, "Really? So a mom and dad losing their child, that's not worse than being blind?"

All blindness is is a slight inconvenience. That's all it is. I share with my students that there's nothing wrong with being blind. It's not the end of the world. With the right attitude, the right training, and the right opportunities, you can contribute. You can be productive in society.

LARRY JOHNSON

Well, it's strange, but the first memory I have of being able to see was when I was about four years old—I held up a fork in front of my face with the four prongs and handle. I remember seeing green grass between the sidewalk and street and the shadows of trees. I have no idea what a face, or a mountain, or even a river looks like.

I have no memory of losing my sight, because it happened when I was a baby—infantile glaucoma. I remember my mother saying that when she was bathing me, she saw a film fall over my eyes. The problem with glaucoma is the buildup of fluid in the eyeball that creates pressure on the optic nerve. If the pressure is not relieved, then eventually it will damage or destroy the optic nerve.

As I grew up, my eyes were hypersensitive to any kind of light. It would cause an excruciating pain, so I wore very dark goggles, which my mother painted with black shoe polish. It was a blessing that as I lost more of my sight the pain diminished. The only thing the doctors knew was to make incisions in my eyeball to release the pressure. They did that three times and finally gave up. My right eye had some light perception, but gradually that has also diminished. Now I'm totally blind.

I loved playing baseball even though I could never catch the ball. I loved being out in the field and hearing the ball hit the bat. I was six or seven years old when I first became a baseball fan. I was excited about being out on the field, with the possibility of maybe one day I'll catch that damn ball.

We had a big, tall radio in our living room. I heard this voice coming out of the speaker. The announcer would describe the game in a very excited and emotional way. It was so stimulating. I grew up in a very fertile time for a person to develop and use their imagination. The sound effects were marvelous, because they enhanced the whole picture. I imagined there was a real person inside of that

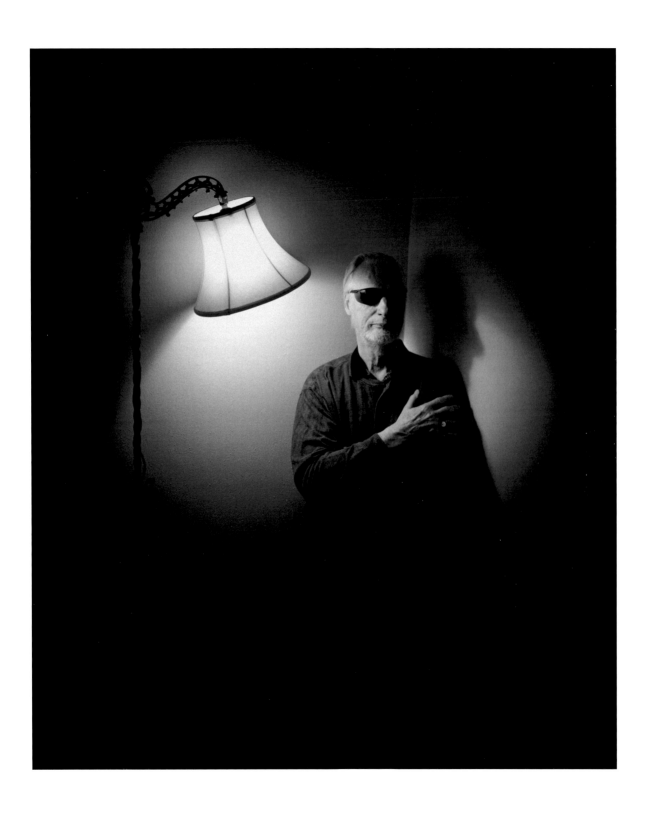

big box, talking to me. I thought, "Wow—I'd like to be in that box one day and do what he's doing." I used to practice imitating the announcer as he described the game. I would begin, "Luke Appling steps in the batter's box. He is batting .253 right now. Here's the windup and the pitch. A swing and a miss, strike one. There's the next pitch, it's low and outside. Ball one." Or, "The shortstop dives and makes a one-handed stop." You could feel it. And you could experience it. And it was part of my game—part of my own entertainment.

I was sixteen when I acquired my guide dog, Tasha. With Tasha I gained a new sense of freedom, independence, and self-confidence. I felt I could go anywhere or do anything with her at my side. My strongest enthusiasm at that time was learning Spanish as a second language. I had an interest in Mexican people, culture, and food. I thought, "Wouldn't it be wonderful to take a trip to Mexico?" Tasha and I could travel alone. Many of these decisions were based on the belief that I could do it.

It took about a year of planning and persuading my family. My mother always supported my daring adventures to try something new. In the 1950s it was possible to take the train all the way from St. Louis to Mexico City. My travels began when I crossed into Mexico. With my limited Spanish, I tried to find out if the train would stop long enough so I could take Tasha to answer nature's call. I asked the conductor, and he told me, "*Oh, no problema, señor, no problema.*"

Well, there was a *problema*, because as soon as I released Tasha from her harness the train pulled away. I was left in this little town halfway between the Mexican border and San Luis Potosí.

I was quite worried and fearful. What was I going to do? My luggage was on the train. I didn't even know the name of the town. Tasha was my source of self-confidence and support. When she came back, I hugged her and she licked me in the face. I thought, "It's going to be okay."

Oh, I've felt sorry for myself many times throughout my life: when I was turned down by a girl or when my ideas were ignored. When I didn't get the job I wanted or when publishers kept turning down my first book. There have been many times in my life when I've felt that I've not been appreciated or understood or given the opportunity to show what I'm capable of. It's very easy blaming the disappointment or rejection on the condition of blindness.

Yes, blindness can be a challenge at times. It causes me to plan different options. It requires some thoughtful planning. I think attitude is the single most important aspect of a person's approach to life. I think attitude determines our success and failure to a large extent. In my case, my mother's attitude of optimism and determination certainly rubbed off. My mother's philosophy has been the most important factor in believing that I can take one more step up that ladder. My mother always told us, "Life's too short. There is no circumstance or disappointment you should waste your time dwelling on." She overcame tremendous odds, when she decided to separate from my father because he was unable to overcome his addiction to gambling. She decided, with only a high school education and no work experience, to take her four children and strike out on her own without any financial help. That took guts and incredible fortitude. I think her wisdom and

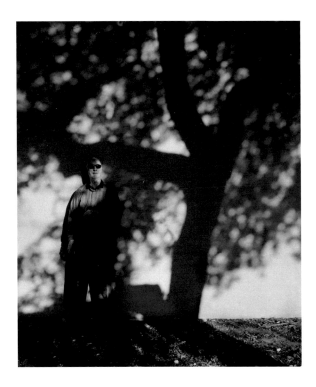

determination have stayed with me all through my life.

When I was young I loved reading Sherlock Holmes mysteries. I was fascinated by his powers of observation, how he worked out solutions to these puzzles. I've always enjoyed the challenges of figuring out things, of puzzle solving. I try not to be in circumstances where I become disoriented. Once I was going to a store and it was snowing. The wind was blowing. I couldn't really detect the sidewalk. I got lost and didn't know if I was in the street or where I was. It was getting colder and colder. I wandered around for a while and thought, "Well, maybe eventually somebody will find me. If not, I'll freeze to death out here." I began to think about my radio heroes, and I wondered how they would approach this situation. It was scary, but also I just considered it as part of the adventure of learning to deal with the unknown and the unexpected.

Synesthesia, as I have understood it, is a crossing or blending of the senses where stimulation of one sense produces sensations in a different sense. Some people, while listening to music, might visualize textures or smells or tastes. In my case, when I think of words or letters written in Braille, I visualize colors. This relates back to my early childhood when I had a sense of color. The name Michael is yellow and Larry is blue. Numbers also have colors. Four is a silver color and ten is red. One hundred is a pink color. When I go into 143 or 276, it's more complicated because I'm seeing a mixture of two colors. I don't know why. It just happens to be how I interpret them.

Sounds can be so meaningful. Not just people's voices but their tones of voice, the words and

inflections they choose to use. Obviously, sounds are very important for orientation. Walking along a street, hearing music from a record store, hearing when cars would pull into a gas station. They become clues as to where you are and where you're going. I also enjoy silence. The absence of sound is just as important as the presence of sound.

Touch is absolutely as important as listening. I think that's how I see the world most intimately. The shape of things, in particular, if they're small enough to be explored by two hands. Then I really have it in my mind; it's a tactile picture. In meeting people, you can tell a lot by a person's hand. How they shake hands but also the structure of their hand. And if you walk with them, you get to touch the arm. And the arm tells you a whole lot about the entire body. My mother was a strong believer in my need to see things with my hands.

When I was working for Southwestern Bell, one of my roles was to try to open up some opportunity for people with disabilities to work for the company. So I contacted the division manager for Operator Services by phone, to determine the feasibility of hiring a competent qualified blind person for employment. His reaction was, "Well, we just really don't have any jobs for blind people. We really don't want any blind people working in our organization." I said, "Well, that's fine, but before we meet, I need to tell you something. You may not know this, but I happen to be totally blind." He said, "Oh, my God. I am so sorry. I didn't mean to say . . ." I said, "No, I just didn't want you to be embarrassed when I showed up." So it was a little awkward and he was uncomfortable at first, but it worked out okay.

Since I was raised in a strict Germanic family, showing emotion was not really part of our expression. We didn't hug a lot. We didn't kiss a lot. In my late wife Deanna's Latin culture, you show your emotions, whether it's happiness or sadness. She taught me that it was important to hug your children and to show positive feelings toward other relatives and friends. I learned to give *abrazos*, which are embraces to close friends and to relatives, whether they were male or female. That was a very important lesson that I learned from her. She died in January 2007.

I think the most important part of a person is how they contribute to mankind. We are measured on the basis of our kindness, our love, our discoveries and creations. Not how tall we are or how short, or whether we're blond or brunette, have blue eyes or no eyes. The word "blind" has an implication of absolute darkness. It's a scary picture for people who are sighted. For some people, blindness is akin to death. They can't imagine living with blindness. In other words, they are only thinking about the limitations, the inability, or the obstacles. It's not that way at all. I really get very frustrated and annoyed when people make general assertions about blind people and characterize them as being greater than or lesser than the average person. Sometimes it's enfolded within a sense of pity or a sense of great admiration. It should be neither. I don't want to be somebody thought of as poor Larry, nor do I want to be thought of as amazing Larry. I want to be just Larry.

Reality is a very personal perception. No two people see reality in the same way. I believe this

table is here because I touch it and feel it. How we approach and understand the world is certainly conditioned by the range of senses that we have available. But it's also conditioned by our education, our upbringing, our attitudes, and our prior experiences with aspects of the world. To ask me, "How do you think your blindness has affected you?" I can't really tell you. I can't imagine what it would be like to see, because I've never had sight.

I have never really longed for sight. What I have longed for was to not be discriminated against because I was blind. I think the greatest misconception is the belief that people who are blind are helpless. How do you brush your teeth? How do you find your mouth? How do you go to the bathroom? How do you cook? Many blind people are fully functioning in the community. They're able to work. They're able to marry and have children. They're able to be contributing, participating, valid members of society. Being blind does not make them less whole, less complete. To change people's minds takes a long time. Some people are ready and willing to have their minds changed, but others are not.

My name is Larry Johnson. I was born in Chicago, Illinois. My first career was in radio and television. I was in that career about twenty-two years. I am an author of three books. I'm seventy-seven years old, and I'm a widower. I have six children and twenty grandchildren. I'm a writer and motivational speaker. And I enjoy very much having fruitful conversations.

ACKNOWLEDGMENTS

From an early age we have a hunger to know more—to have larger lives than the ones we were given and to find deeper compassion and understanding. This project began with a desire to have conversations about the nature of awareness and the complexity of perception. I have heard and learned so much. Losing and finding seem closely connected. I have been blessed with new friends, colleagues, and family members who provided enormous encouragement and support.

Deepest gratitude to my dear friend and mentor Larry Johnson. Larry is a teacher, writer, and tireless encourager to many. Larry's humor and thoughtful advice have given meaningful shape to this project.

Huge gratitude to Mike Gilliam, president and CEO of the San Antonio Lighthouse for the Blind, as my partner and adviser. Thank you for your resoluteness and unwavering advocacy.

My gratitude to Amon and Carol Burton of Austin for their unwavering and enthusiastic encouragement from the beginning.

I want to thank again and again the Kronkosky Charitable Foundation, Tom McGuire, and Molly Dupnick for their belief in this project and the foundation's ongoing financial support as well as their profound support for many meaningful endeavors in our community.

A very special acknowledgment to artist, photographer, and all-around talent Alexei Wood, who worked with and assisted me during this project. It was the greatest pleasure to travel and work with Alexei. His care, compassion, and enthusiasm can be found in each of the narratives you read.

Particular thanks to Roberto (Bobby) Bonazzi, who read each narrative with graciousness and attention. Thank you for your careful suggestions and corrections to the manuscript.

Special appreciation to Chelsea Muñoz, who transcribed most of the recorded interviews. The quality of her work and attention to detail was crucial. Not only did Chelsea transcribe the conversations, but she also offered important reflections about what she heard.

The title of the project, *My Heart Is Not Blind*, came from Frances Fuentes, whose blindness was the result of rare unknown causes. At the time she lost her sight, she was single, with a son eleven

months old, and authorities wanted to take her child away. Frances said, "I fought with my tears. I had to show them how much I loved him, how much I needed him. Being blind [was not] an obstacle because my heart is not blind. Having a kind heart, a loving heart is more important than being blind." I treasured her compassion and the optimism with which she lived. Frances died shortly after we talked.

Deepest thanks also to the following individuals and groups for their support and guidance through the six and a half years I worked on this project: Allen Platt, president and CEO of the Lighthouse for the Blind Fort Worth; Barbara Ras; Daniel Mann, president and CEO of the Lighthouse of Pinellas; David and Claudia Ladensohn; Dean Georgiev; Ho'opona Services for the Blind in Honolulu; Jack Levine; Katie Keim; Marise McDermott, president and CEO of the Witte Museum; the Criss Cole Rehabilitation Center in Austin; Sylvia Perez, executive director of the Lighthouse, Port Richey, Florida; Randall Webster; Joseph Middleton; Carra Garza; Kyle Laconsay; Virgil Stinnett; Wanda Austin; and the Warren Skaaren Charitable Trust.

I am forever grateful for all the individuals who participated in this project. These were not formal interviews but extended conversations over a two- or three-day period. To listen is a privilege. Each person in this project allowed themselves to be seen. They are teachers. They are our voices and guides.

Finally, I thank my son, Madison, and wife, Naomi, who advised and encouraged me throughout, cheering this project forward with generosity and steadfast support. This project would not have been possible without them.

INDEX OF MEDICAL CONDITIONS AND CIRCUMSTANCES

Leber's congenital amaurosis [72]

Leber's hereditary optic neuropathy [152]

Macular degeneration [20]

Osteoporosis-pseudoglioma syndrome [142]

Peter's anomaly [24]

Retinitis pigmentosa [58, 86, 90, 120, 138, 164, 200]

Retinitis pigmentosa, early [12, 156, 172, 180]

Retinopathy of prematurity [16, 46, 62, 126]

Rod and cone dystrophy [32, 168]

Scarlet fever [80]

Septo-optic dysplasia [76]

Spinal meningitis [50]

Stevens-Johnson syndrome [42]

Train accident/collision [54]

X rare unknown causes [116, 188]

Published by Trinity University Press
San Antonio, Texas 78212

Book design by Kristina Kachele Design, llc
Cover image: Dean Georgiev
Prepress by iocolor, Seattle
Printed in China

ISBN 978-1-59534-874-6 hardcover
ISBN 978-1-59534-875-3 ebook

Trinity University Press strives to produce its books using methods and materials in an environ-
mentally sensitive manner. We favor working with manufacturers that practice sustainable man-
agement of all natural resources, produce paper using recycled stock, and manage forests with the
best possible practices for people, biodiversity, and sustainability. The press is a member of the
Green Press Initiative, a nonprofit program dedicated to supporting publishers in their efforts to
reduce their impacts on endangered forests, climate change, and forest-dependent communities.

The paper used in this publication meets the minimum requirements of the American National Standard
for Information Sciences—Permanence of Paper for Printed Library Materials, ANSI 39.48–1992.

CIP data on file at the Library of Congress
23 22 21 20 19 | 5 4 3 2 1

MICHAEL NYE practiced law for ten years before pursuing photography full time. He has received a Mid-America National Endowment for the Arts grant in photography and a Kronkosky Charitable Foundation grant, and he has exhibited and lectured widely at museums and universities nationally and internationally, including in Morocco, India, and Mexico. His journeys to photograph around the world include projects in Russian Siberia, Iraq after the first Gulf War, Palestine, China, and Labrador, and he has participated in two Arts America tours in the Middle East and Asia. His documentaries, photography, and audio exhibitions *Children of Children,* stories of teenage pregnancy, and *Fine Line: Mental Health/Mental Illness* and *About Hunger & Resilience* have traveled to more than 150 cities across the country. He lives in downtown San Antonio.

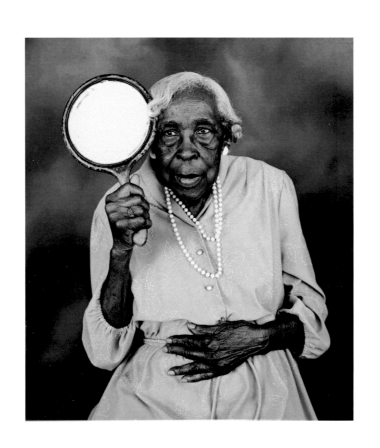